ALSO BY PAUL HOFMANN

*The Sunny Side of the Alps: Year-Round Delights
in South Tirol and the Dolomites*

*Switzerland: The Smart Traveler's Guide
to Zurich, Basel, and Geneva*

*Roma: The Smart Traveler's Guide to
the Eternal City*

That Fine Italian Hand

Cento Città

The Viennese

O Vatican! A Slightly Wicked View of the Holy See

Rome: The Sweet, Tempestuous Life

THE SPELL
OF THE
VIENNA WOODS

❁

INSPIRATION
AND
INFLUENCE
FROM
BEETHOVEN
TO
KAFKA

PAUL HOFMANN

HENRY HOLT AND COMPANY NEW YORK

Henry Holt and Company, Inc.
Publishers since 1866
115 West 18th Street
New York, New York 10011

Henry Holt® is a registered
trademark of Henry Holt and Company, Inc.

Published in Canada by Fitzhenry & Whiteside Ltd.,
195 Allstate Parkway, Markham, Ontario L3R 4T8.

Library of Congress Cataloging-in-Publication Data
Hofmann, Paul.
The spell of the Vienna Woods: inspiration and influence from
Beethoven to Kafka/Paul Hofmann.—1st ed.
p. cm.
Includes index.
1. Wienerwald (Austria)—Description and travel. 2. Wienerwald
(Austria)—Tours. 3. Wienerwald (Austria)—Civilization.
4. Wienerwald (Austria)—Intellectual life. 5. Arts, Austrian. I. Title.
DB785.W5H64 1994
943.6'13—dc20
93-38345
CIP

ISBN 0-8050-2595-2
ISNB 0-8050-3850-7 (An Owl Book: pbk.)

Henry Holt books are available for special promotions
and premiums. For details contact:
Director, Special Markets.

First published in hardcover in 1994 by Henry Holt and Company, Inc.

First Owl Book Edition—1995

Book Design by Claire Naylon Vaccaro
Map Design by Jackie Aher

Printed in the United States of America
All first editions are printed on acid-free paper.∞

1 3 5 7 9 10 8 6 4 2
1 3 5 7 9 10 8 6 4 2
(pbk.)

CONTENTS

CONTENTS

THE SPELL

OF THE

VIENNA WOODS

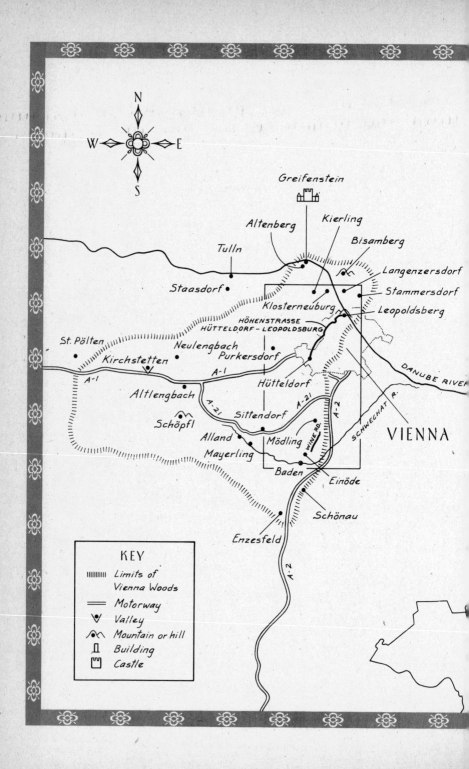

I.

A LYRICAL
LANDSCAPE

❀

"A culture is not better than its woods." The line is by W. H. Auden, who during much of his last fifteen years lived and wrote poetry in a red-tiled farmhouse at the edge of the forests hugging Vienna.

The mellow civilization that the Austrian capital radiated for a couple of centuries before Hitler smothered it in 1938 owes a great deal to the Vienna Woods. The many shades of green, the affecting autumn foliage, the dark firs, the soft contours of hill after hill with their vineyards and ruined castles, a few spectacular gorges and cliffs, the ancient towns and village taverns: all have inspired painters, poets, and especially composers.

Beethoven and Schubert both loved to roam the Vienna Woods, whose twittering birds are occasionally heard in their music. Mozart, too, knew the green hillside well, though he was essentially a city person and a man of the theater. He

didn't need the warblers, the linden trees, and the trout flitting in the clear brook to spur his creativity; yet the second scene of *The Magic Flute* with Papageno and his birds might be set in a clearing of the dense forests near the spa of Baden, where Mozart's wife, Constanze, was taking the waters when he wrote it.

The waltz, which in three-quarter time swept the world during the nineteenth century the way jazz and rock did during the twentieth, is an offspring of the artless dances of the country folk around Vienna. Johann Strauss the Younger, the King of the Waltz, retreated during his dark moods to his hillside home; he created the region's musical monument with his lilting *Tales from the Vienna Woods*, although it's hard to say what those tales were.

Even today, despite motor roads and suburban sprawl, the perceptive visitor will be stirred by the sylvan scenery's lyricism. It is not lovely like Tuscany or dramatic like the Dolomites. In fact, the Vienna Woods betray some ambiguity: not exactly cheerful, they are sweet and melancholy at the same time.

"The Vienna Woods aren't an unproblematic landscape," the Viennese novelist Heimito von Doderer (1896–1966) wrote. "Everything is slightly curving and fragrantly evasive. Yet a certain heaviness lurks behind it, the heaviness of melancholy, a danger also for very healthy persons, indeed, especially for those." The Vienna Woods, where he was born, represented for Doderer a "farewell to mountain and hill, to villa-studded slopes pushing into forested valleys; it is a farewell to the cozily friendly western small-scale world" and a transition to the immensity of the East, which starts nearby in the Hungarian lowlands.

Franz Kafka, the icon of modern angst, found passion with Milena, maybe the only happy moments in his life, in the Vienna Woods; a few years later he died in a sanatorium that looked out on them, another young woman at his bedside.

Gustav Mahler and his friends and fellow musicians Hugo Wolf and Arnold Schönberg were familiar with Vienna's green-belt. So was Sigmund Freud, although he used to tell his children he didn't like the Vienna Woods. As a thirty-two-year-old neurologist, Freud was investigating the symptoms and treatment of hysteria when Vienna and Austria-Hungary were shaken by a drama that had occurred in the Vienna Woods. The heir apparent to the Habsburg thrones in Vienna and Budapest, Crown Prince Rudolf, and his teenage mistress, Baroness Mary Vetsera, had been found dead in a hunting lodge at the hamlet of Mayerling. It was the lurid sensation of the Victorian age. The tragic events of 1889 have never been completely cleared up, and as many questions remain unanswered, the movie-romantic ring of the name *Mayerling* continues to attract tourists from as far away as Japan and Argentina to the somber site.

The Viennese, too, flock to their woods—although not a great many of them to Mayerling—as did their parents and grandparents. Tens of thousands hike, picnic, camp, play, or ski in the hills every weekend; many enjoy comparative solitude on working days or spend their vacations there. No other major European capital can boast such a large and safe recreation area. London, it is true, still has a few pastoral spots on its far outskirts; Parisians can reach the forests of Fontainebleau at some distance from their teeming suburbs to recapture the

mood of the famous woodland pages of Flaubert's *L'Éducation sentimentale*; Rome has spread out into what used to be its lonesome Campagna but has spared some groves in the Alban Hills; Berlin is surrounded by sandy flatland, mitigated by lakes and forests; Madrid is an oasis on the arid high plateau of New Castile. But the combination of mountains, hills, forests with many kinds of trees, grassland, vineyards, old villages, and memorable cultural connections within the city boundaries and in the immediate surroundings is uniquely Viennese.

The Quaker Shoes

During the early years of my life, the Vienna Woods meant to me Sunday strolls with my elders, a rare car ride, school outings, and bosky dates with girls. I grew up at the foot of the Bisamberg, a 1,175-foot (358 meters) sentinel of the forested hills on the opposite bank of the Danube from Vienna. Geologists assume that the big river changed its bed a million years ago on its way to submerged Eastern Europe, achieving a breakthrough between the Bisamberg and the Leopoldsberg, the two hills facing each other on what are now its northern and southern banks.

Our village, Langenzersdorf, stretched for more than a mile (nearly two kilometers) on either side of the old Vienna-Prague highway near the Danube. We called our main drag the Reichsstrasse, or Empire Road, and when I first entered our yellow schoolhouse on a parallel road, the Schulstrasse, we still had an empire—just barely. Then, one November morn-

ing, the teacher came into the classroom to tell us, "Children, you won't have to sing 'God preserve, God protect / Our emperor, our country' anymore. We no longer have an emperor. We are a republic now." After these words she turned her back to the class, but we saw that she was sobbing. Although I didn't know what a republic was, I was aware that we had lost the war and that something tremendous must have happened.

The facade of our schoolhouse remained Habsburg yellow, and we continued calling our main street the Empire Road. When the postwar famine came because Hungary, Slovakia, and Moravia stopped shipping flour, milk, eggs, and meat to Vienna, which was no longer their capital, the American Society of Friends sent food for us children. We wolfed it down in a soup kitchen that had been opened for us on the street floor of the mayor's office on Empire Road. The Quakers, whom I would never forget, also donated children's clothing for us, and I got a pair of incredibly sturdy American shoes.

Those shoes were so large that I could still wear them a year or so later when our extended family started regular Sunday afternoon outings up the Bisamberg. The leader of our hiking party was the patriarch of the Hofmanns, my grandfather, Carl, who ran a flower-gardening business on land he rented from the Abbey of Klosterneuburg across the Danube. He ran the firm jointly with my uncle Julius and an old laborer, and they also worked a rented vineyard on the slope of a nearby Bisamberg spur. With us on our hikes were usually my grandmother, two or three of my cousins, one or the other of their parents, and maybe my father whenever his new, lowly

government job allowed him a Sunday off. My mother had died when I was five years old, and Father had not yet remarried.

From my grandparents' house on Schulstrasse we would walk past the 650-year-old parish church of St. Catherine— where I had been baptized and my mother's funeral service had been held—and up the Hollow Way, a footpath climbing the Bisamberg. It ended at the Picture Oak, a mighty tree hundreds of years old that was hung with religious paintings, many of them faded. Today the Picture Oak still survives; its trunk is mossy, and all of the artwork has disappeared except for a small brass relief representing the Virgin Mary and the Infant Jesus. Similar ancient landmarks can be found in various places in the Vienna Woods across the Danube. They may be reminiscent of prehistoric times when outstanding trees, especially oaks, were venerated as minor deities. We were often reminded that our village was already inhabited in the Stone Age. Testimony to that fact is a five-thousand-year-old sculpture of a fertility symbol, dug up on a low ledge of the Bisamberg during foundation work for a new house in the late 1950s. It is known as the "Venus of Langenzersdorf."

From the Picture Oak our family troop would turn left and trudge across a forest of beeches and pines to the Elisabeth Height, the loftiest point of our modest mountain. It bears a stone column recording that Empress Elisabeth had once visited it; as a small boy I always wondered why Emperor Franz Joseph's wife, then long dead, should have bothered to come up to what seemed to me then to be such a humdrum place. We would pause a little to take in the panorama, which today

impresses me much more than it did when Grandfather was leading us. Below were our village and the Danube; across the broad river stood, majestic on a low hill, the Abbey of Klosterneuburg with its green-patinated domes and twin towers; behind it the Leopoldsberg steeply swept up to the summit.

The adults occasionally spoke in hushed tones about a certain Berndl, a hermit who was supposed to lead a bizarre or even scandalous life. We never set eyes on him then. Years later, as a teenager climbing our hill with my Viennese friends during school vacations, I glimpsed the eccentric. He was of medium height, deeply tanned, with shaggy blond hair and a beard, clad in what seemed to us rags but would today be considered a trendily informal outdoors outfit. He grinned at us but seemed in a hurry to disappear among the trees.

By then Florian Berndl had become something of a public character. Vienna newspapers would from time to time mention him as a "fresh-air apostle" advocating the simple life with plenty of sunshine, physical activity, and vegetarian food. According to Langenzersdorf gossip, the apostle had surrounded himself with a harem of scantily clad young female disciples. Today this Thoreau of the Vienna Woods would hardly be newsworthy, but when I was a child my grandmother and aunts ordered us to stay close by, as if Berndl were lurking in the bushes, ready to pounce and carry us off to his lair.

From the summit of our mountain we would descend to the small village of Bisamberg. Grandfather liked this place, where for several years he had been gardener at the "castle"

owned by a baron—actually just a big villa with four corner turrets in a park.

Grandfather had arrived from Hungary in the 1870s as a journeyman gardener, had married a Vienna gardener's daughter, and had taken the Bisamberg job. The couple's six children had all been born in the baronial gardener's cottage. Of Austrian-Danish ancestry, Grandfather spoke Hungarian as his first language, and all his life his German had what we children found a funny accent. We adored Grandfather because he was ever-indulgent toward us, much more so than were our parents. He also loved his dogs and cats, spoke softly to his flowers and bees, and didn't mind when the ungrateful insects—he kept a dozen hives—mercilessly stung him.

Our Sunday hikes invariably ended in the garden of a Bisamberg inn with old horse chestnut trees, where we sat for an hour or so before slowly walking home on the level Empire Road. We children would get fizzy pink or yellow bottled drinks that were opened by pushing a glass ball down their necks (to me the main thrill of an otherwise boring Sunday afternoon). The adults drank beer, except for Uncle Julius. He ordered red wine, though it cost a little more than the whites grown on the Bisamberg because it came from vineyards either around Krems, upstream on the Danube, or from the Wine Road on the eastern edge of the Vienna Woods.

Uncle Julius needed a lot of red wine every day. As an army conscript he had been sent to the southern front when Italy declared war on Austria-Hungary in 1915, and he had been captured by the enemy in his company's first engagement. The Italians sent these prisoners of war to Apulia, in the deep

south of their country, where the captives were supposed to work in the fields. In the big farming village to which Uncle Julius was assigned there were, as he often told us, only women, old people, and plenty of children. All able-bodied men were far away on the front, battling the Austrians in the Alps. When the villagers found out that the young enemy soldier was a gardener and also knew how to work a vineyard, his Apulian fortunes were made. Local farm families vied for his services.

"It was the best time in my life," Uncle Julius would say to the end of his days. Apulia in those years was parched (and to some extent still is today). There was little water for household and farm needs, but wine was overabundant— especially, it appeared, for Uncle Julius. When, to his disgust, he was repatriated after the war, he astounded and embarrassed the family by polishing off half a gallon of red wine every day. It wasn't the potent Apulian *vino primitivo* to which he had become accustomed, but at any rate the reds from Krems or the Wine Road helped him readjust to civilian life in an impoverished, depressed, and hungry Austria. And I never saw Uncle Julius drunk.

Uncounted workers' and lower-middle-class families in and near the Austrian capital passed their Sundays in the Vienna Woods the way the Hofmanns did on the Bisamberg, while rich or once-rich people retreated to their hillside villas. During the meager years after World War I, and again after the Second World War, the Viennese made sorties into the forests to hunt for edible mushrooms and to pick up dry branches to kindle fires in their kitchens and heat their homes.

Gardener's Latin

In 1919 my father had become the official driver of what was to be a long line of agriculture ministers. He had started out in life as a gardener like his father and his brother Julius, but he was also one of the first people in our village who could drive a car. The wealthy Vienna lawyer whose Langenzersdorf estate my father was managing—a 150-year-old hunting lodge with a vast garden and a pond—had bought one of the first automobiles in our village and wanted his gardener to serve also as chauffeur.

During World War I my father, as holder of a then-rare driver's license, first was assigned as a soldier-driver to staff officers on the Russian front and later, promoted to corporal, drove ammunition trucks up to artillery positions on the Italian front. He was still in army uniform after the collapse of Austria-Hungary when by chance he met his former commanding officer in the Vienna West Railroad Terminal. The officer had been a high civil servant under the emperor, and he had just been asked by the new republican government to reorganize the agriculture department. He needed a driver, and Father thus became a tiny cog in the new state machinery.

It was considered a good job. Father not only enjoyed civil service status, though on the lowest tier of the bureaucracy, but he was also assigned a succession of service apartments in the government buildings into which the inexorably growing agriculture department moved during the following years. My father remarried and took me from the relatives who had been

looking after me in our village to live with him and his second wife at Vienna's center.

I received my first strong impression of the real Vienna Woods when I was nine years old and my father drove me across them. Behind us in the government car sat Austria's Minister of Agriculture and Forestry, Rudolf Buchinger, with one of his political cronies, and they were discussing the conflicting interests of grain farmers and cattle breeders—the former mostly in the plains, the latter in the mountains. I remember the topic because the minister several times used a rhyming dialect phrase then new to me: "*Hörndlbauern und Körndlbauern*" (farmers specializing in horned animals or in corn and grain).

Minister Buchinger, a shrewd and popular politician, seems to have been fond of my father, allowing him to bring me to the farm over the weekend. The minister had political talks scheduled at his rural home at the western approaches to the Vienna Woods, and his driver would once again have to stay over. I had been awed at the prospect of meeting the important man, whom I had never seen before this car ride (although we were living two floors below his office), and had been relieved when I was allowed to slip into the front seat next to my father. I had been afraid I would have to sit beside the minister during the trip, and he would quiz me about school in the patronizing fashion of all adults.

The Buchinger farm was at Staasdorf, a village near the town of Tulln. To reach it we had to traverse the entire Vienna Woods, east to west, on the highway that was a part of the

very old route from Vienna to Linz, now the capital of the Region of Upper Austria, which must have been trod by ancient Roman legionnaires. My father had traveled the road many times with Buchinger and his predecessors in the agriculture department's powerful black Gräf & Stift car, license plate A III 9. Yet the one-time army corporal who only a few years earlier had negotiated hairpin switchbacks under enemy artillery fire in the Dolomite Mountains with ammunition trucks that had iron, not rubber, tires always spoke with respect of the Riederberg. This is a Vienna Woods pass only 1,260 feet (384 meters) in altitude with a few tricky curves. Before the A-1 Motor Road (Westautobahn) was opened, all major traffic between Vienna and Linz, Salzburg, and beyond rolled over the Riederberg, and quite a few inexperienced drivers would get in trouble there. Today the pass road sees mostly local traffic; the route is nevertheless to be recommended to motorists who want to get the true feel of the Vienna Woods.

On that ministerial trip long ago, when we were coming close to the pass, Father pointed with his chin at a large tree on the roadside, murmuring, "*Quercus*, look at that oak!" From his gardening days he had kept the habit— which annoyed me when I was a boy—of citing the Latin name of Carolus Linnaeus's botanical system when referring to a particular plant.

It was already dark when we passed the Riederberg, and I feared I would have to witness a wildlife tragedy. From earlier trips across the Vienna Woods my father had sometimes

brought home a dead hare that, blinded by the headlights, had run into his car. I always felt sorry for these victims of the motor age's intrusion into their habitat, but not sorry enough to refuse eating the tasty game that my stepmother, whom I had soon learned to love, larded and cooked to perfection. I knew that father picked up only hares that his car had killed when he was traveling alone, and he would not stop with the boss on board. I imagined that some hapless animal might not be killed at once and would remain agonizing on the highway or drag itself into the bushes with a hideous head wound. To my relief we heard no thump against the radiator during our trip.

I vaguely remember that weekend on the minister's farm as two days of overeating and boredom. We returned to Vienna Sunday afternoon, and in daylight I saw the hills and forests of the Vienna Woods as a symphony in green while my father, his hands on the steering wheel, pointed out various trees to me with jerks of his head, softly reciting in his gardener's Latin, "*Betula . . . pinus nigra . . . fagus.*"

Hiking Day

During my school years in Vienna my class, like other elementary and high school classes all over the city, would visit the Vienna Woods nine or ten times every year. The occasion was the monthly hiking day that the board of education had introduced after World War I. We would meet at a tram stop

or rail terminal and, under the guidance of one of our teachers, travel to a spot near the forest. The tacit understanding most of the time was that we would have to walk only a little, just enough to reach the nearest grassland or clearing, where we would play soccer to exhaustion, with heaps of backpacks and jackets substituting for goalposts. A few slackers and perhaps the only girl in the class would take it easy, eat the sandwiches they had brought with them, or even talk to the teacher who was responsible for preventing kids from getting lost, falling off a rock, or smoking.

I recall a day when the hiking day program was different. Our fifth-grade teacher, Rudolf Krenn, who always devised new ways to instill knowledge, took us to a stretch of brackish water near the town of Mödling, from which we could see the Vienna Woods hills at a distance of half a mile or so. "This measly ditch doesn't look like much," he said, "and yet once it was a great idea that for some time worked."

He went on to explain that at the end of the eighteenth century a group of promoters started the construction of a canal that was to link Vienna with Trieste, then the principal seaport of the Austrian Empire. The emperor himself was so taken by the mercantilist project that he bought into the consortium. By 1803 the first section of the waterway from Vienna to the town of Wiener Neustadt, some 25 miles (40 kilometers) to the south, was navigable. Mr. Krenn told us how horses on the towpaths pulled flat-bottomed barges loaded with timber, coal, or bricks, and how the bargemen had to pass no fewer than fifty-two locks.

The emperor's canal never went far beyond Wiener Neu-
stadt because the railroad age came, coal engines started pulling
freight trains, and the waterway eventually silted up. We did
get to play soccer that hiking day, I recall, but for a couple of
weeks afterward in the classroom, we drew maps of the Vienna
Woods and the old canal, charting where it would have gone
if it ever had been completed. We also designed pictures of
imaginary canal scenes and built models of barges and locks.
Mr. Krenn always insisted we should learn by doing things
with our hands. Whenever I see a canal I think of the best
teacher I ever had.

As a teenager I went hiking on the paths from the wine
suburbs of Vienna into the woodlands with my first girl-
friends—a local spring-to-autumn rite for young people. We
would most often take the No. 43 tram from the Schottentor,
a central traffic hub near the main building of Vienna Univer-
sity, and ride in it all the way to the last stop in the former
village of Neuwaldegg. From there we would wander up the
slopes into the forests until it was time to go home.

While I was a law student I held an editorial job at an
anti-Nazi periodical, *Monatsschrift für Kultur und Politik*, and the
publisher, Professor Johannes Messner, was a Tyrolean who
missed his mountains. As a substitute for alpinism, nearly every
afternoon he would ride the D tram to Nussdorf, on the
Danube, and climb the Leopoldsberg some 800 feet (250 me-
ters) up a trail known as The Nose, a steep path with many
bends. The slim, sinewy Messner made the trip up the Leo-
poldsberg and back to his book-filled home, near Vienna's two

major concert halls, in about three hours. Unbeknownst to my boss I started imitating him, and for a year or so I would pant up the unforgiving Nose early in the morning a few times every week.

When Hitler's army invaded Austria our monthly publication, like many others, had to fold, and Messner was for some time detained by the Gestapo. I decided to emigrate. The day before leaving Vienna I sentimentally rode the No. 43 tram to Neuwaldegg and walked into the forest. At a spot that held emotional meaning for me because I had been there often with Flora, an Armenian girl who had meanwhile returned to Teheran, I buried the little emblem enameled in the Austrian colors, red-white-red, which members of the anti-Nazi Patriotic Front had worn in their lapels, and which now was outlawed. Even then I knew I was being mawkish, but I was sure I would recall the exact point where the red-and-white badge was if I ever did return. Nearly two decades later I did come back to Vienna, take the No. 43, and stroll into the woods, but I never found the place of my melodramatic ceremony in 1938.

As a foreign correspondent for the *New York Times* for the past forty years, I have been reporting from many countries in all continents, some of which I liked so much that I should have been glad to stay on to live and work in them indefinitely. Recently when I began revisiting all the different regions of the Vienna Woods I found some things altered, but not all that many. Despite the changes, the landscape struck me again by its ambivalence: smiling and moody at the same time.

2.

A STREETCAR
NAMED NOSTALGIA

❀

Travelers who are about to arrive in the Austrian capital by railroad or car from Salzburg, Munich, Zurich, or Paris gain a strong impression of the Vienna Woods during the last thirty or forty-five minutes of their journey. They will see dense forests on either side of the tracks or the motor road, a hilltop castle here and there, friendly valleys and the Wien River—and suddenly, a glimpse of Schönbrunn Palace, the palatial summer residence that the Habsburgs built in the eighteenth century at the rim of the wooded hillside as a pastoral Versailles of their own.

Passengers landing at Vienna International Airport at Schwechat, east of the city, see cheerless flatlands, so they wouldn't suspect that the green hills are near. Yet the Vienna Woods are ever present in the old city, more so than is the Danube. They reach into Vienna like fingers of a giant green hand, gripping the city with slopes and valleys in which ancient

vintners' villages nestle. The villages have long become suburbs, but the rural flavor lingers. They are all only a streetcar, bus, or subway ride distant from the center. Any visitor to the city thus may get a whiff of Vienna Woods air in a couple of hours or less.

Quirky Trams

Although Vienna has had an efficient subway network since 1980—continually expanding as new routes are built—there are still some thirty surface trolley lines. The Viennese have an emotional attachment to their tramway system—they pronounce the word "TRAN-vie"—and they stubbornly clung to it when other cities were substituting buses for streetcars. Now, as urban transit networks all over Europe reconvert to trolley cars to curb air pollution by auto exhaust, Vienna smugly points to the environmental friendliness of its trams. The venerable trams cannot, in good faith, be called a rapid transit system; slow transit would be a better characterization. The trolley cars travel at an average speed of less than 10 miles (16 kilometers) an hour and delay other traffic because many streets are too narrow to allow a motor vehicle to pass through at the same time. A streetcar proceeding with majestic deliberation is often followed by a frustrated cortege of autos that, under city regulations, must halt at a respectful distance whenever a tram stops.

To the Viennese each of the tram lines possesses a distinct,

often quirky, personality and evokes memories from their childhood—perhaps of the people they used to see on the D tram every morning or of the many days when the erratic No. 58 made them arrive late for school. As a small boy I exasperated my elders whenever we were riding a tram because I insisted on positioning myself in front, close to the driver, to watch his maneuvers. With one hand he turned the lever regulating the electric motor, with the other he gripped the large brass handle of the manual brake, and with one foot he clanged the warning bell. Another pedal would dispense sand and gravel onto icy tracks in winter.

After countless stand-up trips at the front of trams I was convinced I would be able to drive one like a professional. Maybe I would have, maybe not, but I never had a chance to try. I was envious every time the newspapers reported, about once a year, that a prankster or a drunk had sneaked into the depot in the small hours, commandeered an empty trolley, and gone joyriding all over sleeping Vienna and the approaches to the Vienna Woods.

It is no longer easy to kibitz at the elbow of a tram driver. The drivers, many of whom are now women, used to stand, but today they are seated in glass enclosures and have push buttons in front of them to operate the automatic mechanisms. The cars, heated in winter, are comfortable, with special areas for baby carriages and disabled passengers. Recorded messages over the public address system announce stops and options for transfers to other streetcar routes, buses, the subway, and commuter trains.

Every time I return to my native city I make sure "my" trams are still operating. They are the J, in which I used to ride to high school classes, and the No. 43, which we took for romantic trips to Neuwaldegg.

To reach the Vienna Woods you may take the U-4 subway to the last stops either at Heiligenstadt, the former village that Beethoven loved, or Hütteldorf, on the Wien River west of Schönbrunn Palace. Or you can ride on one of several streetcar lines radiating from the center, some of them connecting with bus routes right into sections of the Vienna Woods. The names of the last stops of the various lines are those of former hamlets and villages that have long become parts of the capital.

The No. 38 tram line ends in ancient Grinzing, which to the Viennese means wine and song, and passengers may transfer for free to the 38A bus to the city's "House Mountains" (so called because they are considered essential parts of the Viennese habitat), Kahlenberg and Leopoldsberg, 1,553 feet (484 meters) and 1,363 feet (425 meters) high respectively. The No. 38 tram also connects with the 39A bus to Sievering, which retains much more of its village atmosphere than touristy Grinzing does. A transfer to the 35A bus instead will get you to Salmannsdorf, at the foot of the highest hill within Vienna's city boundaries, the Hermannskogel, which has an altitude of 1,739 feet (542 meters). Johann Strauss the Younger wrote his first waltz at Salmannsdorf at the age of six.

The No. 41 tram and 41A bus will take you to a vintners' village that has the woods (German: *Wald*) in its name, Neustift am Walde. The woods are also contained in the name of the

village of Neuwaldegg (reached by the No. 43 tram), from which several roads and paths lead up into the tree-covered hills. The No. 48A bus goes up a green slope on which hospitals spread and the gilded dome of Otto Wagner's stunning Church of the Steinhof psychiatric clinic (1905–1907) glitters in the sun. The historian Carl E. Schorske wrote in his fundamental *Fin de Siècle Vienna* (1961) that the Steinhof hospital church was among "the most radically modern monumental buildings built by a European state since the erection of the Eiffel Tower in 1889."

The No. 62 tram and 60B bus connect with the Lainz Game Park, an immense wildlife reservation seven times the size of Manhattan's Central Park, which is home to boar, deer, and wild horses living among oaks hundreds of years old. The walled park, entirely within the city's administrative limits, reveals a portion of the Vienna Woods preserved just as they were when emperors and noblemen used to hunt in them.

The streetcars to the Vienna Woods leave from the Ringstrasse, the monumental boulevard that seems remote from untamed nature. It was built in the second half of the nineteenth century to replace Vienna's former walls and moats, and it is lined, between well-groomed parks, with structures in the eclectic architecture of its era, copying various styles of the past. There is a revivalist Renaissance university; an imitation Gothic city hall facing a theater (the Burgtheater) in early Baroque opulence; a parliament building with the columns and bronze horse tamers of classical Greece and a statue of Pallas Athena; a pair of Renaissance Baroque twin museums; and the

former court opera, now the state opera, in the early French Renaissance mode. Today the Ringstrasse, with its rows of horse chestnuts seeming to march on parade and its historic architecture mellowed under the patina of more than a century, retains its grandeur.

Vienna's red-and-white electric streetcars still clank along the Ringstrasse, departing from it to the outskirts as they have done for a hundred years, and as did the horse trams before them. They still ring their bells to warn pedestrians and motorists of their approach.

Traveling in a streetcar from the Ringstrasse to the western suburbs, passengers first see gray neighborhoods, mostly with buildings from the late nineteenth and early twentieth centuries, on uninspiring streets. Here and there older buildings, some with noble neoclassical lines, stand out. The cityscape brightens after the tram passes the Gürtel, a beltway with much commercial traffic. Utilitarian blocks of municipal housing projects, some in bright or pastel colors, come into sight. Most of them were built by the Socialist city government between the two world wars—enduring monuments to "Red Vienna," 1918–1934.

There will also be, off and on, some squat structures in the neoclassical and Biedermeier styles of the late eighteenth and early nineteenth centuries, often with faded yellow facades. Black and yellow were the colors of the House of Habsburg, which ruled vast domains from Vienna for six centuries, and yellow used to be the politically correct color for painting aristocratic mansions, villas, courthouses, post offices, and

schools. Vienna's new post offices and other public buildings come in noncommittal grays or in pastel colors, but Austrian mailboxes are still yellow.

As the streetcar proceeds toward the outskirts the low, yellow houses become more numerous, interspersed with old and new villas in fenced-in gardens and with public parks. The streets gently rise, and green slopes become visible. The last stop is likely to be in a former village square. Passengers who transfer to a bus will ride into a valley or up a hill of the Vienna Woods, still on city territory.

Eventually you will see vineyards. Wine has been grown on the hills of the Vienna Woods for at least seventeen hundred years, since Roman times. In the Middle Ages the Viennese derived much of their income from a flourishing wine trade up the Danube. Even today viticulture has its place in the economy of Vienna's suburbs, although the real boom industry there is now real estate development. It is chic to live in one of the former wine villages on the city's green edges, and developers offer large sums for vineyards and other land on the slopes on which they will build yet another fancy villa or condominium. The city's stringent zoning rules aren't always able to check creeping urbanization and gentrification.

A Tuft of Fir Twigs

Tourism has altered the character of the old villages on Vienna's outskirts. For one, it has adulterated the rustic flavor of the

wine-drinking places that are closest to the capital's center, as they are easily reached by sightseeing bus.

The wine growers in Vienna's environs have since time immemorial been authorized to sell their product to consumers on their premises without a special license or the help of a professional tavern keeper or other intermediary. The "people's emperor" Joseph II, an enlightened autocrat, reconfirmed the old vintners' privilege by decree in 1784.

For many generations wine growers in the Vienna Woods would move beds and cupboards out of one or two rooms in their houses in late autumn, replacing them with tables and benches. There they would serve their fresh wine to any guest who might drop in. If a vintner still had some of his young wine left the next spring or summer, people could drink it outside in his courtyard or garden.

The wine grown on the sandy slopes in the vicinity of Vienna is generally white and doesn't age very well. To tell the truth, it's no Sancerre, Moselle, or Soave, and is best drunk during the first year. Many local people even fancy the half-fermented cloudy liquid called *Sturm* (tempest) that is served weeks before the new product is quite ready. The young wine, greenish or pale amber in color, is called *Heuriger* or *der Heurige*. The term is derived from *heurig*, the Austrian dialect's word for "this year's."

The dialect noun *Heuriger* or *der Heurige* also denotes the place where new wine is poured by the producer and drunk by paying guests during some months—legally up to three hundred days—each year. It is a specifically Viennese and

Vienna Woods institution. The forests girding the city are symbolized by a tuft of fir twigs on a pole jutting out of the roof or gable of a vintner's house, an age-old signal that it welcomes guests. "*Ausg'steckt is*" (roughly: the fir tuft is sticking out) is the ritual dialect formula cheering wine drinkers. For centuries people wanting to enjoy a glass or more of genuine young wine in some simple public place have watched for a friendly fir tuft. The phrase *Ausg'steckt is* can today be read also on signboards in the Vienna Woods villages and towns listing temporary wine taverns and in the advertising sections of Vienna newspapers.

At a true *Heuriger* there are no tablecloths. Young wine or muddy "tempest" is drunk from muglike glasses refilled by members of the vintner's family. No tips are expected. No warm dishes are served, although there may be rolls, sliced bread, cold cuts, cheeses, and pickles on a self-service sideboard. Patrons are also welcome to bring their own picnic food with them. Up until recent years, Vienna grocery shops would put together *Heurigenpackerl* (little packages for the *Heuriger*) with cold chicken, ham, and other treats according to the customer's preference. Supermarket shopping has all but ended the old custom.

The mood at an authentic *Heuriger* is rarely boisterous. Most patrons come to chat or flirt; strangers at neighboring tables may strike up a convivial conversation. Regulars, often elderly people, hold their wine well. They may slosh a sip in their mouth for a few seconds before swallowing it (such habitués are called wine biters). Drunken voices and scenes

are uncommon and are resented. Foreigners on their first visit to a *Heuriger* may wake up with a headache the next morning. The young wine goes down all too easily and can be treacherous.

Music is part of the *Heuriger* mystique. A violinist or guitarist and an accordion player may wander into the room, or into the courtyard where the wine drinkers sit under old trees, to play some of the schmaltzy perennials: "Vienna, Vienna / Thou alone / Shalt always be the city of my dreams," or "There will be wine again / And we shan't be around anymore . . ." The golden oldies reinforce the increasingly maudlin atmosphere of a traditional wine tavern on Vienna's outskirts.

Patrons who live in distant neighborhoods and didn't come by car may forget about the "last blue." The night's last tramcar on each route, departing around midnight from the suburbs, has a blue taillight instead of the usual red one. Anyone who misses it has to either take an expensive taxi or set out on a long, sobering walk home.

Don't expect to find *Heuriger* authenticity in Grinzing. The tourist industry has long taken over the former village. Sure enough, plenty of fir tufts stick out from rustic-looking gables; one Grinzing establishment, Altes Presshaus (Old Wine Press) at 15 Cobenzlgasse, even claims to stretch back to a winery first mentioned in 1527. The sham-rural Grinzing enterprises, however, are in fact year-round restaurants geared to out-of-town patrons and package tours, gussied up with wrought-iron storm lamps in their gardens, patterned tablecloths, and other faux-folklore decor.

Vienna's mayor or officials of the Austrian federal government will from time to time entertain distinguished guests at some *Nobelheuriger*, as the high-class version of the traditional wine taverns are locally called, to acquaint them with refined and largely spurious vintners' lore. At such showplaces in Grinzing or in nearby suburbs Schrammel music is de rigueur—the kind of sentimental quartets for two violins, guitar, and a sweet-sounding C clarinet that the prolific composer brothers Johann and Josef Schrammel wrote to perform with other musicians in the wine taverns of late-nineteenth-century Vienna. Johann Strauss the Younger knew and praised the Schrammel brothers.

The ambiance and atmosphere of a *Nobelheuriger* are about as genuine today as most gypsy haunts in Budapest, evenings in Naples with "O Sole Mio" and tarantella, fado singers in Lisbon, flamenco places in Madrid, and yodeling in Munich and Zurich beer gardens.

Nevertheless you may still find a mood of unsophisticated authenticity in a few spots among the Vienna Woods villages. Look for some family-run *Heuriger*, in business for only a few months in the year, or ask local connoisseurs for advice. Likely areas are Klosterneuburg, Perchtoldsdorf, and Gumpoldskirchen; north of the Danube, try Stammersdorf, which is within Vienna's municipal borders. For Langenzersdorf and Bisamberg consult the *Ausg'steckt is* signboards. All these towns and villages can be reached by streetcar, public bus, or commuter railroad (*Schnellbahn*) from the center of Vienna in less than an hour.

Many of the more distant areas of the Vienna Woods are accessible today by public transport in one to two hours. You may also want to do quite a bit of walking. More than 3,750 miles (6,000 kilometers) of marked hiking trails crisscross the forests, climb the hills and ridges, or lead to gorges, castles, lakes, panoramic spots, and man-made observatories. Anyone may stray from the marked paths and trails to penetrate into the thickets—the realm of birds, foxes, deer, and other wildlife. At the time of Beethoven and Schubert bears and wolves still roamed the Vienna Woods; the last bear was killed in 1842.

Some cliffs, often only a few minutes from the nearest bus stop, serve as so-called climbing schools, where beginners learn the techniques they will use to conquer Alpine walls twenty or fifty times higher than the Vienna Woods precipices. In winter, children and grownups shoulder their skis and travel by tram, bus, railroad, or car to some slope beneath the forests. It isn't Saint Anton or Saint Moritz, but for novices it's just right, and they will be home before dark.

3.

THE ALPS'
FRIENDLY SALIENT

❀

The Vienna Woods, with five times the land mass of the five boroughs of New York City, represent a patch of the thick green mantle that once covered most of the European continent. That to a large extent it survives so close to—and even in—a metropolis is remarkable at a time when all too many of the globe's breathing forests are vanishing.

Geographically, the Vienna Woods are the northernmost salient of the Alps in their majestic sweep from southern France to Slovenia and the Adriatic Sea. The hilly woodland spreads over 540 square miles (1,400 square kilometers), forming a broad, live sash from Vienna's north to its west and south. The 2,930-foot (893 meters) Schöpfl, 25 miles (40 kilometers) southwest of the capital, is the district's highest peak.

The Vienna Woods are bordered to the north by the Danube, with a low outpost, the Bisamberg, on the opposite bank. To the east is the Vienna Basin, a plain that beyond a

modest threshold, the Leitha Hills, continues as the Hungarian lowlands. To their south the Vienna Woods rise to the higher and more severe mountains of Styria's Limestone Alps. West of the Vienna Woods hills is a fertile plain named after the Danubian city of Tulln, which was mentioned in the twelfth-century heroic epic of the Nibelungs. Attila the Hun, an idealized "Etzel" in the long medieval poem, rides up the Danube as far as Tulln, preceded by a splendid crowd of warriors and princes from many of his subjugated lands, to meet his Burgundian bride, Kriemhild, whose ferocious revenge for the slaying of her first husband, Siegfried, will soon drag most Burgundians and Huns to their doom.

The Wien River forms the main valley of the Vienna Woods. The Wien is 21 miles (34 kilometers) long, dividing the hilly woodland into a northern zone where sandstone prevails and a southern limestone segment with cliffs and gullies. Like all other streams and rivers of Lower Austria, the Wien delivers its waters to the Danube. On its way across the city of Vienna it is partly enclosed by high walls, partly covered. Most of the time the Wien is just a trickle, but after downpours the paltry stream suddenly becomes a roaring brown torrent, carrying up to two thousand times its usual volume of water.

Firs, pines, other evergreens, oaks, beeches, ashes, birches, lindens, and horse chestnut trees grow in the Vienna Woods. The horse chestnut, which also provides a green counterpoint to the florid architecture of Vienna's Ringstrasse, is a relative newcomer to this part of the world. Indigenous to the hills of the Balkans, the stately tree impressed Prince Eugene of Savoy,

the French-born military leader who was commander-in-chief of the Habsburg armies during the Turkish wars of the late seventeenth and early eighteenth centuries. He had horse chestnut saplings transplanted into soils in and near Vienna. In the Vienna Woods, horse chestnuts grow among other trees in a patchwork pattern; elsewhere in the area, large forests of the aromatic black fir cover the hills. The pinaceous trees, tall and straight as the pipes of a giant organ playing the symphony of the seasons, retain their severe dark green color while the other vegetation on the hills displays many brighter tints of green and, in the fall, of red and brown.

Romans, Barbarians, and Plagues

Some valleys and hills of the Vienna Woods have yielded evidence that they were inhabited as early as the younger Stone Age. A quarry and the remains of shafts dug into the ground near the present southwestern border of Vienna's municipal territory, the Antonshöhe near the former village of Mauer, have been identified as a site where prehistoric people mined hard stones to be used for weapons, tools, and flints for striking sparks to kindle fire. Celtic settlers turned out pottery in a workshop, traces of which can be seen near the town of Mödling.

Celtic tribes coming from the south and along the Danube had become dominant in what is today Lower Austria (south of the big river) and Styria by 500 B.C.; they also lived in a few

villages in and near the Vienna Woods. These Celts were loosely organized in the first state to exist in this part of Europe; it minted its own coins and traded with the Roman Empire. The Romans coveted Styrian steel for the swords, javelins, and armor of their legions. The Roman name for the Celtic kingdom south of the Danube was Noricum, an appellation probably derived from Noreia, a Celtic center somewhere in the present Austrian regions of Styria and Carinthia. Under Augustus, between 16 B.C. and 14 B.C., the Romans occupied the Celtic state without much, or any, fighting.

The new Roman overlords set up a military camp near an arm of the Danube, in an area that is today Vienna's inner city, and called it Vindobona, probably the latinized form of a Celtic place name. Roman rule on the south bank of the Danube would last five centuries.

The Romans built watchtowers, walls, and bastions—a system of fortifications that they called the *limes* (boundary line). It stretched along the southern shore of the Danube and protected the Roman territory from raids by the barbarians dwelling and roving north of the big river, mainly the allied Germanic tribes of the Marcomanni and Quadi. To move troops to strategic locations or danger spots, the Roman engineers also laid out a road roughly parallel to the Danube and the *limes*.

The *limes* road, largely unpaved, cut through the hills and forests of the northern Vienna Woods, but it appears that the Romans left alone other parts of that forested area and the

natives that were living there. The ancient Romans didn't care much for woodland; they cleared vast forests in Italy, North Africa, Spain, and other countries around the Mediterranean. Terrain with a lot of trees seems to have made Roman military commanders uneasy because it hampered the deployment of their troops. Varus, a general under Emperor Augustus, lost three legions when the Germans led by Arminius (Hermann) ambushed and defeated him in the Teutoburg Forest on the Rhine in A.D. 9.

As for the Vienna Woods, the Roman military maintained a rest and recovery center at the area's southeastern edge where sulfurous water flows from the hot springs of the limestone hills. The legionnaires treated their rheumatic ailments and the wounds they suffered in fights with the near-savages beyond the Danube, using what is now the spa of Baden.

The Celts and the Roman camp followers who settled in the valleys and on the slopes of the Vienna Woods must have had their ample share of trouble after the fall of the Roman Empire and the withdrawal of the legions. Teutonic bands avid for rapine and conquest crossed the Danube or sailed to Vindobona from lands upstream. From the steppes of the east swooped hordes of Huns, Avars, and Magyars on thousands of fast horses. A measure of stability in the area was restored only at the end of the Dark Ages when a Germanic margrave installed himself near one of the "house mountains" overlooking Vienna, and the name *Austria* started appearing in documents toward the end of the tenth century. Monasteries, especially those of Klosterneuburg and Heiligenkreuz, became

early centers of learning and civilization, offering a refuge for the rural population in dangerous times.

The terms *Vienna Wood* and *Vienna Woods* in Latin or German are found in written texts from the fourteenth century onward. By that time baronial clans were ensconced in castles on the forested hills and, with their armed men, controlled the routes of communication; they both protected and exploited the farmers and villagers in the valleys.

Besides other afflictions, towns in the Vienna Woods from the late Middle Ages to the first half of the eighteenth century suffered frequent visitations by the black plague. The pestilence would invade them from the nearby metropolis, which in turn imported it from the Near East by way of the Danube trade. When the epidemic had at last relented after killing hundreds of thousands, various forest towns, like Vienna, erected elaborate monuments as tokens of gratitude to the Trinity. Such "plague columns" can be seen today in a courtyard of Heiligenkreuz Abbey, in Klosterneuburg, in Baden, and in other Vienna Woods towns.

A new scourge arrived in the sixteenth century: Turkish raiders. The Ottoman Empire had conquered most of Hungary and sought further expansion into Central Europe. Twice, in 1529 and 1683, the sultan's armies beleaguered Vienna. The Austrian capital withstood both sieges, but the farms, villages, and towns in its environs suffered grievously. The chronicles of those grim times record massacres, plunder, and the abduction of thousands of women and children into slavery.

Mr. Biedermeier and Friends
Discover the Woods

By the end of the seventeenth century Turkish might had been pushed back into the Balkans, and the countryside and hills around Vienna were at last safe from Muslim marauders. The Habsburg rulers built their summer palace and had their French-style park laid out at Schönbrunn—a name that means "pretty wellspring"—and began using the adjacent Vienna Woods as extensive hunting grounds.

Members of the high Austrian aristocracy joined the imperial outdoorsmen in their sport. Farmers were forbidden to kill bears, boar, deer, and foxes—even though the animals kept ravaging their fields and feasting on their goats and chickens—because the wild beasts were to serve for the amusement of the noble hunters.

Well-to-do Viennese, bluebloods and commoners alike, started flocking to the thermal belt on the southeastern edge of the Vienna Woods, particularly to Baden. The old spa became the place to be from July to September once the emperor, his family, and his court began spending each summer there starting in 1803. For thirty-one years, an entire generation, Baden was the warm-weather capital of Austria. Metternich would often come to report to his sovereign and see his own family. The police kept a watchful eye on Napoleon's unfortunate son, the Eaglet, who after the French emperor's downfall lived in Baden off and on with his mother, Marie Louise.

In those post-Napoleonic decades, police spies were every-

where. The ideas of liberty and equality that had swept Europe after the French Revolution seemed to have been deceptive dreams; the old dynasties and aristocracy had regained their possessions and privileges, and in Austria the stifling paternalism of the Habsburgs was triumphant. The rising bourgeoisie sought solace in the coziness and pleasures of private life and the company of friends. The modestly prosperous Viennese middle class found contentment for some time in snug homes where one could entertain congenial guests at musical soirees or poetry readings. They enjoyed abundant good food, frequented the many coffeehouses to read the newspapers and play card games or chess, and went on merry Sunday outings to some pleasurable spot in the environs.

The Romantic movement in philosophy, literature, music, and the visual arts had prepared the Viennese for the discovery and enjoyment of the Vienna Woods. For thousands of years forests had inspired awe; they were viewed as the abode of ghosts, monsters, wild animals, and sorcerers, and as a refuge for shady people, outlaws, and rebels. Folktales echoed such fears: Hänsel and Gretel barely escape a horrible fate at the witch's house in the woods.

In the late eighteenth and early nineteenth centuries, however, forests came to mean freedom. Life in the greenwoods was idealized under the influence of Rousseau, Schiller's drama *The Robbers*, the immensely popular translations of Sir Walter Scott's *Ivanhoe* and James Fenimore Cooper's *The Last of the Mohicans*, Carl Maria von Weber's opera *Der Freischütz*, and other romantic books, plays, and music. To the Viennese the

nearby wooded hills offered an emotional outlet during the upheavals of the Napoleonic era and the repression under Metternich.

Excursions into the countryside and into the woods characterized the Biedermeier epoch—the period between the Congress of Vienna, 1814–15, which reshuffled the mosaic of European states after the collapse of Napoleon's empire, and the revolutions in Paris, Vienna, Berlin, Rome, and elsewhere in the "mad year" of 1848. The term *Biedermeier*, also applied to the sober style of that epoch's furniture and architecture, has its origin in the fictional name of a satirical character who embodied the timorous, law-abiding subject of a police state in the verses of the Swabian poet Ludwig Eichrodt in the 1850s. As people in the Middle Ages didn't know they were medieval, the contemporaries of Metternich and Schubert were unaware of living in the Biedermeier epoch.

From fashionable Baden and from the ancient vintners' villages that were gradually becoming suburbs of the imperial capital, the Viennese in the Biedermeier years began exploring the green hills. Romantic love of nature, the outdoors, and wilderness (a conveniently tame one) drove young city dwellers into the Vienna Woods, usually on sentimental Sunday trips that more often than not ended at a rustic tavern. The *Landpartie* (country party) was the rage then. Biedermeier paintings and drawings show jolly companies of men in blue or brown frock coats and high hats together with young women wearing billowing skirts and carrying parasols on rented coaches pulled by teams of patient horses. The favorite conveyance was a

peasant's wagon with boards put across the sides as benches; half a dozen or more couples could ride on such a *Zeiselwagen* (a word probably derived from the Bavarian dialect verb *zeiseln*, "to hurry").

On each *Zeiselwagen* someone always had a guitar. A long picnic in the green with lots of music, song, and flirting seems to have been the main purpose of the country party. The pleasures of prolonged hiking in the woodland would become popular only two or three generations later, although Beethoven, for one, anticipated them.

Threatened Trees

The coming of the railroad age helped the Viennese become familiar with the forests near their city. A section of tracks along the eastern edge of the Vienna Woods was opened in 1840; it was the initial stage of the present Southern Railroad (Südbahn) that links Vienna with Trieste, Venice, and the rest of Italy. About twenty years later the first trains of the Western Railroad (Westbahn) chugged across the Vienna Woods on their way to Linz and Salzburg.

A serious threat to the Vienna Woods arose during the second half of the nineteenth century. Austria had lost its 1866 war with Bismarck's Prussia, and the government desperately needed money to pay its debts. Vienna timber merchants and real estate developers proposed to buy the state-owned forests west of the capital, paying cash. Parliament seemed about to

acquiesce in the deal, which would have resulted in the cutting of millions of trees, until a one-man crusade managed to swing public opinion and save the Vienna Woods (see chapter 7).

In 1905 the Vienna city parliament unanimously approved a motion calling for the creation of a "Forest and Grassland Belt" around the capital. The project was first proposed a year earlier by Mayor Karl Lueger, a Roman Catholic populist who had ridden the anti-Semitic wave among the lower middle class to win power. However, as mayor from 1897 until his death in 1910, Lueger displayed remarkable administrative skills as well as an understanding of his electors' concerns and an early perception of environmental challenges.

Lueger's idea of a greenbelt encircling Vienna from the House Mountains to a point in the flatlands downstream on the Danube was not translated into reality. His ecological initiative nevertheless contributed to the conservation of large parts of the Vienna Woods. While the plains east and south of Vienna became increasingly industrialized and built-up, stringent zoning regulations curbed further expansion of the hilly suburbs. To impede real estate speculation, the City of Vienna bought up land on the slopes.

The City of Vienna, completely surrounded by Lower Austrian territory, has since the end of World War I been one of Austria's nine self-governing units. Until 1986 the autonomous city was also the capital of Lower Austria. Now, the city of Saint Pölten, 40 miles (65 kilometers) west of Vienna, is the seat of Lower Austria's regional government.

In 1987 the regional governments of Vienna and Lower

Austria, together with Austria's easternmost region, the Bur-
genland, issued a Vienna Woods Declaration. It expressed a
joint commitment to stem "developments and influences that
impair the function of the Vienna Woods as a centuries-old
cultural landscape and most popular recreation area in Vienna's
immediate vicinity." The declaration urged all public authori-
ties to take the necessary measures to protect the Vienna
Woods and to "conserve them for us and for future genera-
tions."

Despite such official pledges, pressures and encroachments
on the Vienna Woods continue. There is a mounting demand
for suburban residences and second homes in the verdant
hills, both from prosperous local people and from affluent
foreigners—diplomats, staff members of international organi-
zations, and corporate executives posted in the Austrian capital.

Local conservationists have long warned about what they
call the *Verhüttelung* (infestation by shacks) of the Vienna
Woods. Viennese workers and lower-middle-class families have
in fact for generations yearned for their own handkerchief-size
plot of land somewhere on the outskirts to grow tomatoes and
greens and with their own hands build a shed where they can
spend weekends from spring to fall. People in Prague and other
cities in this part of the Continent have the same craving for
a tiny semirural spot with a cabin to call their own—it's the
central European version of the Russian dacha way of life.

Now, however, it's not shacks that threaten the Vienna
Woods, it's ranch-type residences with swimming pools, barbe-
cue pits, and two-car garages. New roads have made hitherto

out-of-the-way woodland easily accessible. Austria built its Western Motorway (Westautobahn, A-1) across the Vienna Woods in the late 1950s with two branches: one starts near the suburb of Hütteldorf close to Schönbrunn Palace; the other connects with the Southern Motorway (Südautobahn, A-2), Vienna-Styria-Carinthia-Italy.

The A-1, Austria's principal east-west axis, runs as an elevated road through the village of Kirchstetten, a few hundred yards from the farmhouse where W. H. Auden wrote his *Thanksgiving for a Habitat* in praise of his Vienna Woods home. If he cared to walk into the pine forest behind the house he found himself in utter solitude within minutes.

Yet exhaust fumes and other forms of air pollution result in acid rain, damaging trees and other vegetation. Many Vienna Woods trees are sick or dying. Reforestation efforts are afoot in various patches, but they create tree farms rather than genuine woodland with its connective tissue of underbrush. The Vienna Woods are nevertheless far better off than are most forests in the Continent's industrial countries, and today's strengthened ecological awareness may indeed save them.

4.

PASTORAL
SYMPHONY

❀

Choosing one of the northernmost approaches to the Vienna Woods, we boarded the D tram on the Ringstrasse at its State Opera stop. Ten minutes later the streetcar turned radially off the broad boulevard, and I said to my guests, a Chicago couple who were newcomers to Vienna, "Look to your left. You'll get a glimpse of the garden house and park of the Liechtenstein Summer Palace." I pointed out the ornate complex. "Liechtenstein? Isn't that a dwarf country somewhere near Switzerland where rich people park their money?" Charles asked. "Correct," I replied; the tiny Principality of Liechtenstein on the Rhine, wedged between the Swiss canton of Saint Gall and Austria, is a fiscal paradise that derives a good deal of its income from financial services and the sale of its pretty postage stamps. It is also a prosperous industrial country that, small though it is, could well live exclusively on the products it manufactures and sells abroad, from building materials to millions of sets of false teeth.

The ruling prince of Liechtenstein is the chief of an old and illustrious family that has its roots in the Vienna Woods. On a later trip we would see the historic Liechtenstein Castle on a hill near the town of Mödling, I promised. Over the centuries the Liechtensteins acquired—and to a great extent lost again—vast possessions in Austria and Bohemia, while residing most of the time in Vienna. The family went to live permanently in their medieval castle at Vaduz, the chief town of their Rhine territory, only after Hitler annexed Austria, and they managed to keep their miniature monarchy independent. Now the principality is even a full-fledged member of the United Nations. In Vienna there are two Liechtenstein palaces, one on the central Minoritenplatz and the Summer Palace, which houses a gallery of modern art. The Liechtensteins took most of their fabulous collection of old paintings with them to Vaduz.

The D tram had long passed the Summer Palace and the rebuilt Franz Joseph Railroad Terminal from which trains leave for Bohemia before I was through with my Liechtenstein stories; I hope I didn't bore my guests. "Quick, look to your right!" I commanded as the tram was taking a slight curve. "What you see isn't the minaret of a Disneyland mosque, it's the disguised smokestack of a municipal incinerator." The soaring, slender tower, bulging high up into a golden globe, in fact releases filtered fumes from the garbage that the city's sanitation department burns in the building. Friedensreich Hundertwasser, one of Austria's leading postmodernists, designed the facility and tinted it in ice-cream hues.

A little farther the tram was rolling along the seemingly endless frontage of a municipal housing project, five to seven stories high, in which five thousand people live in nearly fourteen hundred apartments. A large central plaza opposite a D tram stop is dominated by six short, stout towers over the large lettering "Karl Marx Hof." My guests appeared puzzled. Karl Marx as the patron saint of a Vienna building complex in the post-Communist era? (*Hof* means "court" and was used, coupled with the name of someone to be honored, for units of Vienna's vast municipal building program between the end of World War I and the 1960s.)

"This superblock, cited in many books on architecture, remains the showpiece and emblem of the public-housing policy of Red Vienna between the two world wars," I explained. "I have seen one of these central towers in ruins, shattered by artillery, and it happened long before the last war. The big guns were fired at the Karl Marx Hof by Austrian Army batteries brought into position on the north bank of the Danube." The year was 1934, and we were having a full-blown, though short, civil war. Private armies organized by the Socialist party and by conservative and rightist groups had long been clashing somewhere or other in Austria nearly every Sunday before the situation became really nasty. Armed Socialists barricaded themselves in some of the municipal housing projects, including the Karl Marx Hof, and the conservative government, backed by the army and by paramilitary pro-Fascist formations, went about smoking them out. After a week or so of fighting, with hundreds of people killed, the rightists won and the

Socialist party went underground. Austria and its capital were for four years governed by a semi-Fascist, semiclerical regime supported by Roman Catholics and rightists as well as by Mussolini from abroad. Pressures from Nazi Germany were mounting steadily until Hitler made a deal with Mussolini and took over the country in 1938.

I didn't inflict all my reminiscences of my earliest brush with civil war on my friends from Chicago. The fact is that I took the D tram to have a look at the shot-up Karl Marx Hof only a couple of weeks after that artillery attack. We residents of the city center were only vaguely aware of what was going on; neither the radio nor the newspapers had much to say about the fighting during those dramatic days, but we heard a lot of rumors and the faraway thunder of artillery.

At what must have been the height of fighting I found nothing better to do than irresponsibly go to a movie with my girlfriend Annie. The cinema, which we reached in a long ride on the No. 52 tram, was in a neighborhood near the wooded hills of Rudolfsheim that seemed quite calm. I don't remember which film lured us to such an outlying theater. When it was over and we were leaving we heard what sounded like strokes of a whip but actually was rifle fire. We didn't realize at first what was happening, but the other moviegoers all surged back into the foyer and so did we. An hour or so passed until the shooting had ended, the streetcars were passing again, and we could go home. Annie's mother forbade her to ever go out with me again.

Beethoven Promenades

The D tram carrying me and my Chicago friends had meanwhile stopped at Grinzinger Strasse and we had gotten out. "This neighborhood is Heiligenstadt," I told my friends. "Beethoven loved it; the hillside is quite near, as you can see." A statue of the composer—one of several in Vienna—stands in the Heiligenstadt Park at the center of the former village near the late Gothic Church of Saint Michael. Over the years Beethoven inhabited various houses in Heiligenstadt and in the nearby village of Nussdorf.

He had at least three dozen addresses in Vienna between 1792, when he arrived to stay in the Austrian capital from his native Bonn on the Rhine, and his death in 1827. He was never easy to deal with, often quarreled with his landlords and neighbors, and with advancing age and deafness became increasingly irascible. He would play the piano at any hour, sing without words—to his neighbors it sounded like howling—and leave a mess behind when moving out in a huff after a few months.

The elderly guardian at the small Beethoven Museum at 6 Probusgasse, near the Church of Saint Michael, told us that the composer lived in seventy-nine different places during his thirty-five years in Vienna. The veracity of much of what museum personnel, professional guides, and local people pass off to strangers as well-known fact is, however, questionable.

It was in the two-story house with the wooden outside stairs from the small, homey courtyard leading up to his quar-

ters that the composer penned in 1802 the self-revelatory document known as his Heiligenstadt Testament. "O ye men who think or say that I am malevolent, stubborn, and misanthropic, how greatly do you wrong me!" it reads. The thirty-one-year-old Beethoven addressed his "will" to his two brothers (he later removed the name of one, Nikolaus Johann, because he had had a falling out with him). He explained in his pathetic message to posterity from Heiligenstadt that for years he had been afflicted with progressive deafness and that doctors had been unable to cure it. "Born with a fiery and lively temperament, and very susceptible to social pleasures, I was early forced to segregate myself and to spend my life in solitude," he went on. "What humiliation when someone stands near me and hears a far-off flute and I cannot hear a sound! Or when someone hears a shepherd sing and I cannot hear anything! Such experiences nearly drove me to despair, and it would have taken little to put an end to my life. One thing only restrained me, the art of music."

As we were leaving the Beethoven Museum I couldn't keep myself from telling my guests what Probusgasse, the name of the slightly winding street on which we were walking, signifies. Marcus Aurelius Probus, Roman emperor from A.D. 276 to 282, is credited with having brought viticulture to the Vienna Woods. Ancient texts indeed report that Probus, as a general in Gaul and on the Danube, had his legionnaires plant vineyards near their garrisons. It seems probable, nevertheless, that the Celtic population of Noricum, for hundreds of years under the influence of Roman civilization, had been growing and drinking

wine well before the third century A.D. The Viennese at any rate like to believe that their wine was originally a gift from an imperial benefactor whose very name suggests probity, a virtue not always practiced by wineries, and they named a street near the vineyards after him.

From the Probusgasse we went to the Pfarrplatz (Parish Square) of Heiligenstadt where, at No. 2, Beethoven lived in 1817. The house at No. 5 stands at the site of a former inn, Zur Schönen Aussicht (At the Beautiful View), where the composer was a frequent guest. Let's hope he didn't throw dishes into the waiter's face there, as he was reported to have done sometimes when the food wasn't to his liking. Pfarrplatz, with its very old Romanesque church, Saint Jacob's, and the low houses in its vicinity, still looks like a village square.

We went up the Eroicagasse—named after Beethoven's Third Symphony—with its vistas of the Nussberg, a slope of the Kahlenberg with grassland and vineyards. "Nobody loves this countryside more than I do," Beethoven once wrote in a letter to Theresa von Malfatti, the niece of an Italian-born doctor who treated him for some time. The composer was then in love not only with the Heiligenstadt scenery but also with little Baroness Malfatti; her family, however, didn't want him as a suitor.

According to Anton Schindler, the musician who was Beethoven's friend, sometime unpaid secretary, and early biographer, the composer himself would point out the precise spot where he had conceived the second movement of his Sixth, or "Pastoral," Symphony. The place is called the Wiesental

(Meadow Valley), along a little stream between the present suburbs of Heiligenstadt and Grinzing; in Beethoven's time it was still open countryside. Schindler recalls a stroll there with Beethoven: "Sitting down on the grass with his back against an elm tree, he asked whether there was a yellowhammer singing in the uppermost branches. There was no yellowhammer. Then he said: This is where I composed the scene by the brook, and the yellowhammers and quail, the nightingales and cuckoos all around played their parts." The birds are indeed heard in the "Pastoral" Symphony, Beethoven's outstanding contribution to program music.

"Aren't the overtures to *Egmont* and *Coriolanus* also program music?" Charles, a hi-fi addict, asked. "And isn't *Fidelio* program music, as every opera is?" We were still discussing descriptive and absolute music as we turned from the Eroicagasse into a leafy lane, Beethoven-Gang (Beethoven Promenade). It runs along the Schreiberbach, a brook descending from the Kahlenberg that in its lower part is lined with posh residences. It must have been a footpath with unobstructed views of the Nussberg slopes at the time when the composer took his daily strolls up here from Heiligenstadt. A statue representing the young Beethoven rises at a spot surrounded by trees and shrubbery, halfway up the promenade, where he is said to have paused habitually to take in the panorama. The place is known as Beethoven-Ruhe (Beethoven Rest), and the statue, erected in 1883, was Vienna's first Beethoven monument.

Fond of the Heiligenstadt countryside though Beethoven was, he also liked the more dramatic Vienna Woods valleys

near Mödling and Baden. One of his pupils, Ferdinand Ries, reports that Beethoven used to wander on lonely, often impervious, paths "through forests, valleys, over mountains," which stimulated his creativity. More than a century later the Vienna writer and acerbic aphorist Karl Kraus scoffed: "Vienna has beautiful surroundings into which Beethoven frequently fled"—from the Viennese.

When in his forties and fifties the composer became a famous eccentric who, walking in the streets of Vienna or taking his solitary hikes on the hillsides, was wrapped in a rumpled overcoat. Its pockets bulged with sketchbooks, a carpenter's pencil, and maybe a huge ear trumpet; his graying hair would be covered with a shapeless high hat of undefinable color. In his earlier years in Vienna he still had taken care of his person and dress. When the dramatist and poet Franz Grillparzer met Beethoven (two or three years after suicidal depression had inspired the composer to write his Heiligenstadt Testament), he found him elegantly attired, "contrary to his later habit."

At the Beethoven Rest I asked my guests whether they felt like walking a little up the slope of the Kahlenberg—no big deal, Beethoven probably did it often. By all means, the couple said, and we turned into the rising Kahlenberger Strasse. There was almost no traffic, but suddenly three skateboards with six small, yelling boys on them flitted past us. The solitary road, now paved, seems to have become a favorite track for racing and—after snowfalls—sledding for the youngsters of the Heiligenstadt and nearby Nussdorf sections.

On either side of the street laborers in the vineyards were hoeing the ground and looking after tendrils, a scene enacted here since antiquity. Vines require much work, especially in this part of the world, where they have to weather frost and snow.

As we were approaching a crossroads I told my friends we would soon come to the Iron Hand, an old inn presumably named after a metal signpost that once must have stood there. "When I was young," I told them, "I drank the new wine with friends at the outdoor tables of the Iron Hand quite a few times; we might have a snack there." But there were no outdoor tables and no inn. Instead we were facing a high, brown wooden fence surrounding what looked like a private mansion. Betsie, Charles's wife, went near to read the brass sign on the entrance door. "Oh no!" she exclaimed. "So funnee!" The sign was in English: "Don't be afraid of the dog— Beware the owner!" Cosmopolitan gentrification had come to the Iron Hand.

Witty Rococo Prince

Before turning right to descend toward the Kahlenberger Dorf (Kahlenberg Village), I coaxed my friends into walking a few minutes farther up Kahlenberger Strasse to visit what remains of Vienna's highest cemetery, about 1,000 feet (305 meters) above the city. The street entered a forest, and after a few steps we mounted a stairway at our right and I pushed open

a creaking iron gate. Under mossy acacias and maples there were a few weather-beaten headstones and, at the center, a large oval tomb. The inscription on a gray stone slab read: "Prince de Ligne, 1735–1814." Adjacent were the headstones of the prince's wife, Franziska, 1739–1821, and their granddaughter, Sidonie Potocka, 1787–1828.

"The Belgian nobleman who is buried here," I told my friends, "was the very embodiment of the rococo age, a friend of empresses, emperors, and kings. He knew Rousseau and Voltaire as well as the adventurers Cagliostro and Casanova. He was a brilliant general and diplomat; he did a lot of writing; he was reputed to be the wittiest person of his time and was also a formidable ladies' man. Most people today who have heard of Ligne at all know about him only because of his joke when asked how the Congress of Vienna was going. 'The Congress isn't going much, it dances,' was his famous reply. He was an inexhaustible source of bons mots and anecdotes."

Why was the Belgian prince buried high up on the Kahlenberg, of all places? my friends wanted to know. I explained that Ligne, who became an Austrian field marshal, had been offered two residences, on the Kahlenberg and the Leopoldsberg, by Emperor Joseph II, his friend. Ligne used both but preferred the Kahlenberg summit, where he took over a former hermitage of Camaldulian monks. What had been their refectory became a hall for receptions and dances, occasionally even for theatrical performances.

Ligne not only gave merry parties but also had the hillside developed. Among other things his laborers built the steep

"Nose" path, which Professor Messner and I climbed up and down 150 years later. The field marshal maintained a town apartment too—the top floor of a pink house on a bastion of Vienna's old fortifications that he rented from a tailor. The limping Talleyrand, the former bishop who represented the restored Bourbons of France at the Vienna Congress, cursed every time he had to struggle up four narrow flights of stairs to Ligne's place to attend one of his receptions. As Ligne used to ride about in a pink carriage as well, the Viennese called him the rose-colored prince.

Charles Joseph Prince de Ligne was born in Brussels, the scion of an ancient noble family whose chiefs were princes of the Holy Roman Empire and grandees of Spain and who had long enjoyed the privilege of addressing the emperor as "cousin." At the age of sixteen he was introduced by his father to Empress Maria Theresa in Vienna, and she at once made him a dignitary of her court. When he was twenty his father made him marry a sixteen-year-old Liechtenstein princess, Franziska, and he became an officer in Maria Theresa's army. He distinguished himself during the Seven Years' War and in other military campaigns and was awarded Austria's highest honors, the Order of the Golden Fleece and the Order of Maria Theresa.

Between wars Ligne cut a dashing figure in Vienna and Paris, reputedly was a lover of Countess du Barry, King Louis XV's last mistress, and was close to Queen Marie Antoinette, the sister of Emperor Joseph II. He also corresponded with writers and scholars. Other European courts vied with Ver-

sailles and Vienna to attract the amusing prince at least as a guest. Goethe described him as "the merriest man of the century"—the eighteenth century, that is.

In 1787 Ligne, as personal representative of Maria Theresa's son Joseph II, accompanied Empress Catherine the Great of Russia on her fabulous journey to the Crimea, the territory that Grigory Potemkin, her favorite, had just won for her. In a letter to his sovereign and friend Joseph II, Ligne denied the "ridiculous report" that Potemkin, whom he esteemed, had erected villages of cardboard and put up paintings of cannons along the route to deceive Catherine and her guests. The Russian empress found Ligne delightful and characterized him as an "original, deep thinker who commits follies like a child." From the Black Sea the prince brought with him to Vienna a Turkish servant, Ismael, who stayed with him for the rest of his life and became a Christian.

In later years Ligne lived mostly in Vienna, writing books and treatises, giving and attending parties, forever embroiled in amorous intrigues. At one time he was supposed to be sharing a mistress with Emperor Franz I, a grandson of Maria Theresa. Ligne's collected works, *Military, Literary, and Sentimentary Mixtures* (the French title contains the pun *sentimentaires* instead of *sentimentaux*) fill thirty-four volumes, offering some sharp observations amid much dross. The prince never spoke more than a few phrases in German; he didn't need to know the language well, as everybody at court and in the society circles he frequented spoke French. He died after having caught a cold during one of the innumerable dances in the giddy

Vienna of the Congress. His doctor, Giovanni von Malfatti—the same who occasionally treated Beethoven—could not save him.

According to another characteristic story, Ligne's brief, fatal illness was brought on by the seventy-nine-year-old prince's braving a December snowstorm as he waited in vain for a young lady who stood him up. A youthful count is supposed to have seen Ligne, wearing a long overcoat, walking up and down the bastion near his town apartment. Asked what he was doing there in such weather, the prince explained: "You see, in love only the beginnings are charming. For that reason I always find pleasure in starting again. At your age I would let them wait; at mine, I am being kept waiting and, what's worse, they don't show up."

On his deathbed Ligne remarked he was happy to offer the jaded Viennese and their Congress guests the spectacle of a field marshal's funeral. His last words were said to have been, "Long live Maria Theresa!" Thousands of troops lined the streets, and the King of Prussia, the Czar of Russia, and any number of Habsburgs walked behind the coffin as it was taken to church. After the rite a carriage took Ligne's remains to the Kahlenberg, where he had asked to be buried.

One imagines that Ligne had known the three ladies-in-waiting of the Habsburg court, Albertine, Antonie, and Franziska Horsner, whose joint headstone is near his tomb. The prince assuredly knew and admired the "Bride from the Kahlenberg," Karoline Traunwieser, who is also buried near the Ligne tomb; she died a few months after him at the age

of twenty. During her brief life she was celebrated as the most beautiful girl in Vienna, praised for her charm and sweetness. The verses engraved on the black marble slab over her tomb include a line in English by the poet Edward Young: "Ye that e'er lost an angel, pity me."

Near the cemetery exit we saw a note stating that the cemetery had been consecrated in 1783 and contained 148 graves. Most of them have long since disappeared. We walked back to the Iron Hand crossroads and from there descended the steep road to the Danube.

Franz Lehár's Castle

The Kahlenberger Dorf is a small village in a nook of the hillside, with old houses on narrow, crooked streets huddling around the parish church of Saint George, a few hundred yards from the big river. I showed my friends where the arduous Nose path up the Leopoldsberg starts, turning left from No. 357 Heiligenstädter Strasse. We were all three too tired to even try climbing to the first bend. We took the bus to Nussdorf, which passes the village at ten-minute intervals.

Beethoven knew Nussdorf, Heiligenstadt's sister village, well and may often have taken a rest at the same spot on its main square where we had our long-deferred snack in a café. He may even have ordered apple strudel—a Viennese treat for centuries—as we did. After our strudels and cappuccinos I showed my friends the villa nearby, at 18 Hackhofergasse,

that local people call the Schlössl (Little Castle). Emanuel Schikaneder, the theater manager who wrote the libretto for *The Magic Flute* and commissioned Mozart to furnish the music for the opera, had it built for himself in 1802, and Franz Lehár, the composer of *The Merry Widow* and other operetta hits, bought it in 1932. The Little Castle is now a museum containing memorabilia of its two famous inhabitants, but it can be visited only by appointment.

"I just have to tell you how I met Lehár," I said to my patient friends. It must have been soon after the composer had purchased the Nussdorf property. I had landed a job at the tax office on Obere Donaustrasse, which overlooked the Danube Canal. From 8:00 A.M. to 5:00 P.M., with an hour for lunch, I registered payments, made by postal order or bank transfer from citizens and companies, on sheets in a file cabinet; then I went to law classes in the evening. The stiff file sheets of important tax clients bore yellow riders, but one bundle of sheets in my file cabinet had a red rider, meaning VIP. It was Lehár's dossier. I had of course nothing to do with fiscal assessments; these were made by senior officials on the floors above the hall where I and some fifty other people like me were slaving. From time to time the upstairs officials came down to look at our files. The computer age would start a generation later.

One day Lehár arrived in our hall in person, accompanied by his lawyer, the obsequious director of our office, and the flustered chief of my section. The composer, then in his sixties and one of Austria's wealthiest and most popular personages,

had received an order to pay overdue income tax plus penalty, although his lawyer contended that the amount had been transferred to us some time ago. Work in our hall, never hectic, stopped completely, and everybody looked at me as Lehár and the three men with him closed in on my file cabinet. I pulled out the bundle of sheets held together by the red metal rider: to my intense relief the last entries showed that Lehár had indeed paid up. A mistake had been made on an upper floor. Lehár didn't say anything, and I was in the clear. I still remember the grave courtesy of the white-haired composer, who was dressed in a suit of fine gray-blue fabric such as I had never seen before. The one-time bandmaster of the Austrian-Hungarian Army (his father in Hungary had held a similar military-music job) looked every inch the millionaire man of the world that he in fact was.

As he left, Lehár shook hands with me and said, "Thank you, Herr Doktor!" He wasn't being sarcastic, although I was then only in the first year of law school, and it took no acumen to guess that I wasn't a doctor nor was mine a job requiring a university degree. My cynical veteran colleague and office mentor Pfriemer, who nursed the file cabinet next to mine, commented afterward, "Even a world-famous composer is humble at the tax office." A few months later I found a more inspiring job.

I was through with my autobiographical Lehár anecdote just as we were back in the main square of Nussdorf, glad to board the D tram again, at its last stop, for the return trip. Its tracks circle a building that was once the terminal of a cogwheel

railway for the Kahlenberg, climbing 1,037 feet (316 meters) over 3.3 miles (5.5 kilometers). After clanking up and down the Nussberg slope for nearly half a century, it ended service in 1921, and the tracks were torn out. There is, however, still a Zahnradbahn Strasse (Cogwheel Railway Street) in Nussdorf. In twenty minutes the D tram took us from the ultimate bastion of the Alps back to Vienna's inner city.

5.

THE HOUSE
MOUNTAINS

⚜

A few days later I made my next trip alone to find out how the House Mountains had changed since I had last seen them. I took the No. 38 tram from the Schottentor. The streetcar emerged from the underground terminal below the Ringstrasse at a spot where passengers see to their left the gardens that now are called Sigmund Freud Park. A sculpture devoted to the founder of psychoanalysis stands on the grounds that he crossed many times on his way between his home and Vienna University's main building or en route to Café Landtmann on the opposite side of the Ringstrasse, where he was a regular and occasionally played tarok with doctor friends.

Close to the first tram stop, on the right side, is an intersection from which the sloping Berggasse descends. Freud lived at No. 19 Berggasse and received patients there from 1891 to 1938, making this the twentieth century's best-known Vienna address worldwide.

The No. 38 proceeded between medical and scientific institutions to Nussdorfer Strasse, passing Schubert's birthplace, a low, simple building at No. 54, on the right, now a museum dedicated to the composer. A little more than twenty minutes after the departure the streetcar turned into a passage on Grinzing's main square, its last stop. I crossed the square to catch the No. 38A bus, which runs every thirty minutes from Heiligenstadt to the top of the Kahlenberg by way of Grinzing.

A group of Japanese tourists and several local people were waiting at the bus stop. The Hauptplatz (Main Square) of Grinzing, a rectangular incline, looked more or less as I had remembered it. There were the old vintners' houses with their fir tufts, the horse chestnut trees, and the late Gothic parish church on its low hill to the left. Several facades had recently received a new coat of white or yellow paint, and a visitor could suppose that the courtyards and interiors had been dressed up to create the impression of a *Nobelheuriger*. At 10:00 A.M. a whiff of old village atmosphere seemed still lingering; later in the day the sightseeing coaches would park, the lights go on, and the musicians tune up.

The No. 38A bus was full when it departed from Hauptplatz. As it ascended the Cobenzl Strasse it passed other touristy restaurants pretending to be folksy wine taverns and a row of villas, some of them from the turn of the century, some new. After the second stop one could see vineyards on slopes left and right of the street. The developers haven't yet been able to get their hands on *that* choice real estate, I said to myself. Following a few steep bends the Cobenzl Strasse merged with

the Höhenstrasse (Road of the Heights), a highway winding from the suburb of Hütteldorf in the city's west to the House Mountains on the Danube, crossing the slopes, spurs, and valleys of the Vienna Woods hills at an altitude of 900 to 1,200 feet (about 300 to 400 meters), well above the wine villages. The scenic road, some 13 miles (more than 20 kilometers) long, had originally been planned as a feature of Mayor Lueger's "Forest and Grassland Belt." It was eventually built between 1935 and 1938 as a work project during a period of widespread unemployment.

If the Höhenstrasse, which makes it all too easy for cars to reach the summits of the Kahlenberg and Leopoldsberg, didn't already exist, it probably could not be started today because environmentalists would justifiably fight the project. Determined hikers still ascend the Kahlenberg or Leopoldsberg on well-marked footpaths in one to one and a half hours.

Mozart and Freud on the Cobenzl

The No. 38A bus turned left and headed along a stretch of the Höhenstrasse toward the panoramic Cobenzl stop. The Cobenzl name belongs to an old Austrian noble family, and it recurs in the annals of diplomacy. Count Ludwig Cobenzl was Empress Maria Theresa's brilliant ambassador at the court of Catherine the Great. Count Philipp Cobenzl, who served as Austrian ambassador to the Netherlands, was a great art collector, influential at the Vienna court, and a notorious religious skeptic.

In 1755 the Cobenzls built themselves a summer villa 1,237 feet (377 meters) up on a hill of the Kahlenberg group of hills overlooking the city of Vienna.

Mozart spent some time at their hillside estate in the summer of 1781. A member of the Cobenzl clan, Countess Marie Karoline Thiennes de Rubeke, had been his first pupil after he established himself as an independent musician in Vienna (he wrote piano variations for her), and he was probably glad to be offered a rural vacation by Count Philipp Cobenzl.

The twenty-five-year-old composer was charmed by the place. "The little house isn't much," he wrote, "but the landscape, the forest!" He noted that an artificial grotto had been built near the villa (few rococo parks were without such a romantic addition, with maybe a few make-believe ruins). The whole was "magnificent and very agreeable." This is one of the very few passages mentioning the countryside in any of the approximately five hundred letters written by Mozart that have come to us. A tireless traveler and letter writer, he continually reported to his father, sister, wife, and friends about the cities he was visiting, the people he was meeting, and the music he was playing or hearing, proving himself a sharp and often pungent observer of human character and of art—but landscapes, however grandiose or idyllic, didn't seem to impress him. The patch of the Vienna Woods where he was a guest of the Cobenzls did.

Later-generation Cobenzls transformed their simple villa into a little castle; their mansion eventually became a hotel, which was torn down long ago. I got out of the bus and

found that the Castle Café Cobenzl with its scenic terrace, a fashionable spot between the two world wars, was still in business, and I saw a newer establishment behind it, Grill Heuriger Cobenzl, which does without much of a panorama. I couldn't see any trace of the artificial grotto that had struck Mozart's imagination.

I strolled to the nearby Himmelstrasse. *Himmel* means heaven, and for centuries that's what people have called the hill near the Cobenzl above the vintners' village of Sievering (which is more rustic than neighboring Grinzing). I was looking for a Sigmund Freud memorial that I had seen only in photos; eventually I found it off the shoulder of the street, under trees and near some shrubbery at the edge of a slope sweeping steeply down to Upper Sievering. An inscription in a facsimile rendering of Freud's handwriting engraved on a dark stone slab reads: "Here, on July 24, 1885, the secret of dreaming revealed itself to Dr. Sigm. Freud." This translation, though awkward-sounding, is more faithful to the original German than the usual one in idiomatic English, found in much of the literature on Freud: ". . . the secret of dreams was revealed to . . ."

The site, at an altitude of 1,273 feet (388 meters), is known as the Bellevue Hill. It perpetuates the name of an old hotel, the Belle Vue, which disappeared after World War I. This was a converted villa in Italianate style with a large upsweep of stairs leading to an arcaded portico and two short turrets flanking the second floor. Like other Viennese families, the Freuds spent a few weeks in the hotel some summers toward

the end of the nineteenth century; in their case the sojourn was a substitute whenever they hadn't enough money for a vacation in the Tyrolean or Salzburg Alps, which they loved. An 1892 photograph of the building with the name "Belle Vue" in large letters on the portico is one of the exhibits (No. 143) in the Freud Museum at 19 Berggasse.

"Freud had a strong dislike of the famous Wienerwald [Vienna Woods], with the solitary exception of the Cobenzl," according to Ernest Jones, his disciple, friend, and authoritative biographer. Jones added that Freud's children on the other hand were fond of it. Why did Freud strongly resist whenever his children tried, in Jones's words, to "drag him" into the Vienna Woods? The biographer suggests that Freud's hostility may have been due to the scarcity of mushrooms on the forested hills (though there are quite a few mushrooms in the more remote parts of the Vienna Woods) as he was an avid mushroom hunter who would indulge that passion in the Tyrol and near Salzburg. There, during forest strolls with his children, he would throw his gray-green velour hat on some fat specimen he had just spotted, summon his offspring, who were lagging behind, with the silver whistle he always carried with him on such expeditions, and solemnly uncover his find.

Or, Jones writes, Freud may have objected to the Vienna Woods because of their proximity to the city that he always said he hated. But Martin Freud, looking back much later, doubted that his father's often-expressed dislike of Vienna "was either deep-seated or real." Londoners and New Yorkers, too, will often say they hate their city whenever something

goes wrong, the younger Freud remarked, offering as his opinion "that sometimes my father hated Vienna and sometimes he loved the old city." In fact, over several years Freud repeatedly passed up opportunities for decorously moving elsewhere, and he was reluctant to leave Vienna even when he and his family were in grave peril there after Hitler had made his triumphant entry into the city in 1938.

During his last years in the Austrian capital, Freud appears to have made his peace with the Vienna Woods. He frequently visited a summer house in the hills that his favorite child, Anna, and her American friend Dorothy Burlingham had bought. Dorothy, who belonged to the wealthy Tiffany family, had left her husband and with her four children had moved to Vienna. The children became Anna Freud's first patients, and for ten years, until 1938, the Burlinghams lived in an apartment one floor above the Freud family at 19 Berggasse. In 1930 Anna and Dorothy jointly purchased a small farm cottage in the village of Hochrotherd on a ridge some 1,700 feet (530 meters) high that separates the valleys of the Wien and Liesing rivers. The village, southwest of the town of Breitenfurt, commands vistas of the Schneeberg (Snow Mountain) to the south, which, at an attitude of 6,808 feet (2,234 meters), is the loftiest peak in Lower Austria. The entire Freud family used the property, which had come with three acres of land, and Anna did some gardening. Her father was pleased that he could reach Hochrotherd in less than an hour from his Berggasse home and appears to have enjoyed the greenery and the panorama.

As for the role of a Vienna Woods hill in the history of

psychoanalysis, there is Freud's own testimony. In a letter from the Belle Vue, written on June 12, 1900, to his Berlin friend Wilhelm Fliess—the two were later to become estranged— Freud reported that life in the hotel was very pleasant for everybody, and that after the blooming of the lilacs and laburnum the fragrance of the acacias and jasmine was now in the air, and the wild roses were about to bloom. Freud went on, half facetiously, half in earnest: "Do you really believe that at some future time there will be an inscription on this house, 'Here, on July 24, 1895, the secret of dreaming revealed itself to Dr. Sigm. Freud'? The prospects for this so far are dim."

The epochal dream Freud had on that date, and which he thoroughly analyzed, is known to Freudians as "Irma's injection." The dream's Irma complains to Freud about severe pains in her throat, stomach, and abdomen; he looks into her mouth and, seeing odd symptoms, concludes that although he has been psychologically treating her, other doctors—who have meanwhile appeared on the dream scene—are responsible for her condition, having administered to her an injection of an inappropriate substance with an unclean syringe.

Examining his dream sequence by sequence, Freud determined that Irma was a composite personage with strong elements of a real-life patient named Emma whom both he himself and Fliess had been treating. Freud interpreted the dream as betraying a desire that neither he nor his friend Fliess but other physicians should have caused Irma-Emma's distress. A basic tenet of psychoanalysis—dreams as wish fulfillment—had been established.

The Belle Vue dream eventually led to the book *Die Traum-*

deutung (The Interpretation of Dreams), which Freud's Vienna publisher Franz Deuticke brought out late in 1899 with the date 1900. Deuticke could not have foreseen that psychoanalysis would indeed become one of the great intellectual currents of the new century. Only a few hundred copies of the volume had been sold six months later when Freud wrote the letter to Fliess about a plaque on the Belle Vue. At one time Freud took Ernest Jones to the Belle Vue restaurant and recalled the "great event" of the Irma dream. His disciple and future biographer made the "obvious remark about a tablet" without knowing that Freud himself had, half in joke, written to Fliess about such a memorial.

The inscription, an enlarged facsimile of Freud's own hand with his usual mixture of Germanic and Latin characters (two systems of penmanship that during his time were taught concurrently in Austrian schools), was put on the marker indicating the location of the former Belle Vue after World War II and is reproduced on picture postcards.

Both Mozart, who rarely responded to beautiful landscapes, and Freud, who didn't care much for music, experienced epiphanies of sorts on the Cobenzl. What a pity, I thought, that Freud never attempted a thorough analysis of Mozart's personality and of his own mushroom ritual.

A Polish Shrine

My recognition of the Cobenzl and Bellevue hills had ended just as the next 38A bus came around. Five minutes later I

arrived at the Kahlenberg summit. The last stretch of the road had once been the uppermost section of the cogwheel railway from Nussdorf. The route, across a forest of beeches and oaks, was overfamiliar—like almost every Viennese, I had traveled it I don't know how many times hiking, by car, or by public transport.

The No. 38A halts at a vast parking lot before returning to Grinzing and Heiligenstadt or, during the warm months, proceeding on the Road of the Heights to the Leopoldsberg. I sauntered toward the Church of Saint Joseph and found that the small Baroque edifice, built in 1628, had been adorned with two new plaques on its facade. The one on the left pays tribute in Polish and German to King John III Sobieski for his leading role in the "salvation of Christianity" from the Turks in 1683; the right-hand tablet records that John Paul II, the Polish pope, visited the little church on September 13, 1983, exactly three hundred years later.

A Polish travel group whose battered coach I had seen in the parking lot was inside the church. Some of the Poles were praying in front of a copy of the image of the Black Madonna of Czestochowa, which had been donated to the church by Pope John Paul II and which the priests of the Resurrectionist Order, now in charge, had placed in a niche on the left. The church on the Kahlenberg has become a major Polish national shrine although it is by no means certain that King John Sobieski actually prayed in it before leading his soldiers down-hill to battle the Turkish besiegers of Vienna. He may have done so instead in the church on the summit of the nearby Leopoldsberg, as will be seen.

The uncontroversial fact is that the commanders of the forces that had at last assembled to relieve Vienna attended mass on the morning of the decisive battle. They were King Sobieski, who had brought 10,000 infantry, 14,000 horsemen, and 28 guns with him, and Duke Charles of Lorraine, who headed a motley force contributed to the Holy Roman Empire by Austria, Bavaria, Saxony, and some small German principalities—8,000 foot soldiers, 13,000 cavalry, and 70 guns. Pope Innocent XI, deeply worried by the Muslim thrust into the heart of Europe, had sent a fiery Capuchin, Marco d'Aviano, as papal legate to the Christian armies. Friar Marco said mass before the battle and gave a sermon urging the commanders and officers in the church to rout the infidels. We don't know in which language the Italian Capuchin preached.

The tall, corpulent Polish king served at mass, and the melancholic Duke of Lorraine, who was kneeling in front of the altar, is said to have had at his side a young French-Italian nobleman who had recently joined the Imperials after French King Louis XV had repeatedly spurned his pleas to be given a military commission. The volunteer, Prince Eugene of Savoy, was then nineteen years old; fourteen years later he would become the supreme commander of the Habsburg armies and emerge as one of the greatest military leaders in a turbulent era. For hundreds of years Austrians would sing "Prince Eugene, the Noble Knight," a martial tune celebrating the Savoy hero's capture of the Turkish fortress city of Belgrade in 1717.

In September 1683 the Polish and Imperial forces swept down from the hills, tearing into the 130,000 Turks who for more than two months had kept Vienna in their stranglehold,

and forced them to withdraw precipitously into Hungary. During the battle Prince Eugene distinguished himself by his bravery in several engagements while serving as a dispatch rider, maintaining liaison between the Duke of Lorraine and the Polish king.

The Polish tourists who were leaving the Church of Saint Joseph with me pointed with delight at the lettering on the low-slung modern building in front of us: "Café-Restaurant Sobieski." From earlier visits I knew that the place is usually crowded on weekends, but this was a Thursday, and only a few tables were taken when I had a cappuccino. The waitress was talking to the counterman in Croatian, and some Polish guests wrote picture postcards.

I walked over to the panoramic terrace past the dusty entrance to the Kahlenberg Hotel, which for some time had been out of business. Years earlier a friend of mine had lived there for a few months, commuting every working day by car to his office near the center of Vienna. "I am getting a lot of attention from the staff," he had told me. "Some days I am the only guest."

The terrace at the edge of a slope that steeply descends to Nussdorf is equipped with a coin-operated telescope, but it goes blind after what can't be more than three minutes. Even the naked eye can take in a grand panorama: the city of Vienna spreads out some 1,000 feet (330 meters) below, with the Gothic steeple of Saint Stephen's Cathedral and other old landmarks as well as some new ones, like the incinerator's minaret, standing out. To the left is the broad Danube River, now bisected by a narrow artificial island, 13 miles (21 kilome-

ters) long, that was created in the 1970s and 1980s both for flood control and as a recreation area, at a cost of four hundred million dollars. Far downstream I thought I could detect a dark patch on the horizon that might have been smoke or smog from the industrial zone of Bratislava, the capital of Slovakia. On clear days—that Thursday wasn't one—good eyes can see as far as Slovakia and, below the low ridges of the Leitha Hills, into Hungary. Also on clear days, the river actually looks blue when seen from above; most of the time and from most angles the "blue Danube" of the celebrated waltz by Johann Strauss the Younger has a dull gray hue.

From the lookout terrace I walked up to the highest point of the Kahlenberg, 1,553 feet (484 meters) above sea level, to the Stephanie Belvedere, a gray observation tower with 125 steps. The nineteenth-century stone structure was closed, as it now usually is. Nearby is a needle-shaped television tower, 529 feet (165 meters) tall. There is no view from its base.

Cradle of Austria

I pushed on toward the other of Vienna's two House Mountains, the Leopoldsberg, walking there instead of taking the 38A bus again. The red-marked footpath traverses the wooded saddle between the twin peaks a little below the last section of the Road of the Heights. In twenty minutes I was on the Leopoldsberg, the corner pillar of the Vienna Woods and of the Alps.

A church also rises on top of the Leopoldsberg. The edifice

with two short towers and a low, green-patinated dome was built in 1679 on the site of an earlier chapel that had been destroyed by the Turks. The church is dedicated to Saint Leopold, the twelfth-century Margrave Leopold III of Babenberg, and it carries a plaque in memory of Friar Marco d'Aviano, claiming that the pope's legate worshiped here in 1683 with the Christian armies. Nearby is a tablet put up in 1983 by "Ukrainian Veterans Abroad" to commemorate the Ukrainian Cossacks who died in the Battle of Vienna three hundred years earlier. Now, I wondered, which of the two neighboring hilltops saw the historic tableau of the Christian nobility and soldiers at prayer before attacking the forces of Islam?

A signboard in the small church's entrance hall, retracing the history of the place, didn't solve the puzzle but offered interesting information. It stated that evidence of a prehistoric settlement on the summit, circa 3000 B.C., had been found; that there were remains of Celtic fortifications; and that to the ancient Romans the present Leopoldsberg had been Mons Cetius, a strategic elevation marking the border between their empire's provinces of Noricum and Pannonia. The signboard also said that the church had been heavily damaged in a 1945 air raid.

Until the Church of Saint Leopold was built in 1679, the hill on which it stands was called the Kahlenberg. The hill that is now known as the Kahlenberg was referred to as the Sauberg (Sow Mountain), maybe because of the wild boar populating it. It was officially renamed the Josefsberg after the Church of Saint Joseph had been erected at its top, but the Viennese

started calling it the Kahlenberg, and that name has stuck. On which of the two hilltops the leaders of the Christian armies listened to Marco d'Aviano's sermon in 1683 has remained open to debate. History is full of such minor enigmas.

The report of the Capuchin friar's mass and exhortation is based solidly on contemporary chronicles, but a legend connected with the Leopoldsberg is not. In grade school we learned that Leopold III of Babenberg, the Pious, had resided in a castle on the hill that would later be known by his name, and that the Leopoldsberg was the "cradle of Austria," because from there the Babenberg dynasty consolidated its hold on the country and created the foundations of the state. "When you run out of school as you always do, stop for a moment and look to your right," my first teacher in Langenzersdorf told us. "Across the river you see the cradle of Austria."

I wasn't particularly impressed then, also because I didn't have a clear notion of what she meant: what did our country and the mountain across the Danube have to do with a baby's bed? Nor was I too happy to have been given Leopold as my middle name. There were many Leopolds in our village—Saint Leopold is the patron saint of Lower Austria. The name and its homey abbreviation *Poldi* to me had a plebeian sound.

During the 270 years of Babenberg rule over Lower Austria and eventually over Styria in the Alps to the south, none of the Babenberg margraves and dukes ever lived permanently on the Leopoldsberg, historians say. Leopold III had his residence in Klosterneuburg on the Danube, northwest of the hill that bears his name. I could have strolled down to that town in

about forty minutes on a pleasant road that I knew well from many earlier visits, but I had promised to take Italian friends a few days later to the place where Franz Kafka died, and the trip would also bring us to Klosterneuburg. So I chose to descend again, after so many years, on the steep Nose path.

Before tackling the Nose, I lingered for some time on the hilltop. Near Saint Leopold's Church is a large, gray two-story building backed by a fir grove. The lackluster structure, which houses a plain restaurant, was erected in part with materials saved from the old Ligne residence (which the "rose-colored prince" seldom used). The restaurant's garden, with many tables under old plane and linden trees, has a spectacular view. On its eastern parapet is a stone map, showing in relief the outlines and landmarks of Vienna and enabling visitors to identify what they see. Looking to the northeast from the restaurant terrace I beheld my village, Langenzersdorf, across the Danube but close enough for me to spot what had been my grandfather's house and garden and my school.

As I walked down the abrupt eastern slope of the Leopoldsberg, much more cautiously than I used to do half a century earlier, I thought about a series of pictures I had seen in the great Biedermeier exhibition in the Vienna Künstlerhaus (Artists' House) in 1988. The six crayon lithographs by Moritz von Schwind, the painter who was one of Schubert's closest friends, are entitled "The Country Party to the Leopoldsberg." The sequence humorously depicts the excursion of more than a dozen young people in an open coach pulled by two phlegmatic horses. Some of the women are hatless, with elaborate hairdos;

the men sport diverse headgear: high hats, long-visored berets, and a military-type cap with a square top, Polish style. A chubby fellow with a silk hat and long sideburns who is clutching a little dog vaguely resembles Schubert as shown in the portraits we have of him; he was still alive in 1827 when Schwind drew the pictures.

The first sheet of the series represents the excursionists piling into the already overloaded vehicle, the man with the high hat who could be Schubert causing a small disaster by breaking bottles full of wine. The following prints show the young people walking up a slope; merrily eating their picnic lunch under trees; indulging in a siesta; and invading a vineyard, only to be surprised by a guard who exacts payment for the grapes they have plucked. The sixth drawing shows the glum return under a rainstorm. I wondered where Schwind's Biedermeier party had climbed the Leopoldsberg; surely not on the Nose path, which even downward now seemed to me hard on the knees and legs. I was glad to reach the Kahlenberger Dorf after half an hour and catch the bus to Nussdorf.

6.

KAFKA IN
THE FOREST

❦

A few days later I was back in Nussdorf, this time with two young Italian women. My friend Gabriella, who teaches at a high school in Rome and is fascinated by Kafka, had brought her sister Rita, an architecture student, with her on a long-planned visit to Vienna. I had talked with Rita during the tram ride about the history of the Karl Marx Hof and public housing in general. Now, as we were waiting for the No. 239 bus to Klosterneuburg, we were discussing Kafka's *Letters to Milena*, which both sisters had just read. Gabriella quoted Max Brod as saying that Kafka's part of the correspondence belonged "among the most significant love letters of all time." Brod, Kafka's friend, saw the bundle of letters only many years after they had been written. The letters had been kept in the safe deposit vault of a Prague bank for almost two decades before Milena released them. Milena's letters to Kafka have disappeared; in all likelihood the addressee destroyed them.

I asked Gabriella if she had noticed Kafka's references to the Vienna Woods in his letters, and she knew at once what I was talking about—the writer's reminiscences of his four days with Milena in the early summer of 1920, the longest period the lovers ever spent together. Their affair was mostly epistolary. I showed off what little Czech I had managed to pick up, first during my young years in Vienna, when we heard the language spoken fairly often, and again during the short-lived "Prague Spring" of 1968 when I was reporting to the *New York Times* from Prague on the political thaw in Czechoslovakia. "*Milena* means 'beloved,' and the diminutive *milenka* is 'sweet-heart,' " I told the sisters. In Czech, the stress is on the first syllable in both *milena* (MEE-lay-nah) and *milenka* (MEE-len-kah). "Kafka must have used the diminutive again and again when the pair made their romantic hikes in the Viennese hillside."

Milena was twenty-four at that time, more than twelve years younger than Kafka, and her marriage to Ernest Polak (sometimes spelled Pollak), a Jewish Prague intellectual, was heading for the rocks. Milena Jesenská had become Mrs. Pola-kova much against the will of her anti-Semitic father. In Prague the young couple had frequented the famous Café Arco where Kafka, Brod, the poet and writer Franz Werfel, and other members of the local German-speaking intelligentsia were hanging out. When Polak moved to Vienna to do graduate work at the university, he and his wife became fixtures at the Viennese literary cafés. Milena, however, appeared ill at ease in the Austrian capital. She made translations from Czech,

wrote contributions to a Prague newspaper, and translated some stories by Kafka, including *The Metamorphosis*, from the original German into Czech.

Kafka, then on sick leave for a pulmonary condition (which was to turn out to be incurable tuberculosis) in balmy Merano in the South Tyrol, wrote her, and an exchange of many letters ensued. An epistolary affair developed, soon becoming passionate on Kafka's part. He and Milena eventually agreed to a meeting in Vienna, which took place at the end of June 1920. From Kafka's letters to Milena, and from what she later told Brod and other sources, it appears that the two lovers went out two or three days in a row to the forested hillside, maybe on the No. 43 tram. "The horse chestnut trees were in bloom then," she would tell a fellow prisoner, Margarete Buber-Neumann, whom she befriended in the Nazi concentration camp of Ravensbrück, where she was to die after surgery in 1944. (The Gestapo had arrested Milena in Prague in 1939 as a "Jewish-related" subversive.)

From the *Letters to Milena* it may be inferred that Kafka experienced heights of passion in the Vienna Woods. "I love the whole world, and this includes your left shoulder," he wrote, "and your face above me in the forest and my face resting on your almost bare breast. And that's why you are right in saying that we are already one, and I'm not afraid of it, rather it is my only happiness and my only pride, and I don't confine it all to the forest." On another occasion Kafka wrote to Milena that what he wanted was to hold her hand in his: "Silence, deep woods."

Years later Milena reminisced in a letter to Brod: "Every-thing was simple and clear, for example, I dragged him [Kafka] over the hills on the outskirts of Vienna, I running ahead, since he walked slowly—he tramped behind me—and when I close my eyes I can still see his white shirt and tanned throat, and the effort he was making. He tramped all day, up and down, walked in the sun, and not once did he cough. He ate a fearful amount and slept like a log; he was simply healthy, and during those days his illness seemed to us something like a minor cold."

Kafka, however, wouldn't prolong his stay in Vienna. How could he justify another few days away from his job at the Prague Workers' Accident Insurance Institute, whose director he dreaded? Milena's comment: "Frank cannot live. Frank does not have the capacity for living. Frank will never get well. Frank will die soon. . . . He is like a naked man among a multitude who are dressed." Kafka and Milena met once again on the Austrian-Czechoslovak frontier but sensed they had already drifted apart. Later, in a letter from a sanatorium in the Tatra Mountains, he broke off the relationship with her.

Indoor Flowers

Milena was back in Prague when Kafka returned to Vienna— to die. He had been in Berlin for some time, living with Dora Dymant, the twenty-year-old Polish girl from an Orthodox family whom he had met in a Jewish People's Home at a resort on the Baltic Sea.

Early in 1924 Kafka moved back to Prague and went to live again with his parents, a decision he considered a personal defeat. Already gravely ill, he was sent to Vienna, where the medical school was then regarded as leading in treatments of tuberculosis. He failed to improve in the university clinic of Professor Markus Hajek. Meanwhile Werfel, who had also moved to the Austrian capital, and other friends were looking for some suburban place where Kafka might breathe more easily. At the end of April he was transferred to the private sanatorium of Dr. Hugo Hoffmann, an elderly and apparently ailing physician in the village of Kierling near Klosterneuburg. The facility had beds for only a dozen patients, but Kafka's friends were satisfied that he was receiving good medical care from the Vienna University doctors who were regularly visiting him. Dora Dymant looked after Kafka almost around the clock.

According to Brod, who took time off from his job on the German-language newspaper *Prager Tagblatt* in Czechoslovakia's capital to visit Kafka, the Kierling sanatorium was "friendly," and the patient was "in a lovely room filled with flowers and looking out on the green countryside." Brod also quotes from a letter that Professor Oskar Beck of Vienna University wrote him on May 23, 1924, reporting that "Dr. Kafka was having very sharp pains in the larynx," and that Miss Dymant was caring for him "in a self-sacrificing and touching manner." Unfortunately, the professor's letter warned, the patient's lungs and larynx were in such a state as made it appear impossible for any specialist to help him. Kafka was ordered to speak as little as possible and was given painkillers. He began communicating with those around him by notes scribbled on slips of paper.

Toward the end Kafka was much concerned with the flowers in his room: "Do you have a minute? Do me a favor and spray the peonies." "Indoor flowers must be treated in a completely different way." "Would it be possible to have some laburnum?"

About Kafka's last days we have the testimony of a friend, Dr. Robert Klopstock, who spent many hours with him. Kafka wrote a letter to his parents, praising the "good air and food" of the Kierling sanatorium and expressing gratitude that a Professor Tschiassny was frequently coming from Vienna in his own car to see him, charging almost nothing, an "extremely kind and unselfish man." Kafka worked on the proofs of his story *The Hunger Artist* and during the night again received painkillers. When Dr. Klopstock moved away from his bed to clean the syringe, Kafka whispered, "Don't leave me!" Dr. Klopstock replied, "But I am not leaving you." In a deep voice Kafka said, "But I am leaving *you*"—his last words. He died on June 3, 1924, a Tuesday. His remains were taken to Prague for burial.

Both Gabriella and I had read Brod's biography of Kafka, and as we were reminding each other of its concluding pages our bus reached the Niedermarkt (Lower Market) square of Klosterneuburg adjacent to the Klosterneuburg-Kierling railroad station near the Danube. We changed to another bus and, on the same tickets, proceeded to Kierling. The route skirted the hill on which Klosterneuburg Abbey rises and entered a gradually narrowing green valley. The area was dotted with many new houses and villas, quite a few of them no doubt the second homes of Vienna families.

In ten minutes the winding highway became the Haupt-strasse (Main Street) of Kierling, a village stretching for more than a mile (about two kilometers) between wooded slopes. The former Sanatorium Hoffman at 187 Hauptstrasse is a gray three-story building, now privately owned and subdivided into apartments. An official sign proclaims it a historic landmark.

From Vienna I had called a Klosterneuburg school princi-pal, Norbert Winkler, the local representative of the Austrian Kafka Society, and he had arranged for us to be admitted to 187 Hauptstrasse. Though it is not known which was Kafka's sickroom, Mr. Winkler told us it was probably one with a balcony on the top floor looking out on a small garden and a green slope behind it. Another room in the house serves as a Kafka memorial and library.

There is also a photocopy of the dedication page in what was probably the last book Kafka read, Franz Werfel's *Verdi: A Novel of the Opera.* "To Franz Kafka, deeply revered author and friend, with a thousand wishes for a speedy recovery," the inscription read. Werfel, who was about to travel from Vienna to Venice, sent the volume with a bunch of red roses to Kierling about mid-April 1924.

Gabriella had never heard of Werfel's *Verdi,* and when I told her it had been translated into Italian she said she would get hold of it at once in Rome and read it. I took the two sisters up the Hauptstrasse to Kierling's recently renovated parish church at the village center. On a platform near the belfry a bust of Kafka by the sculptor Hans Freilinger rests on a large chunk of Vienna Woods sandstone. It was commissioned by the Kafka Society and put up in 1984, sixty years after the

writer's death. Mr. Winkler had told me, "Until the Commu-
nist regime in Czechoslovakia collapsed, Kafka was an unperson
in that country, and nobody in Prague seemed interested in
Kierling. Now more and more Czech scholars come to visit
the place."

Ersatz Escorial

We took the bus back to vineyard-girded Klosterneuburg to
visit the Abbey. We arrived just in time, minutes before 11:00
A.M., for the last of the three guided tours that are conducted
every morning (there are four more tours in the afternoon).
Our fellow sightseers were Swiss and German, and I told the
guide I would translate his explanations to my Italian friends,
so he wouldn't have to bother.

"The town of Klosterneuburg goes back to prehistory, and
the ancient Romans, who called the place Asturis, had a fortress
here," the guide intoned. "But the building complex that you
see was founded by Margrave Leopold the Third of Babenberg,
the Pious, in 1113, and completely rebuilt under Emperor
Charles the Sixth in the first half of the eighteenth century."
This was heavy stuff for Gabriella and Rita, and I told the
history of Klosterneuburg in my own words.

The margrave, I said, may have led a saintly life, but surely
he was also a shrewd politician with a knack for playing his
cards right and supporting the winners in the medieval power
struggles between the papacy and the German emperors on

one hand, and between the quarreling factions within the German Empire on the other. After the death of his first wife, Adelheid, he married the sister of Emperor Henry V, Agnes, who was the widow of a Swabian duke, thereby gaining a substantial dowry and new prestige./

It was the first but certainly not the only time that an Austrian ruler won new land and greater power through an advantageous marriage. *"Bella gerant alii / Tu felix Austria nube"* (Let others wage war—you, happy Austria, marry) was the Latin couplet that congratulated the Habsburgs four hundred years later on their successful matrimonial policies. Leopold III had no fewer than seventeen or eighteen children by his two wives. Seven died young; most of the others in their turn made profitable marriages.

Bent on extending his domains, Leopold III moved his residence downstream from the Nibelungian town of Tulln to where we were standing now, and built himself a castle next to a convent of Augustinian canons. Canons, sharing in the government of a cathedral or abbey, were the aristocrats among religious communities, garnering much more respect than mere friars or monks.

In elementary school they had told us a different story: Leopold III and his new bride were standing on the balcony of their castle at the summit of what is now the Leopoldsberg when a gust of wind carried off the precious veil of the new margravine. Search as Leopold's men might, they never found that piece of Agnes's wedding finery, much to her chagrin. Nine years later, during a hunt, Leopold saw a strange gleam

emanating from some shrubbery and found that it came from his margravine's veil, entangled but intact in the branches of an elderberry bush. The Virgin Mary then appeared to the margrave in a vision, commanding him to build a church and convent on the spot.

The name *Klosterneuburg* is composed of the German words for "convent" and "new castle." Where had Leopold's castle been? According to the legend of the veil, it was on the hill that today bears his name. But scholars insist that the margrave, as he was extending his domains and moving downstream from Tulln, fixed his new residence at Klosterneuburg. One of his successors would relocate to Vienna around the middle of the twelfth century. Rome canonized Leopold III in 1485, long after the Babenberg dynasty was extinct.

As our group was standing in a vast courtyard, the guide pointed to a wall behind us, near the visitors' entrance, saying it was a remnant of Saint Leopold's castle. He also told us that the large, ornate church in front of us went back to 1114 and that through the centuries it had repeatedly been restored, enlarged, and in part rebuilt. The medieval abbey adjoining the church, an early beacon of scholarship and the arts, had at its center a splendid Gothic cloister from the thirteenth and fourteenth centuries, which we were going to see momentarily.

I explained to my Italian guests that the imposing Baroque building at the east side of the church was the result of an imperial dream and had been designed by the Italian architect Donato Felice d'Allio. He was called in by the Habsburg emperor Charles VI, the father of Maria Theresa, to build an

"Austrian Escorial." Charles had grown up in Spain, and when he started ruling in Vienna in 1711 he planned to transform Klosterneuburg into a religious and dynastic center on the model of the former royal residence near Madrid, El Escorial. D'Allio's designs for an ersatz Escorial foresaw an immense complex with four large inner courtyards and nine domes; construction started in 1730.

When Charles VI died ten years later, about one-fourth of the giant project had been completed. Maria Theresa, having to cope with wars and other emergencies, stopped the costly building work in Klosterneuburg. What had already gone up is now known as the Imperial Edifice—four splendid building tracts around a vast square courtyard. Two large domes, bright green from patina, are topped with large reproductions of the Austrian archducal hat and the imperial crown. "The green cupolas together with the twin towers of the Abbey Church are among my earliest and enduring visual impressions," I told the sisters. "I can close my eyes anywhere in the world and see them as I saw them as a small boy looking across the Danube from the village where I grew up."

Our tour guide meanwhile was herding us into Saint Leopold's Chapel, a Romanesque hall that was once the chapter house. It holds Klosterneuburg's most precious treasure, the Altar of Verdun. This winged altar contains fifty-one blue-enameled and gilt plaques in three rows picturing biblical episodes, with Latin inscriptions explaining each scene. The panels are the work of Nicholas of Verdun, one of the greatest goldsmiths of his time, and were installed in 1181 on orders

from the abbey's provost, Wernher. The bones of Saint Leopold are in a gold-enameled shrine above the altar.

The remainder of the hour-long guided tour was a kaleidoscopic sequence of cloisters, side chapels, marble altars, stained-glass windows, frescoes, stucco work, and large halls in the Imperial Edifice hung with precious tapestries. We went quickly around the eight rooms of the Abbey Museum, where I showed my guests a series of panels by the late Gothic master Rueland Frueauf the Younger (1470–1545). One of them represents a bearded Saint Leopold, wearing a red cape with ermine trimmings and something like an ermine turban, kneeling before the legend's elderberry bush with the margravine's long veil entwined in the foliage. A luminous apparition of the Virgin Mary holding the Infant seems to float in the azure sky, while the margrave's horse and two knights on one side and a brace of greyhounds on the other suggest the hunting theme. Other panels picture the Leopoldsberg as an exaggeratedly harsh Alpine peak, as if the artist had never attempted to climb it or even seen it.

We were hungry and tired, but I insisted that before lunch we should have a glimpse of Klosterneuburg's famous huge wine cask in the Abbey Cooperage on the west side of the main courtyard. The barrel, holding more than twelve thousand gallons, is not the biggest in the world, as I was told when I was a boy, but it is impressive enough, though empty now. "Look at the wooden stepladder on the left side of the cask," I said. "On November 15, the feast day of Saint Leopold, hundreds of people climb up on it to slide down on the other

side of the barrel—apparently a popular amusement since 1704, when the monstrous cask was built. I myself have done it once, although not on Saint Leopold's day. Our grade-school class made a trip to Klosterneuburg, and the teacher talked an abbey employee into opening the cooperage for us and letting us slide down the barrel. Look how smooth the staves are, polished by the backsides of innumerable children and adults."

At last we repaired to the Stiftskeller (Abbey Cellar), a restaurant serving large numbers of guests, including parties of sightseers, in a no-nonsense fashion. An alfresco meal in its garden under old trees near the historic church is more pleasant than are the large whitewashed dining rooms with their bustling waiters. I ordered red St. Laurent to go with our lunch. This vintage, distinguished by agreeable tartness, has long been produced by the abbey's winery. St. Laurent has been available for years in Austrian supermarkets, is now being served on Austrian Airlines flights, and may even be found on the shelves of some wine shops in the United States. Can all this dark red liquid come from the vineyards around Klosterneuburg, vast though they are?

The abbey has functioned through the ages as a thriving economic enterprise. It used to own extensive land on both sides of the Danube and plenty of real estate in Vienna. The area on which my grandfather operated his gardening business with his hothouses, tool shed, power pump, water pipes, and bee house was rented from the good canons of Klosterneuburg. Now the land is no longer theirs, and the Region of Lower Austria has built a kindergarten and elementary school on what

was Grandfather's realm and his grandchildren's playground. When the abbey started selling off properties on the left bank of the Danube after World War II, my father too bought a small plot where he could indulge his green thumb and his passion for the Linnaean system of botany.

The Animal Watcher

We lingered a little over our wine and then coffee, deciding to scrap a projected visit to a ruined castle some five miles upstream of Klosterneuburg. The sisters had tickets to Richard Strauss's *Salome* at the Vienna State Opera that evening and wanted to rest a little at their hotel before dressing up. As we were returning to the city in one of the frequent blue trains of the *Schnellbahn,* I told my friends what we were passing up by not traveling a few stops in the opposite direction.

The name of the dilapidated eleventh-century castle that we weren't going to see, *Greifenstein*, sounds like the German words for "grip the stone" (in modern German *greif den Stein*) and has inspired various legends; actually it is probably derived from a medieval owner, Grifo. The castle tops a rock domi-nating a sharp bend of the Danube around a northernmost bastion of the Vienna Woods and the Alps. Repeatedly de-stroyed and rebuilt, the former stronghold was abandoned and decayed when a Prince Liechtenstein bought it at the beginning of the nineteenth century and had it romantically restored as a make-believe monument of the age of knighthood.

I first saw Greifenstein when I was nine or ten years old and our school class visited the ruin on one of our periodic excursions. I was deeply shocked to hear the guide tell us, without even a twinkle, that one of the naked halls he was showing us had once been the "torture chamber." This was clearly a part of his usual spiel. I suppose it is from that day that I have always viewed hilltop castles with misgivings. I don't know whether anyone was ever tortured in Greifenstein (the castle was at one time a prison for disgraced clerics), but whenever I see such a fortified place with towers and battlements in a menacing position above a river or road, however romantic it may seem, I think of robber barons and of the arrogance and despotism of petty lords. I always loved Goethe's verses, "America, you are better off / Than our continent, the old one / You have no ruined castles . . ."

Half a century after my first visit to Greifenstein I drove out there to interview Konrad Lorenz, the scientist who had shared the 1973 Nobel Prize for Physiology or Medicine for his research into animal behavior. I found that the few houses below the castle that I remembered had become a village with many new buildings, looking down on a large hydroelectric plant, a marina, and beyond the large riverbed, a vast patch of forested wetlands near the town of Stockerau. The pseudo-romantic castle ruin was now housing a restaurant of some pretension and a collection of old weapons.

When I called on the Nobel laureate at a mansion that had been his grandfather's home at 2 Lorenzgasse in the nearby Danubian village of Altenberg, he was sitting in front of a large

aquarium, watching the fish in it and taking notes. To talk to me, the white-bearded scientist yielded his observation post and notebook to a Chinese woman, a university graduate who was on an internship in his laboratory-residence. I said I had expected the Herr Professor to be dealing with geese and ducks—Lorenz's studies regarding them were one of the more popular aspects of his work. "Oh no," he said with a chuckle. "I am through with domestic fowl for some time. The people in the village thought I was crazy, playing parent to goslings."

He explained to me the importance of imprinting, the early learning process whereby a social animal picks up behavior patterns from a parent or substitute parent. From imprinting our conversation veered to the alienation that small children, according to Lorenz, were suffering in urban societies when they were passed from one social worker to the next. Eventually we discussed the riverbank forests that once lined the Danube for hundreds of miles; locally they are called *Auen* (in the singular, *Au*). I said I was glad to have seen what looked like an intact *Au* on the opposite bank of the Danube. "Alas, the *Auen* are vanishing," the Nobelist replied. "Every year another piece of them is being whittled away somewhere, birds and other animals are deprived of another portion of their habitat, and the ecosystem suffers." Lorenz's lively wife said her husband was very glum about the future of the earth and life on it, and the Nobel laureate nodded, looking far from gloomy.

7.

THE

TREE SAVIOR

❀

I recently took the *Schnellbahn* from Vienna's Western Rail Terminal (Westbahnhof) to visit the Vienna Woods District office in the town of Purkersdorf on the Wien River. The trip took twenty minutes. Two passersby in the town whom I asked about the Vienna Woods headquarters said they had never heard of it, but I found it eventually at 11 Hauptplatz (Main Square), in a modern building with a shopping arcade and café tables in the courtyard. The upstairs office's door was closed, bearing a sign reading, "Shall Be Back at Once." The "at once" turned out to be half an hour, but nobody besides me was waiting. The friendly, middle-aged woman who eventually came to unlock the door seemed astonished to see a customer; she was the entire staff and must have been shopping.

Talking with her, I learned that the Vienna Woods District isn't an administrative entity but a loose grouping of towns and villages in the area, supported by private business with the

blessing from the regional government of Lower Austria. The association publishes tourist folders and arranges reservations at the district's hotels and inns. One of its latest illustrated brochures started like this: "At a time that must rely on artificial paradises, a natural paradise like the Vienna Woods is an incomparable attraction. Gentle hillsides and harsh rock, ravines with rushing waters and vineyards on peaceful slopes, dense woods, dreamy meadows and mysterious riverbank forests surround Vienna like an open wreath."

The Vienna Woods District also sponsors various walking events, including a three-day International Vienna Woods Hike every August, centering on the town of Mödling, with performance badges for participants. I asked the woman at the Vienna Woods District office what might be a nice, easy hike around Purkersdorf before lunch, and she said, "Get to the other side of the railroad tracks and walk up to the Schöffelstein and back again. Red markings." The name *Schöffel* rang a bell, and I set out.

Over a high wooden bridge I crossed the Wien River and the highway running along its south bank and found myself in a children's playground on sloping grassland. There were swings and dark brown logs carved in the stylized shapes of giraffes and boar, but no kids—it was school time. Across a beech forest a path led up a hill, the Schöffelstein (Schöffel Stone), about 360 feet (120 meters) above the Wien valley. On top of it stands an obelisk in a clearing surrounded by tall trees and a few park benches. An inscription reads: "In memory of Joseph Schöffel, the courageous and selfless savior and protector of the Vienna Woods, in honor of his victorious fight for

the cause of right and truth during the years 1870–1872. As an incentive and example for future generations erected by the gratefully committed municipalities of the Vienna Woods, citizens of [Vienna and Lower Austria] in July 1873."

It all came back to me. Teacher Rudolf Krenn, the same man who had taken my class to the abandoned canal skirting the Vienna Woods, had more than once told us about a successful nineteenth-century crusade to preserve the Vienna Woods. Joseph Schöffel (1832–1910) was a retired army officer and an amateur geologist. When the government announced a plan to sell vast state-owned forests near the capital to timber merchants who would cut most of the trees, he launched a one-man campaign to block the project. Neither the Austrian Parliament nor the city of Vienna seemed to care; the Habsburg Empire had lost its 1866 war and needed huge funds to pay its debts. Parliament passed a bill in 1872 providing for the sale of much of the Vienna Woods to the timber industry for 20 million florins (somewhere between $50 million and $100 million in 1993 dollars), a deal that held out chances for enormous profits to be gained by the purchasers.

Schöffel cast himself in the role of an investigative reporter and dug up evidence that government officials were implicated in shady financial maneuvers. He published his findings in many articles he contributed to Vienna newspapers, warning that irreplaceable national assets were about to be squandered. Publicly taking on the imperial-royal bureaucracy was then unheard of, and Schöffel soon seemed in deep trouble, facing charges of subversion and fomenting hatred against public authorities. He stuck to his guns, and court proceedings never

resulted in a sentence. A popular groundswell against selling off the forests mounted, and Parliament eventually repealed the 1872 legislation that had authorized the scandalous transactions. Some imperial-royal civil servants whose malfeasance the crusader had proved were disciplined.

The town of Mödling elected the savior of the Vienna Woods as its mayor, and he became a member of the Reichsrat, the Austrian Parliament. His tomb is in the Mödling cemetery. The choice of a hill near Purkersdorf for a monument honoring Schöffel suggested that the town, which in old times had administered a large part of the forested district, was to be regarded as the unofficial capital of the Vienna Woods.

There isn't much of a view from the Schöffelstein, but a vast panorama can be enjoyed from an observation tower that was built in 1978 some 300 feet (about 100 meters) higher up, on the Rudolfshöhe (Rudolf's Height), surrounded by a wildlife reservation.

I redescended to the Wien River and, before returning into town, strolled a few hundred yards along Purkersdorf's "Nature Instruction Path." This is a riverbank promenade lined with trees, shrubs, and other plants of many different species, all labeled with their German and Latin names; my father would have had a marvelous time. A large signboard carried ceramic panels with multicolored pictures of dozens of edible and poisonous fungi. "Use only mushrooms that you know accurately!" the legend warned.

Not all the edible kinds shown on the signboard can be found near Purkersdorf, but it seemed to void Sigmund Freud's

complaint about too few mushrooms in the Vienna Woods. As a small boy, when food was scarce in Vienna, I knew neighbors who often trekked into the nearby hills and came back with muddy shoes and full rucksacks; soon a delicious smell would waft from their kitchen. Mushroom hunters would jealously guard the secret of the places in the forests where they had scored, leaving inconspicuous markings on trees or rocks in order to find them again on later expeditions. The early morning hours after a rainy day are said to be most favorable for a successful mushroom search.

Mushroom hunting in the Vienna Woods became popular again in the lean years during and after World War II. Today's practitioners can be spotted at Vienna's west and south railroad terminals in the early morning of any weekday, especially after a spell of bad weather. Often they may be a husband and wife who look like retirees and are clad in loden, wearing hiking shoes and carrying knapsacks. They take local trains to obscure stops from which they will walk, often for long distances, off the marked paths to reach their secret hunting grounds. Mushroom gatherers are usually intensely distrustful of one another. Their thrill is the search, not gastronomy—they may give most of the mushrooms they bring home to friends.

Hereditary Postmaster

Back in the main square of Purkersdorf, I looked around for half an hour. Hemmed in as the town is by the highways on

either bank of the Wien River and by the railroad tracks, it has spruced up its small historic core, now a pedestrians-only area. In the stagecoach era Purkersdorf was the first or last stop on the old Vienna-Linz highway. Countless travelers passed through here, stretching their legs and taking some refreshment while the horses were fed or changed. Mozart first saw Purkersdorf at the age of eleven in September 1767 during his family's journey from Salzburg to Vienna, and he came through often in later life.

Near the fourteenth-century parish church, a Gothic edifice with a Baroque onion-shaped dome crowning its steeple, stands the town's most impressive building, the Post House. Postmaster was then an important office to hold. A nobleman and retired colonel named Joseph von Fürnberg, who was hereditary postmaster in Purkersdorf, had a new post station built in 1796, apparently at his own expense. The large neoclassical structure, with a columned portico, was recently restored. Six remarkable bas-reliefs, on the yellow facade between the windows, allegorically represent the tasks of postal service. In front of the two-story building, now housing the offices of a notary public, among other tenants, is an old milestone indicating the distance to Saint Pölten and carrying the Habsburgs' double-headed eagle in relief.

Not far from the Post House, an all-year maypole rises on the main square. Topped by a metal rooster, it displays the gaudy symbols of arts and crafts—a cook with a skillet, a tailor with a pair of scissors, et cetera—and the coats of arms of Purkersdorf and Lower Austria. Such pseudofolklore maypoles,

merrily hinting at what local business has to offer, are found today in other Vienna Woods towns as well as elsewhere in Austria, Switzerland, and Germany. I am getting tired of them.

A plaque on a low-slung building at 2 Kaiser-Josef-Strasse, near the parish church, records that Napoleon spent the night there in 1805. The house, once a Carmelite convent, had become an inn, and the French emperor, after his victory in the Battle of Austerlitz, was leading his armies toward Vienna. In Purkersdorf Napoleon's brother-in-law, Joachim Murat, received an official delegation from the Austrian capital, who meekly presented the French general with the symbolic keys to the city, pledging that Vienna would not be defended.

Purkersdorf has a few good restaurants around the main square and on the outskirts, but I wasn't very hungry and sat down for a bite in the café below the Vienna Woods District office. I ordered the all-purpose Austrian snack, frankfurters, with a glass of apple juice. Franks are known in Frankfurt as *Wiener Würstchen* (little Vienna sausages), whereas the Viennese, who devour them at any time of day or night, call them *Frankfurter*. Rationally, I disapprove of them. They are loaded with fat; their fillings (supposedly all pork) are often mysterious; and their casings, more often tough than crackling, are usually sheep intestines imported from such faraway countries as Iran. Yet whenever I return to my native country I too sink my teeth into a linked pair of franks (never, never use a knife!) at railroad stations or roadhouses, at sidewalk stands or in cafés, the way I can't resist hamburgers in the United States. The *Semmel* I got with the franks was stale. The Viennese are

proud of these white-flour rolls, which are part of their standard breakfast and are also eaten throughout the day, often with sandwich fillings. Their name is derived from the Latin *semel*, which means "once" or "at a single time"—a one-time individual helping of bread. *Semmel* are or should be crisp and chewy early in the morning when the blond rolls come from the bakery; as the day goes on they become sticky. I should have asked for a slice or two of the tasty rye bread that is available all over the Vienna Woods.

8.

AN

EXPATRIATE'S

HOME

❀

Penny was a South African who was doing postgraduate work in England and had come to Vienna to do research on W. H. Auden. Friends had told her I might be in town and how to get in touch with me. I was and she did. As we were riding the R-50 regional train from the Vienna West Terminal to the village of Kirchstetten, where Auden had lived during the warm months of his last fifteen years, I told Penny how I had learned of his death.

The *New York Times* had sent me to Vienna in September 1973 to catch up with developments in Austria and neighboring countries. I worked out of a hotel room and frequently called local colleagues, as newly arrived foreign correspondents will do to keep abreast of the news. One Saturday toward the end of my stay an Austrian employee of United Press International who had been helpful earlier in the week called me at my hotel and, for a change, needed advice himself.

"I am alone at the office," he said, "and they are driving me crazy from London with telex and phone queries about a Brit who has died in some village out in the sticks. Any idea what's so great about him? His name is Ouden." He pronounced it as if it were to rhyme with HOW-then. What was the man's first name? I wanted to know. "Oh, I have only the initials, W. H." "Better get busy," I replied. "He is or was one of the most important poets in the English language. Call the local gendarmerie for confirmation and have them tell you as many details as they know."

As it turned out, I explained to Penny, Auden had not died at his home in Kirchstetten but in a small Vienna hotel a few hundred yards from the UPI office and the place where I was staying. He had come to the city from Kirchstetten for a poetry reading, and his heart gave out during the night.

Our train, nearly empty, had meanwhile traversed much of the Vienna Woods, skipping some minor stops that are serviced only by the *Schnellbahn* commuter trains. After a forty-minute ride across the green hills we were at Kirchstetten station, and as we were getting out I told Penny, "Auden usually waited on this platform whenever he expected visitors, which was fairly often. He lived by the clock and would express satisfaction when the train from Vienna—they run at hourly intervals—was on time, as it usually is. His day was rigorously structured: he would get up at 6:30 A.M., work until eleven, go shopping in his Volkswagen, have lunch, take a brief siesta, work some more in the afternoon, have cocktails at 6:00 P.M., dine an hour later, and go to bed early. Auden would glance

at his wristwatch every now and then to make sure he was sticking to the timetable he had set for himself."

Kirchstetten station is on the old highway to Saint Pölten, now the regional capital of Lower Austria; opposite the tracks is an inn with outside tables under huge linden and horse chestnut trees. Nearby are a bank, a beauty parlor, and a small cluster of other houses. "Is that all?" Penny wondered. I informed her we would have to walk for half a mile (some 800 meters) to reach the village proper. Two dozen cars were parked outside the station. Kirchstetten, which now has about twenty-five hundred residents, has lately become a commuters' haven, the home of people holding jobs in Vienna or Saint Pölten.

A green sign, reading in translation "Weinheber and Auden Memorials," pointed southward. It required another explanation: "Kirchstetten is very proud of having been the home of not just one but two poets. The other was Josef Weinheber, a Viennese who lived and died here long before Auden settled in the village. The two never met, but Auden read Weinheber's books in Kirchstetten, and in a long poem he expressed his respect for his late colleague's craftsmanship. As a young man I greatly admired Weinheber and bought a collection of his verses in our dialect, entitled *Wien Wörtlich*, which may be translated as 'Vienna Verbatim' or 'Vienna Word for Word.' Weinheber was a post office employee who began writing poetry as a sideline; success eventually enabled him to quit the state job, which he hated. He had an enviable way with words and a mastery of metric forms. He brought off perfect stanzas

in the common, but often picturesque and pungent, vernacular of Vienna. He could also write exquisite poetry in standard German."

I was terribly disappointed and angry, I told Penny, when after Austria's invasion by Hitler's soldiers in 1938, I learned that Weinheber had been a clandestine Nazi for years; he then started acting as a virtual propagandist for the Hitler regime and was honored by it. He eventually went to live in Kirchstetten, where he had bought a small property. In the spring of 1945, when the Soviet armies were closing in on Vienna and fanning out into the Vienna Woods, Weinheber killed himself by taking an overdose of sleeping pills. The Roman Catholic Church would not permit the body to be interred in the consecrated cemetery grounds, so his family laid him to rest in his own garden.

"They buried you like a loved old family dog," Auden wrote in his 120-line poem in praise of Weinheber in 1965. "Categorized enemies twenty years earlier," the British-American went on, "we might have become good friends"— friends who, sharing a common ambiance and love of the word, over glasses of golden wine from nearby Krems might have had long talks on language, syntax, and versification. "Here, though, I feel at home as you did."

The poem voices esteem for the neighbor and colleague whose workmanship as a poet proved he was "one who was graced / To hear the viols playing." Other verses in Auden's poem suggest Weinheber didn't really know what was going on in Hitler's Greater Germany: "Good care, of course, was taken / You should hear nothing."

I told Penny about Auden and Weinheber as we walked to the village across rolling maize and sugar beet fields with a forested ridge as a backdrop. Benches at the roadside carried signs stating they had been put there by the village's Embellishment Board. Rabies warnings on utility poles cautioned householders and visitors against letting dogs or cats run around freely. A rabies epidemic had been advancing in central Europe for years, affecting foxes and other Vienna Woods animals as well.

Poets' Slope

When we reached the village, dogs in fenced-in gardens started barking furiously; either they weren't used to strangers in the solitary streets or were just bored. There were a few old, low houses, but most buildings looked new or recently renovated, a few with bright plastic siding simulating clapboards that made them resemble New England homes. A sloping walkway near the parish church was marked Dichtersteig (Poets' Slope), a reference to Weinheber and Auden. Pictures of the two were displayed on a freestanding masonry pillar nearby. The Roman Catholic Church of Saint Vitus, on the rise that is the village center, was closed. Recently restored, the six-hundred-year-old edifice was accessible only for services.

Entering the village cemetery adjacent to the church's north wall we at once saw the headstone of Hedwig Weinheber, the poet's wife, who survived him by eleven years. I didn't find Auden's grave and asked a white-haired woman

who was watering flowers on a grave to point it out to us. She herself wasn't quite certain at first but quickly spotted it. "The English Herr Professor was a friendly man, well liked in the village," she remarked. "He never missed Sunday mass."

Auden, an Anglican, was a regular at the local Roman Catholic church, where he lustily sang the hymns in German. In the annual Corpus Christi procession he used to walk with the mayor and other local notables behind the village priest, and he became the reverend's friend. After church he would drop in at the Gasthaus Seitz, the nearby inn owned by an influential family, for franks and beer.

Auden's grave is close to the church wall, left of the cemetery entrance. It is marked by a black iron cross with wavy decorations, an iron lamp with a candle, and this inscription:

W H Auden
21. 2. 1907 – 29. 9. 1973
Poet & Man of Letters.

The grave was covered with ferns and other green plants, appearing well tended. In its simplicity it contrasted starkly with the marble headstones and elaborate flower decorations of most other tombs in the cemetery. One of the most ornate of them, four slots to the left of Auden's grave, was the resting place of Dr. Samir Charoar, who from 1955 to his death in 1986 was Kirchstetten's village physician. The tombstone carried inscriptions in German and in Arabic script.

Past the memorials to the village's war dead (twenty-three names for World War I, fifty names for World War II) we

walked down Poets' Slope to a small park. Under large linden trees in front of an ancient wine cellar stood a pillar of raw-edged sandstone, topped by a likeness of Auden's deeply furrowed face.

We crossed a small stream, the Sichelbach (Sickle Brook), on a bridge and walked through an underpass below the Vienna-Salzburg Motorway. The nearest exit of Austria's A-1 autobahn is at Saint Christophen, a mile and a half (2.5 kilometers) to the southeast. Beyond the motorway is Kirchstetten's choicest neighborhood, Hinterholz (Backwood), with well-kept houses and gardens. The rising, curving Audenstrasse—the road was officially given the poet's name in his lifetime—leads to his former residence, at No. 6. A dark forest of tall pine trees starts immediately behind the building. "A house backed by orderly woods / Facing a tractored sugarbeet country"—so Auden described the only home he ever owned, in his 1966 cycle, *About the House*.

The property is surrounded by a dark brown wooden fence. At the main entrance two bronze name shields read "W H Auden" and "Chester Kallman." The present owner, Franz Strobl, later explained to me: "They are the original nameplates. I put them up again a few years ago."

Kallman, an American fourteen years younger than Auden, was his longtime companion. The pair lived together in Kirchstetten from spring to autumn every year, and the younger man did much of the cooking. Auden spent winters first in New York, then in Oxford, while Kallman usually moved to Greece for a few months.

Earlier, from 1948 to 1957, Auden had spent his summers

in a secluded house at Forio on the Island of Ischia in the Bay of Naples. In 1957 he was awarded the Feltrinelli Prize of Italy's Accademia Nazionale dei Lincei, an old learned society, amounting to more than thirty thousand dollars. He wanted to buy the house in Forio d'Ischia but its owner, having learned of his tenant's windfall, demanded an outrageously high price. Piqued, Auden wrote a poem, "Good-bye to the Mezzogiorno" (meaning Italy's South, where "one has been happy") and looked for another summer residence. Among friends he spread word he wanted to live in a wine country near a city with an opera house. The Vienna Woods appeared to meet his requirements.

An advertisement in a Vienna newspaper offering the Kirchstetten property for sale was spotted by the daughter of his old Austrian friend Hedwig Petzold and brought to Auden's attention. He went to the spot and was captivated at once by the eighteenth-century farm cottage, especially by its wooden outdoor stairs leading up to an attic with a dormer window. He bought the house and three acres of land around it for twelve thousand dollars (in 1957 dollars) and had an American kitchen and other conveniences installed. During his long periods in Kirchstetten, Auden would climb the green-painted stairs every morning to his isolated workroom. It was in that attic that he wrote *Homage to Clio* (1960), *City Without Walls* (1969), and the posthumous *Thank You, Fog* (1974), among other works.

Auden and Kallman's housekeeper was a local widow, Josefa Strobl. Her son now owns the house. Mr. Strobl and his

wife, like many other Kirchstetten residents, commute to jobs elsewhere every day—he to a place near Vienna, she to Saint Pölten. I spoke with them separately, by telephone. Mrs. Strobl said that keys to their house were at the mayor's office and that a visit in her and her husband's absence could be arranged, "but there is really nothing to see inside right now." Penny and I preferred not to invade the Strobls' home when they weren't there.

Mr. Strobl told me, "The Herr Professor left everything he possessed to Mr. Kallman in his will. Soon after inheriting, Mr. Kallman sold the house to my mother on condition he could always live in it. Mr. Kallman died in Athens in January 1975, and his father, a New York dentist, laid claim to the house, but of course had no legal title." Mr. Strobl, like everybody else in Kirchstetten, pronounced the dead poet's name "Ouden."

The village of Kirchstetten and the regional government in Saint Pölten persuaded the Strobls to consent to the transformation of a part of their home into an Auden memorial. Mr. Strobl's wife said, "Our attic is being restructured. Work is slow because there is always the question of funds. The authorities go ahead a little whenever they have the money, then stop again. At any rate, our house won't be a museum. What visitors eventually will see is Mr. Auden's study and an adjoining new room in the attic that will serve as an Auden research center. Mr. Auden's books, records, and the other things he left are at present in boxes at the Culture Department of the Lower Austrian Regional Government in Saint Pölten for indexing."

I suggested to Penny that she should contact the Austrian Society of Literature, which was Auden's host the evening before his death; it would be able to put her in touch with some of the two hundred people who attended his last poetry reading as well as with other sources. At the end of September 1973 Auden had closed his Kirchstetten home for the winter and had moved with Kallman into a hotel near the Vienna State Opera for the weekend, prior to their departure from Austria. Auden was to go to Oxford, where he had the use of a "grace and favour" cottage at Christ Church, and Kallman would fly to Greece.

Auden's reading in Vienna took place in the Palffy Palais, which faces the former imperial palace, the Hofburg. The Society of Literature had organized the affair to mark the publication of a volume containing German translations of many Auden poems. Their author by then spoke fluent German and could make jokes in Austrian dialect, but he preferred to have a prominent Vienna actor, Achim Benning, read the translations, including the German-language version of his tribute to Weinheber. At the end Auden himself read in the original English a few poems that the audience had heard earlier in German. He appeared fatigued and was taken by car to his hotel although it was only a ten-minute walk.

When Auden didn't emerge from his room the next morning, Kallman, who had attended a performance of *Rigoletto* at the State Opera, had the door forced open and found his friend lifeless in bed. According to a postmortem, Auden had suffered a heart attack. A plaque at 4 Walfischgasse in Vienna, once the

Altenburgerhof Hotel and now an office building with a tavern on the street level, commemorates Auden's death there.

Auden was buried in Kirchstetten on a lovely Vienna Woods autumn day, according to attendees of the funeral. Among the mourners were his brother, who had come from England, Kallman, Auden's old friend and fellow poet Stephen Spender, and many local people. The parish priest of Kirchstetten officiated in German and Latin, and an Anglican clergyman from Vienna said prayers in English. The village band played funeral music. The family had been offered a London burial in Westminster Abbey, but Auden's brother, John, said the poet had come to consider Kirchstetten his home and should rest there. A tablet placed later in Poet's Corner at Westminster Abbey carries a W. H. Auden verse and the words, "Buried at Kirchstetten, Lower Austria."

Blue and Yellow

Penny took notes of what she had seen and heard in the village, and she said she would like to call her father in Johannesburg because this was his birthday. She had written him from London, but he surely would be thrilled to hear her voice from Austria. I said, "Let's go to Neulengbach; it's nearby, it's a real town, and you have a much better chance to get through to South Africa from there than from Kirchstetten." By train we reached Neulengbach in ten minutes but found the post office closed, to reopen only at 2:00 P.M. Penny said she wasn't quite

sure about time zones but would almost certainly find her father at home later in the afternoon. This gave us time for lunch and a stroll around the pretty town.

We were directed to the Restaurant Alter Markt (Old Market) as the "in" place of Neulengbach and found it more pretentious than I had expected. The service was smooth, however. Later I was told that Neulengbach was becoming fashionable with a smart, young Viennese crowd, and that yuppies in the capital were scouting the town every weekend with a view to buying or building second homes. We had a classic Viennese dish, *Tafelspitz* (boiled beef), which was gratifyingly tender and came with potatoes and a sauce of mixed apples and horseradish. I asked for "golden" Kremser wine to give Penny an idea of the sort of vintage Auden liked at Kirchstetten, what he would have drunk had he met with Weinheber.

There are few points in Neulengbach where one doesn't see its castle, we found out during our leisurely after-lunch walk. The multicornered three-story structure, with its bright red roof and massive towers, sits on an isolated round hill that is densely covered with horse chestnut and beech trees. Beneath it Neulengbach spreads all around the hill and along two streams that contribute their waters to the Danube. The town stretches also along the highway to Saint Pölten and along the railroad tracks. Wooded hills and ridges are east, south, and west. "How picturesque!" Penny said. "Only, it's not how I expected the Vienna Woods to look. I must have had dark fairy-tale forests in mind."

The castle that dominates the town, I told her, was built in the twelfth century by the lords of Lengenbach, a powerful aristocratic clan that owned some twenty strongholds around the Vienna Woods. The Lengenbach coat of arms was blue and yellow, and blue and yellow are today the official colors of Lower Austria.

As for the fortunes of the Lengenbach family, they moved to their new, vast abode, which we were seeing, from another, smaller castle near a village, now known as Altlengbach, 4 miles (6.5 kilometers) south of Neulengbach. They did well to shift their residence. The Turks destroyed the old castle in 1529, and the ruin of Altlengbach was never restored. The Neulengbach castle withstood the Turks during both of their major invasions, in 1529 and 1683. The Lengenbachs have long died out, and the Neulengbach castle, now privately owned, often provides the setting for theatrical events and concerts.

We sauntered into the oldest part of town, south of the castle, and in its elongated market square were greeted by the inevitable commercial-touristy maypole. "Welcome to Neulengbach—the Pearl of the Vienna Woods," read a sign hanging from it. Around the square stood a few dignified old burgher houses, one with a Gothic doorway from the fifteenth century, and the sixteenth-century town hall in Renaissance style had an octagonal turret. Nearby were a supermarket, the Café Piano Bar Davidoff, and the Black Eagle Inn, with a restaurant and guest rooms. A real estate agency displayed listings in its show windows offering properties at the equivalent of from $200,000 to $700,000.

The dull gray facade of a less than lovely building complex on the north side of the market square was brightened by a sundial complete with a mural. The painting represents a heroic-looking nude horse tamer with one dark and one white steed—night and day. Underneath is a rhymed stanza by Josef Weinheber, a sometime resident of Neulengbach before he moved to Kirchstetten. The verses, evidently commissioned by the town fathers, are in standard German. I translated them for Penny without bothering about rhymes:

> *The heart beats, the shadow shifts*
> *What failed yesterday, today succeeds*
> *What succeeds today, is a phantom tomorrow*
> *Conquer time to be a man.*

Schiele in Prison

"This is the court building of Neulengbach," I told Penny, "and a very prominent artist was once held in its cells—Egon Schiele." Now I had my guest's full attention. Penny said she had seen Schiele paintings for the first time just recently in London, and they had disturbed her. "I found something tortured, morbid in his nudes," she observed. "Kinkiness? Angst? Was he hostile to women?"

I had looked at plenty of Schiele drawings and paintings myself and had read up on the artist in preparation for an earlier book; I told Penny what I knew about his Neulengbach adventure.

Schiele was twenty-one years old and had already attracted some attention by shows of his early works in Klosterneuburg and Vienna when he moved to Neulengbach in 1911. With him was his model and mistress Wally Neuzil, whom he had taken over from his sometime mentor Gustav Klimt, the pioneer of Vienna's *Jugendstil* (Youth Style, the name for the central European version of Art Nouveau).

As a designer, Schiele is said never to have needed an eraser. He represented his models in his angular style, often without bothering about background. The son of a syphilitic father who had eventually lapsed into near-insanity, Schiele was obsessed by the female anatomy, especially that of adolescents. Before coming to Neulengbach he and Wally had been run out of the town that was the birthplace of his mother in Bohemia, where he had been portraying naked children; his girlfriend apparently had helped him find his underage models.

In Neulengbach too Schiele was soon in trouble. In the spring of 1912 he was arrested on charges of having committed sex offenses against a local girl who was not yet fourteen. He spent three weeks in the holding pen of the Neulengbach courthouse and then was transferred to the penitentiary in Saint Pölten, where he was held for another three days. At his court hearing, twenty-four days after his arrest, his alleged victim withdrew what she had said during pretrial testimony, namely that the defendant had sexually assaulted her. A rape charge was dropped, and the court sentenced Schiele to three days' imprisonment for having shown pornographic material to a minor. Since the period of Schiele's detention by far exceeded the prison term, he was released at once.

During his twenty-one days in the Neulengbach court-house Schiele painted thirteen watercolors of his prison cell, its chair, its bunk, and an orange, which he described as "the only light" in his existence as a detainee. Most of his jail pictures are now treasured by the famous Albertina Gallery in Vienna. After his trial Schiele and Wally left Neulengbach, and in Vienna they became estranged.

Schiele married a woman three years younger than he, lived through World War I in comfortable army posts on the home front, and died during the influenza pandemic of 1918, three days after his wife had succumbed to the disease.

We walked to the courthouse door at 2 Hauptplatz and at its side saw a faded poster announcing that Schiele's cell would be open to visitors "on the occasion of the 80th anniversary of his detention" (April 1992). The text contained a telephone number. I called it and asked the woman employee of the courthouse who answered, "Would it be possible for us to see the cell although the anniversary has long passed?" "Sorry," she said. "Repair work is going on right now, and no outsider can be admitted. Eventually the ground-floor cell may become a sort of Schiele memorial. Good-bye."

I told Penny that a faithful replica of the Neulengbach cell could be viewed in a new Egon Schiele Museum at Tulln, the Danubian city where the artist's father had been railroad stationmaster and where he himself had been born. Curiously, the museum is a converted former district courthouse on Tulln's river embankment. I had visited the place soon after it was opened on the hundredth anniversary of Schiele's birth (June 12, 1890), and I remember the reconstruction of his

Neulengbach prison cell on the ground floor—the heavy wooden door under a narrow window opening to the courthouse corridor that was secured with a strong steel grill, the short bunk, the naked lightbulb. Reproductions of Schiele's watercolors were on the whitewashed walls of the cell. In the other rooms of the two-story Tulln building I saw various Schiele works in the original or reproductions, as well as his death mask.

Penny said that although Auden was her main concern for the time being, she would look at the Schiele drawings and paintings in the Vienna museums, but she would skip Tulln. We walked to the foot of the castle hill, close to the courthouse, to admire the mighty trees. We then searched for the Gothic synagogue in the courtyard of a house at 37 Wiener Strasse, the enduring proof, I had been told, that a Jewish community had been thriving in the market town during the late Middle Ages and in the sixteenth and seventeenth centuries. Only the bare walls remained.

The Neulengbach post office is a modern building near the Neulengbach Markt railroad station (there is also a Neulengbach Bahnhof station on the town's northern end, where much shunting of *Schnellbahn* and goods trains goes on). From one of the phone booths Penny found it easy to dial Johannesburg, and she talked with her father for a long time. Afterward she paid what amounted to nearly twenty dollars in tolls to a chubby woman who was also selling postage stamps, handling registered letters, weighing parcels, and counting words on telegram forms, all the while chatting with a woman leaning against her counter, just distant enough to permit customers to be served.

9.

HERMES AMONG
BOAR AND DEER

❀

The Austrian capital's Historical Museum had organized an
exhibition titled "Being a Child in Vienna" in the Hermes Villa
of the Lainzer Tiergarten (Lainz Game Park), and it occurred
to me that this was as good an occasion as any to revisit
that green enclave. The show's theme must appeal to anyone
brought up in the old city, and besides, I hadn't seen the
Lainzer Tiergarten for decades. Quite a few Viennese rarely, if
ever, set foot in it although the vast nature reserve is within
the administrative city limits and easily reached by public
transport. Most foreigners, busy with the Spanish Riding
School and other tourist attractions in Vienna, never see it.

Few cities anywhere can boast such a huge tract of pristine
land. Three-quarters of the hilly 9.5 square miles (nearly 25
square kilometers) of the Lainz Game Park are forested, and
many hundreds of boar, deer, wild sheep, and other animals
have their habitat there. It's one chunk of the Vienna Woods
that has remained largely unchanged over the centuries.

The vast green district was an imperial hunting ground as early as the sixteenth century. Empress Maria Theresa had it surrounded with a wooden fence, and her son Joseph II had the fence replaced in 1787 with a brick wall more than 15 miles (24 kilometers) in length.

About the only major building in the entire imperial hunting reserve was then a chapel dating back to the fifteenth century that had been destroyed by the Turks and was later rebuilt. Emperor Franz Joseph preferred during his long reign (1848–1916) to do his hunting in the mountains near Salzburg rather than in the walled section of the Vienna Woods on his capital's outskirts; he had the ornate Hermes Villa built there for his empress. When Emperor Wilhelm II of Germany made a state visit to Vienna in 1892 he went deer stalking in the Lainz Game Park. After the fall of the Habsburgs in 1918 the Republican authorities opened the enclave to the public. Today the green area is the property of the City of Vienna, by law a national park.

Deep inside the park two old hunting lodges offer simple meals and other refreshments to hikers. An observation tower was erected on a hill near the center of the game reserve, at 1,649 feet (514 meters) in altitude. Another hill, known as Wienerblick (Vienna View), in the game park's northeast, 1,392 feet (434 meters) high, commands a grand panorama of the city. There are a few bad-weather shelters scattered about, but aside from the Hermes Villa the vast forests and grasslands with their streams and ponds are free of any major structure.

For the visit to the game park and the exhibition on

children I wanted company. A friend from New York who happened to be in Vienna with her fifteen-year-old son said they would be glad to come with me. I cautioned them that we would not be back at the city center before late afternoon.

There are quicker ways to get to the Lainzer Tiergarten, but we chose an unhurried one that would give us a chance to travel through neighborhoods that the average tourist hardly ever sees. When we boarded the No. 62 streetcar at the State Opera, mother and son settled into window seats. A short woman, maybe forty years old, was at the controls, and I should have loved to be at her side, pretending to be a small boy again, as she drove the tram at a deliberate tempo through sections—former villages—known as Wieden, Margareten, Meidling, Hetzendorf, and Speising, all the time sounding her car's bell to warn drivers and pedestrians, never having to brake brusquely. We passed the old Technical University at our left and its postmodern green library building on our right, noted a yellow eighteenth-century palace and gray nineteenth-century tenements, skirted plenty of municipal housing projects and several parks, rolled for a stretch on the beltway (Gürtel) with its heavy commercial traffic, and saw trains of the Southern Railway. The No. 62 then proceeded on the far southern side of the Schönbrunn Palace grounds, and we got out at the Hermes Strasse stop.

We changed to the No. 60B bus, which passed more public gardens and a big hospital and had its last stop at the Lainz Gate of the game park. The entire trip from the State Opera had taken almost an hour. The Lainz Gate is one of seven

entrances to the green realm, the one most easily reachable from the city center; two of the seven gates are open only on Sundays and holidays. The game park can be visited from 8:00 A.M. to dusk, Wednesday to Sunday, between Easter and October 30. A restricted eastern segment, known as the Hermes Villa Park, accessible only from the Lainz Gate, is open all year. Admission to the Lainzer Tiergarten is free.

Dogs, Beware!

Near the gatehouse we saw a warning that dogs were not allowed into the game park. Why? the boy from New York, Alex, wanted to know. I asked the guard who was sitting at a small desk at the ground floor of the gatehouse, and he laughed. "It's not so much to protect our game as to protect the dogs," he said. "I live here and should like to keep a dog, but dogs, however you leash them and watch them, will manage to get loose sooner or later and run around the Tiergarten, chasing animals. A dog won't survive if one of our big boar mauls it."

The guard told us that according to the latest animal census, nearly 1,000 boar, more than 300 deer, 700 mouflons (wild sheep), and scores of wild horses were living in the game reserve. Furthermore, he said, many species of bats were populating hollow tree trunks and caves, and thousands of birds of all the kinds found in Austria were nesting in the park. Are there any snakes? the American boy asked. "Yes," the

guard said, "slowworms and other harmless reptiles, but I've never heard of any vipers here." At any rate, he recommended, it was best to stay on the marked paths.

The game park is crisscrossed by 50 miles (80 kilometers) of hiking paths across the forests and grassland, up and down the hills. If visitors stray off them, nobody seems to mind. As a boy I had heard of people who would spend the night on some hilltop or in a remote clearing of the vast enclave after the gates were closed. This surely happens now as well, especially during warm summer nights. The Forest Administration signs at the gates and at a few other points don't expressly forbid lingering somewhere off the marked paths; they only prohibit kindling fires or throwing away burning cigarettes because of the danger of forest blazes. I had seen few such warnings elsewhere in the Vienna Woods, and people in various places there had told me forest fires were a rarity.

We went past a children's playground with logs in the shapes of animals and headed to the Hermes Villa along a "nature instruction path" similar to the one I had seen near Purkersdorf: various trees and other vegetation labeled with their German and Latin names. Alex didn't care for being instructed, and I remembered how I too winced at my father's Linnaean mania. Now I caught myself glancing at the trees first before checking the labels to see whether I had identified them correctly. Alas, I wouldn't have passed a botany test.

It took us nearly half an hour to walk to the Hermes Villa, a sumptuous little château surrounded by forests, which Franz Joseph had had built for his wife, Elisabeth, between 1882 and

1886. When the villa was ready for her, the high-strung empress, born a princess of the Bavarian royal dynasty of the Wittelsbachs, was close to fifty. With her fine features, raven hair, and admirably slim figure, she was still celebrated as one of Europe's most beautiful women.

Restless Empress

Soon after Elisabeth's marriage to the young Emperor Franz Joseph—a first cousin—she began showing impatience with the rigid Spanish court etiquette in Vienna's imperial palace (the Hofburg) and in Schönbrunn Palace. She dutifully bore the emperor three daughters and a son (her first child, Sophie, died early), but she was virtually excluded from their education by her stern mother-in-law and aunt, Archduchess Sophie. Utterly frustrated and bored, Elisabeth did a lot of horse riding and started absenting herself from Vienna for increasingly long periods.

She traveled to Bavaria, Hungary, England, and Ireland and, ostensibly for health reasons, lingered in the Greek island of Corfu. By the late 1870s she seemed to have gone into permanent exile, roving about Europe. Franz Joseph, who loved Elisabeth and patiently put up with her antics, clearly hoped to keep her near him by providing a lavish hideaway for her in a secluded corner of the Vienna Woods. No outsider was admitted to the imperial game park.

The emperor commissioned Carl von Hasenauer, a profes-

sor of architecture at the Vienna Academy of Fine Arts, to design what was to become Elisabeth's private residence. Hasenauer had helped build the Burgtheater (Court Theater) and the imperial museums on the Ringstrasse; his refuge for the empress blended the Italian and French Renaissance styles. Prominent Viennese painters, sculptors, and interior designers decorated the villa's staircase, halls, and rooms. To maintain her enviably slender figure, the empress dieted and exercised relentlessly, and the Hermes Villa included a well-equipped gymnasium in which she worked out for hours every day she lived there. A larger-than-life statue of Hermes was put in front of the building, furnishing a catchy name for it. Elisabeth loved anything Greek, and the god of travel, who acted as a herald for the major divinities of Olympus, was an apt symbol of her restlessness.

The Hermes Villa suffered heavy damage from war actions and Soviet army occupation in and after 1945. It was completely restored soon after the war and is now used for temporary exhibitions. We walked around the building to see it from all sides, and before visiting the show on children in Vienna we made a stop at the ground-floor restaurant. The cappuccino was invigorating, and Alex had the first Coke of his daily quota.

Exhibitions in the Hermes Villa yield the bonus of glimpses into the opulent interior of an eccentric empress's retreat. The château's architecture is a hodgepodge of Renaissance and Baroque features, and its staircase and halls are adorned with frescoes and paintings by Hans Makart, whose idol was Rubens,

and by Gustav Klimt and other pioneers of the *Jugendstil*, which would soon triumph in Vienna. As we progressed from one section of the children's exhibition to the next we were allowed to walk across what had been Empress Elisabeth's bedroom. A large canopied bed stood in the second-floor hall, which seemed surprisingly gloomy despite the large windows looking out on the forest. Elisabeth must have fancied romantically somber colors.

The show itself was a treat more for me than for Alex. His interest was aroused a little by the nineteenth-century toys on display, but he soon appeared bored, though too polite to say so. I was stirred by pictures and objects related to Vienna's education system between the two world wars, when I went to school. There was a row of wooden desks of the kind our class had when Mr. Krenn taught us—who knows from which storeroom the Historical Museum had managed to salvage them!

I let my hand wander over the rough brown surface of one, feeling the grooves cut by penknives and instinctively lifting the metal lid of an inkwell; on the bottom there were still dry flakes of the tarry ink into which we used to dip our steel pens. It came back to me how our parents had sat on the uncomfortably low benches behind such desks when we were performing a Christmas play that our teacher had adapted for us and which we produced in the classroom. I was playing an angel in a long white shirt with feathery wings precariously attached to it, but with my head embarrassingly naked (at that time all boys in our school had shaved heads because of a

recent lice alert). The costume-renting shop had run out of wigs although I had been promised one with long blond curls. Despite titters in the audience I stoically recited my angel's lines.

In the Hermes Villa show were displayed, under glass, the original report cards of prominent Viennese. I had met and interviewed one of these people several times during the 1970s, the late Federal Chancellor Bruno Kreisky. His first-grade report card, duly signed by his father, showed top marks for all subjects; he had been a much better student than I was at that age.

Back Scratching

After spending more than an hour in the Hermes Villa the three of us set out on a stroll around the game park. From a grassy knoll we took a look around and saw hill after green hill all the way to the horizon, with higher ridges to the south and west. One might hike and camp here for days, we agreed. In a clearing on our left we noticed some horses lazily wandering and grazing. "They don't look wild at all," Alex said disappointedly, but the guard at the Lainz Gate would confirm later that they indeed were untamed.

We climbed a thickly wooded slope off the marked path and came to an enclosure. Behind the wire fence a herd of large boar, all sows, were jostling and grunting, devouring chunks of melons, apples, beets, and bread that a party of

visitors were throwing them from the outside. The regulations posted at the entrance said, "Feeding the animals is dangerous and therefore prohibited," but the boar lovers, obviously habitués, had brought the goodies with them in large bags and nobody had stopped them. One elderly man in a loden jacket was fondly scratching the shoulder of a big black animal that had pushed close to the fence and visibly enjoyed the attention while munching noisily.

Descending again across beech and oak forests we regained a marked path when, at a distance of about fifty steps, a huge, dark animal with long fangs, a male boar, was crossing it. The isolated fellow either had broken out of an enclosure or was allowed to roam freely. It didn't mind us, but I shouldn't have liked to scratch *its* back.

In another clearing we saw a flock of wild sheep with long curved horns that gazed at us with curiosity. Some came closer but turned disdainfully on realizing we wouldn't feed them. Far away, across dense underbrush, something reddish brown with tufts of white was moving fast—deer? No other human beings except us were in sight. The birds in the trees were singing and chattering incessantly. "An enchanted landscape!" the New York woman whispered. "Yeah, just like Times Square," her son wisecracked.

We decided it was getting late and we shouldn't try to walk all the way to the observation tower on its wooded hill. "We got the idea anyway," the boy said. "I'm hungry." Having penetrated into only a marginal fraction of the game park, we had already lost our bearings. We searched for a signpost and

eventually found one at a crossroads: one path led back to the Hermes Villa, the other straight to the Lainz Gate.

The restaurant in the château had herb soup on the day's menu, we remembered, but the boy's mother said though she was tempted to taste it, she would prefer a meal in the glass-enclosed veranda of an eating place we had seen outside the Lainz Gate. "It looks like a real diner," her son said enthusiastically. We went there for a late lunch—hearty goulash with plenty of paprika, followed by, at the boy's firm request, apple strudel. To speed up our return to the city center we took the No. 60 tram from the last stop of the No. 60B bus, and at the Hietzing stop changed to the U-4 subway. In thirty minutes we were at the State Opera.

10.

TOUR NUMBER
FOUR

❧

Charles and Betsie, my Chicago friends, were back in Vienna
after side trips to Prague, Bratislava, and Budapest, and before
returning home wanted to take the "Vienna Woods–Mayer-
ling" sightseeing tour that the concierge of their hotel had
recommended. "Let me join you," I said. I had often been to
all the places on the tour itinerary, I explained, but should like
to see and hear how they were being presented to tourists.

My friends had picked up the brochure of the Vienna
Sightseeing Tours, a pool operation in which a number of
official and private travel organizations participate with the
backing of local hotels. The come-on, in English, for Tour
Number Four read:

Vienna Woods–Mayerling/Heiligenkreuz-Seegrotte. A half-
day excursion which shows you the most beautiful
sights of the southern part of the *Vienna Woods*. Passing

the *Roman City of Baden* which is famous for its thermal springs, we take you to the romantic *Helenental* and the former *Mayerling hunting lodge*, today a commemorative chapel, where the *Crown-Prince Rudolf*, the only son of Emperor Franz Joseph, committed suicide with *Baroness Vetsera* in 1889. In the *Cistercian Abbey of Heiligenkreuz* (1133) you visit the medieval cloister which houses the remains of the last Babenberger. Driving by the *Höldrichsmühle* where Franz Schubert composed his Lied "*The Lindentree*," you arrive at the *Seegrotte*. From there, after a boat ride on the largest subterranean lake in Europe, you leave the Vienna Woods and return to Vienna, passing *Liechtenstein Castle*. The tour ends at the Opera House.

The promotional prose must in part be obscure to foreigners. ("What is a 'last Babenberger'?" Betsie asked.) The brochure nevertheless appears to work. The four-hour Tour Number Four, costing 420 schillings (thirty-five dollars at the time's conversion rate), is conducted almost every morning in the year, and from April 1 to November 1, also every afternoon.

Shortly after 9:00 A.M. on the day preceding my friends' flight to Chicago I waited for them at Vienna's bus terminal above the Wien Mitte (Vienna-Center) railroad and subway station, which is underground opposite the Vienna Hilton Hotel. Sightseeing and long-distance buses were parked at various platforms, and the Budapest-Vienna coach was just disgorging travelers, who must have gotten up early that morn-

ing. Charles and Betsie arrived in the Vienna Sightseeing Tours limousine that picked up customers at various hotels. The city's flourishing tour business revealed itself as a well-oiled assembly-line operation.

Participants in Tour Number Four were asked which language they wanted to hear, and we were shown to a bus with the signs "4," "English," and "Italiano" on the windshield. Two other coaches nearby were for German-speaking tourists and for people who understood French or Spanish. In our bus about half of the forty passengers were Japanese. Among them was a very thin elderly man who carried a folding chair with him and during stops would sit down on it near the coach while a younger Japanese woman, apparently a relative, would massage his neck and shoulders.

Our tour guide was a man in his thirties who spoke English and Italian fluently. As the bus was rolling on Vienna's beltway to the Southern Motor Road (Südautobahn, A-2) he told us, using a microphone and speaking alternately in the two languages, that Vienna was one of the European cities with the largest area and that the Vienna Woods were more than three times the size of Vienna. He didn't say that a part of the Vienna Woods is inside the capital's municipal boundaries.

Then the guide spoke about Mayerling. From how the Japanese and the Italians pricked up their ears I gathered that most of the passengers had been drawn to Tour Number Four by that name.

"Many of you here will remember Charles Boyer or Omar Sharif in the part of Crown Prince Rudolf in one of the

Mayerling films," the tour guide said. "A highly romantic subject. Actually, we don't know to this day how he and his young girlfriend, the Baroness Vetsera, died. Was it suicide? Was it murder? There are many theories. Some people stubbornly believed and still believe that the couple didn't die at all at Mayerling but got away and lived happily ever after on some island, maybe Corfu, under false names. This of course is nonsense."

While the coach was approaching the town of Baden we saw wooded ridges and slopes covered with geometrical rows of vines to our right. The public address system played a sound track with a medley of Viennese waltzes. I snorted, but a few of our fellow passengers, especially the Italians, wagged their heads and tapped their feet in three-quarter time. "You can't escape the waltz in Vienna, the *csárdás* in Budapest, or the tango in Buenos Aires," said Charles, the widely traveled music snob.

Our bus left the A-2 Motorway at its Baden exit and soon afterward passed a bridge over a ditch—a froggy remnant of the old canal to Wiener Neustadt to which Mr. Krenn had led my class many years earlier. The tour guide told us that the center of Baden was interesting but that we couldn't see it because it was closed to motor traffic. He mentioned that many historic personages had taken the waters in the spa but didn't elaborate.

The bus skirted Baden at its southern neighborhoods, which were pretty enough. Our road was lined with nineteenth-century mansions and villas, hotels and pensions, large

parks with old trees, and a big bathing establishment. I remembered it well because when it was new, in the early 1930s, I came out with many other Viennese on some summer weekends to marvel at its thermal wonders, swim in the enormous open-air pool, and take the sun on a sandy strip or on its lawns. The Baden pools have been known to attract as many as ten thousand bathers on hot August Sundays.

As we were leaving the town from its west we passed below the high arches of an aqueduct that for 120 years has been supplying Vienna with excellent water from the Alpine foothills in the south.

Helena's Valley

Soon after the aqueduct we glimpsed, on our right, the old Church of Saint Helena, a low edifice with a steeply inclined roof over its yellow-and-white facade and a short turret with an onion crown. A ruined castle looked down on the church from jagged gray cliffs on a hill behind it.

The guide didn't say anything about the church and didn't explain that the Helenental (Helena's Valley), which our bus was entering, was named after it. I mentioned to my friends that Napoleon visited the spot in 1809 and is supposed to have been so impressed by its beauty that he remarked to aides he would like to end his days in the suburb and valley of Saint Helena. His wish was granted, too, in a way—he was exiled to the bleak Island of Saint Helena.

For fear of appearing pedantic, I didn't tell Charles and Betsie that the small church, which is from the early sixteenth century, contains a theological curiosity. It is the so-called Potters' Altar, a sandstone relief showing the Trinity in the shapes of three crowned men, apparently of about the same age, each holding an orb in his left hand—the Father, the Son, and the Holy Spirit. The richly ornamented work of art, weighing 6,600 pounds (3,000 kilograms), was commissioned by the potters' guild of Vienna around A.D. 1500 and was donated to the city's Cathedral of Saint Stephen. It stood there for nearly 250 years until Pope Benedict XIV in 1745 prohibited the representation of the Holy Spirit as a human being. The pontiff, a renowned scholar, wanted to prevent the Christian doctrine of the Trinity from degenerating into a cult of three gods instead of one. The canons of Saint Stephen's in Vienna obediently removed the Potters' Altar from their cathedral, but instead of dumping it they made some money by selling it off to Baden, where it was tucked away in the marginal little Church of Saint Helena. It has been on display there ever since, and worshipers lingering in front of it usually don't know that they are having a brush with heresy.

Although I was sparing my friends a tricky point of theology, I couldn't abstain from pointing to the ruined Rauhenstein Castle with its sullen square tower high above the church: "Up there Beethoven's flaky nephew, Carl, tried to commit suicide by shooting himself not with one, but with two pistols. Yet it wasn't overkill—he survived, while causing the composer deep anguish and a lot of trouble."

Beethoven had taken charge of Carl after the death of the latter's father, Caspar, the composer's brother. The youth proved shiftless, and Beethoven constantly nagged him. Carl increasingly resented his uncle's scolding and secretly got in touch with his mother, although Beethoven disapproved of his sister-in-law and had forbidden Carl to see her. In July 1826 Carl must have felt he couldn't take his uncle's incessant rebukes any longer. He pawned his watch, bought a pair of pistols, went from Vienna to Baden, and got drunk. The next morning, surely hung over, he went to his uncle's favorite spot, the entrance to the Helenental, climbed to the ruined castle on the valley's right side, and fired both weapons at his temple.

The young man must have had a hard skull, because neither bullet penetrated it. Local people eventually found Carl with his head wounds and had him transported to Vienna, where he was first delivered to his mother's home and then was taken to a hospital. Beethoven, then fifty-five years old and already in bad health, was greatly upset. With the help of influential friends he eventually got his nephew into the army as a cadet.

Our tour guide didn't tell us that both Beethoven and Schubert loved the Helenental and often took long walks in the valley. Instead he drew our attention to the ruins of Rauhenstein Castle on our right and of another stronghold, this one with a triangular keep, called Rauheneck, on a hill on our left. He said that the two castles once effectively controlled the mouth of the valley—"Now, just keep looking out of the windows and enjoy the picturesque views of the Helenental!"

The pair of gaunt landmarks frowning at each other across

the valley dates from the twelfth century. A Knight Turso von Rauhenstein is mentioned in medieval chronicles. Later, other clans owned the two strategic castles, which at times withstood sieges and at others were captured by enemies. The Turks eventually destroyed both fortresses.

The public address system on our bus played again the soundtrack with the waltzes that we had already heard twice. We were proceeding on the curving road along the Schwechat River, which millions of years ago achieved a breakthrough here across the limestone hills and ridges of the Vienna Woods. From Baden the river flows across the flatlands of the Vienna Basin into the Danube near the town of Schwechat, which has lent its name to Vienna's international airport.

On either side of our road rose steep slopes covered with beeches, firs, and thick underbrush; every so often naked cliffs stuck out of the greenery. Footpaths rose left and right from the road. We passed an inn or café at about every mile, but there were few, if any, other buildings in the gorge. At one point our coach passed a tunnel through a giant rock that reached perpendicularly into the water. When Beethoven was hiking in the Helenental he had to bypass that rock over arduous paths—the passage through it was blasted out only in 1827, the year of his death.

As soon as the soundtrack was over, our guide started plugging cassettes of it, which were for sale on the bus along with multilingual brochures containing color pictures of the sights on Tour Number Four. Most of the Italians—notoriously big spenders when they travel—and a few Japanese in our group bought one of the two items or both.

Ominous Hamlet

The bus driver had negotiated the winding road at moderate speed for about fifteen minutes and now could go faster as the valley widened and the highway straightened. After another ten minutes we were in a green bowl in the terrain where the Schwechat River receives streams from side valleys. "This is Mayerling," the guide announced. "Don't expect to see a lot. Some of you may be disappointed." Surrounded by wooded hills, a hamlet with a few scattered buildings was before us. Our coach parked in front of a garden wall next to three other sightseeing buses. There were also a few private cars with German and Italian license plates—Hamburg, Munich, Trieste, Padua, Bergamo.

We walked up a rising garden amid rows of tall beech trees and were told to wait in front of a reddish-brown chapel in revival Gothic style. The thin Japanese sat down on his folding chair near the steps to the chapel entrance to receive another neck-and-shoulders rub. The other people from our bus were standing around, some taking snapshots of the chapel facade, of the two-story building on its right with a long wing around the corner, and of the garden. Nobody said a word; only the birds twittering in the trees were heard.

When the batch of sightseers that had preceded us had been processed, the chapel door was opened to admit our troop. What is officially called the Crown Prince Rudolf Memorial Site is accessible mornings and afternoons daily, with a one and a half hour noonday interval. A sign forbids picture taking inside the chapel.

The interior looked like that of any of the several other nineteenth-century churches in neo-Gothic style in and around Vienna. I was reminded of the side chapels of the Votive Church that had been built near the Schottentor in Vienna in memory of Emperor Franz Joseph's escape from an assassination attempt in 1853; in elementary school I had served as an altar boy at the Votive Church for a couple of years, donning a child's red cassock that was seldom cleaned.

Speaking in a low voice, the tour guide told us that after the death of his only son, Franz Joseph had ordered a chapel to be built into Crown Prince Rudolf's hunting lodge. The emperor entrusted the chapel and what had remained of the original building complex to a community of discalced Carmelite nuns, who were to pray every day for the soul of the dead crown prince. Our guide stepped to the altar, saying: "Here exactly was the bedroom and the bed in which the emperor's son and Baroness Vetsera were found dead."

A smaller chapel to our left, separated by plate glass from the main sanctuary, contained cult objects donated by Rudolf's mother, Empress Elisabeth, we were told. The frescoes in the chapel, we learned, represent the patron saints of the House of Habsburg and also Saint Leopold, who had belonged to the preceding dynasty of the Babenbergs.

Some whispering rose from our group, standing between the pews, when the guide said a few words about the community in charge of the memorial: "They are cloistered Carmelite nuns. There are at present twelve nuns in the adjacent convent, the youngest twenty-five years old—she joined two years ago. The nuns never come out, not even for mass, which they follow

through the grates you see here." He pointed to grillwork near the altar.

Our group then passed through two memorial rooms at the right side of the chapel. A few people glimpsed at old photos showing how Mayerling looked in Crown Prince Rudolf's time and at portraits of Rudolf and his parents. There was no picture of Baroness Vetsera, who died with him: for the Mayerling Memorial Site she didn't exist. At a desk near the exit a young woman—not a nun—sold picture postcards. Our entire visit lasted ten minutes, and as we were walking to our bus, another party that had been waiting in front of the chapel was admitted.

A Little Vatican

From Mayerling, past the right side of the chapel and nunnery, our bus drove up a rising highway between grassland and forests. We passed a fancy restaurant on our right, inevitably called Kronprinz (Crown Prince), part of a new hotel. From a saddle between densely forested hills we descended to the small abbey town of Heiligenkreuz (Holy Cross) in a broad valley. Our coach entered an archway to our right, traversed an outer courtyard, and parked in a large, irregular square surrounded by low, yellow-painted buildings. The abbey is a town within the town, a little Vatican like the fictional monastery complex depicted in Umberto Eco's novel *The Name of the Rose*.

Through a passageway under a turret we walked into

another vast courtyard, shaped like a trapezoid, with two-story arcades on one side. In a corner, under enormous linden trees, were the outdoor tables of the Abbey Cellar Restaurant, whose excellent wines, grown by the monks and their local labor force, I remembered from earlier visits. A Baroque column dedicated to the Holy Trinity rises at the center, facing the narrow facade of the Romanesque-Gothic abbey church.

The guide told us that the Heiligenkreuz abbey was founded by Margrave Saint Leopold III in 1133 (two decades after Klosterneuburg Abbey). The pious margrave had procured from the Holy Land a relic that was believed to be a sliver of the True Cross, and he called on Cistercian monks from the abbey of Morimond in France to establish a new religious center in this part of the woods. The Cistercians, observing an austere version of the Benedictine rule, laboriously cleared some woodland for cultivation and have been in Heiligenkreuz ever since. At present, the guide said, there were fifty-three monks in the complex, engaged in administering its extensive land holdings as well as in pastoral work and teaching in the abbey's seminary and the district's schools.

Our guide was now much chattier than he had been in Mayerling. He took us to the abbey's Gothic cloister and showed us the brilliantly colored stained-glass windows and leaden well of the Well House. We went on to the Chapter House. At the center of that low-vaulted square hall is a life-size stone figure, its face mutilated, resting on a sandstone slab. "This is the tomb of the last duke of the House of Babenberg, Frederic the Second, the Quarrelsome," the guide declaimed.

"He died in a battle with the Hungarians on the Leitha River, far from here, in 1246, but his men carried the day. The statue, which represents him, was damaged by the Turks."

A number of other Babenbergs are buried underneath the Chapter House, including Duke Leopold V, who took part in the Third Crusade, 1189–1192. Upon returning to his domains he had his fellow crusader, King Richard the Lion-Heart of England, detained as he was passing through Vienna and held for ransom.

In a whisper I informed my guests from Chicago that the remarkable dynasty of the Babenbergs had originated in Franconia, Southern Germany. They ruled large areas in Lower Austria and eventually also in Styria to the south, for more than 250 years, first as margraves and later as dukes. They were patrons of poets, troubadours, and artists, first at Klosterneuburg and then at their court in Vienna. They opened up the Vienna Woods and brought a measure of prosperity to their expanding domains. The end of the Babenbergs plunged Lower Austria into turbulence until Rudolf of Habsburg from eastern Switzerland was elected King of Germany and won out in a power struggle in Austria.

The tour guide said that the monks of Heiligenkreuz assembled in the drafty Chapter Hall whenever they were to elect a new abbot but that the community's chapter now held its regular meetings in a more comfortable hall in another building. We passed closed doors with a sign reading "Klausur"— meaning that only monks were allowed to enter—on our way to the abbey church. Our guide had keys to the doors leading

into the church from the cloister. "He seems quite at home here," Betsie observed.

The church impressed my friends. The narrow, lofty main portion, consecrated in 1187, is a severe Romanesque building; the large choir, built about a hundred years later, is brighter and contrasts with the nave by its delicate Gothic ornamentation. "I don't know much about architecture," Charles said, "but here I understand the difference between Romanesque and Gothic. It's like a textbook." The guide drew our attention to the magnificent Baroque pews, which, like other Baroque art in the church and abbey, were the work of Giovanni Giuliani, an Italian sculptor who for most of his adult life was artist-in-residence as a layman in Heiligenkreuz in the first half of the eighteenth century. Giuliani also shaped the Trinity Column in the main courtyard.

As we were leaving the church we glanced at its enormous organ. It has forty-five hundred pipes and was installed in 1804. Schubert wrote a four-hand fugue for the instrument and performed it here with a friend a few months before his death. Anton Bruckner, one of the top organists of his day, also played in the church during a visit to the monks shortly after Crown Prince Rudolf's death.

In front of the church the guide told us that we were on our own for half an hour before the bus was to leave: "You may wander around the various courtyards, and you will find the abbey's souvenir shop here on your right." "Aha," I remarked to my friends, "that's the deal between the abbey and the tour operators." Though I thought we might as well split, have an early lunch at the Abbey Cellar, and return to Vienna

by public bus, Betsie protested that she wanted to see the underground lake. So we strolled around the vast monastery compound while most of our tour companions bought picture postcards and souvenirs, and the elderly Japanese, who by now looked frazzled, was administered another thorough massage.

During our entire visit to the abbey we saw only one monk. He was a blond young man—perhaps a novice—in an immaculate white cowl who had a thick sheaf of papers under his arm and seemed to ignore us as he quickly crossed the main courtyard. At one of the doors a sign detailed the monks' daily schedule: Matins at 5:15 A.M., followed later by mass and more praying and chanting at the canonical hours before vespers and compline. "No wonder the guy looked busy," Charles observed. "He may want to get some work done between all those devotions."

It was not yet noon (*sext* for the monks) when we all boarded the bus again. As we were leaving the town of Heiligenkreuz at its eastern side, I pointed to my left and said, "Near here is the cemetery where Rudolf's girlfriend, Baroness Vetsera, was buried in all secrecy. Today visitors still snip leaves and branches from the trees near the tomb as souvenirs." I didn't know at the time that the tomb had been empty for years.

Schubert at the Mill

Soon we were in the Hinterbrühl, a deep ravine through which the Mödling Brook flows, enclosed by wooded heights and

towering limestone rocks. Black umbrella firs on the rugged cliffs and ruined castles on the hilltops contribute to the somberly dramatic character of the landscape. "During the Biedermeier era romantically inclined Viennese were crazy about the Hinterbrühl," I told my friends. "To make the place even more enthralling, the Prince of Liechtenstein, who owned most of the land around here—he was also a field marshal of the Austrian army—had a few phony dilapidated landmarks built. Ancient and medieval ruins, genuine or fake, were the fashion then."

Our bus passed a roadside hotel with several cars parked nearby, and our guide said, "Look to your left. That's the Höldrichsmühle, an old inn where Franz Schubert is said to have written the song 'The Linden Tree.' " Not very enlightening. *Höldrichsmühle* means the mill of the Höldrich family (whose real name may have been Hildrich). At Schubert's time the medieval flour mill had been an inn for two decades, and it is quite likely that the composer and his friends, during their frequent excursions into the Vienna Woods from the town of Mödling, stopped at the picturesque place once in a while. Whether he wrote the affectingly nostalgic "Linden Tree" at the inn, however, is highly questionable. The song is one of the least gloomy in the *Winterreise* (Winter Journey) cycle, based on poems by Wilhelm Müller, a romantic German who but for Schubert would be forgotten today. Schubert started work on the series in February 1827, when he was plagued by recurring headaches, depressions, and other ailments that may have been due to inadequate treatment of syphilis, which he had contracted years earlier.

When he sang the *Winterreise* for the first time for his friends in the house of Franz von Schober in Vienna, where he was lodging, Schubert's audience was disconcerted by the glum atmosphere, verging on despair, that pervaded the cycle. The wealthy Schober, among the composer's closest friends, said the only song he had really enjoyed was "The Linden Tree." Schubert reportedly replied to the muted criticism that he liked the *Winterreise* better than all his other songs, "and one day you will too."

Two linden trees, not just one, stand in front of the Höldrichsmühle today, and there is a well with an old wooden pump nearby, suggesting the "well before the gate" where the baritone narrator of Schubert's song had often been dreaming "many a sweet dream" in the shadow of a linden. The well is left of the archway entrance to the recently restored, comfortable Höldrichsmühle Hotel and Restaurant. On the wall of the two-story building is a frescoed portrait of Schubert next to a marble tablet claiming him as a former guest. Who can prove or disprove that the well existed in Schubert's day and that he jotted down notes under the linden?

Underground Lake

From the Höldrichsmühle our bus proceeded past villas and estates to the Vorderbrühl, where the valley of the Mödling Brook widens. (*Brühl* is archaic German for a "wet, swampy place"; *hinter* means "posterior," and *vorder* "anterior.") We halted in front of a tree-covered slope near the left bank of the

stream on the southwestern outskirts of the town of Mödling. Between a souvenir stand and a café was the narrow entrance to a tunnel into the hill, surmounted by the crossed-hammers symbol of mining. While our debilitated Japanese was revived by an energetic rub, the tour guide informed us that he was handing us over to an attendant of the Seegrotte (Lake Grotto), and that after our visit to the underground lake we would have time for "coffee, frankfurters, beer, cake, or whatever" at the café: another tie-in.

I anticipated our new guide's explanations by quickly telling my friends that the subterranean lake was actually nothing but a flooded mine, and that if they felt claustrophobic we might as well stroll along the nearby Mödling Brook with its old trees left and right, and enjoy the leafy promenade. "Let's go in," Betsie commanded, and we did. I had been in the old mine twice before and hadn't cared for its touristy exploitation.

Mining for gypsum started on this spot in 1848. From an initial shaft, lateral galleries were dug on three levels, and many thousands of tons of the soft mineral were brought to light until 1912, when water from underground streams invaded much of the mine. The grotto guide said that after World War I, film people shot some scenes in the flooded galleries, and in the 1930s promoters installed lighting, transforming the drowned mine into a sightseeing attraction. Then, during World War II, the Nazis pumped out the water and used the drained galleries in the hill as a bomb-proof aircraft factory.

At the entrance to the Lake Grotto I had bought a picture postcard reproducing a grainy World War II photo. It shows

five workers in coarse overalls (prison garb?) busy around a still wingless fighter plane fuselage in a low-vaulted tunnel. Cables are strung overhead, and a tool kit rests on a platform with castors; wooden sawhorses support the aircraft body. There is nothing resembling an assembly line—the scene rather suggests a small-time mechanic's workshop. The English text on the reverse side of the card reads: "Here was built the first jet fighter of the world (Heinkel He 162)." If the Nazis lacked the equipment for mass production, they had plenty of man-power. The guide told us that two thousand people, mostly slave labor, toiled in the underground plant, which generated its own power and had kitchens and other facilities.

By the end of the 1940s the Lake Grotto had been cleared of wartime detritus and was reflooded; sightseers started visiting it again. At present hundreds of tourists arrive every day. Our party boarded two white battery-powered boats, and we cruised on what we were told was "Europe's largest subterra-nean lake," 1.5 acres (6,200 square meters) in area. The Japanese tourists couldn't seem to get enough pictures of one another with the rough-hewn gallery walls and our sister boat as a background. The fragile Japanese man who had perked up after the latest massage seemed to derive a particular thrill from the boat ride and posed for his companion's camera. I remarked to my friends that I preferred the Blue Grotto on the Isle of Capri, a natural wonder, for underground cruises, but Betsie and Charles gallantly claimed they were enjoying the man-made Lake Grotto.

When we saw daylight again, after some forty minutes,

the Italians of our group headed toward the café, lured by a big sign in their language, "Caffè all'Italiana—Espresso." Our tour guide, who had remained outside, was flirting with a young woman colleague in charge of one of several other tour buses that had meanwhile arrived, and he seemed in no hurry to leave.

We did move at last, well over an hour after we had reached the Lake Grotto, and the bus driver was impatient to get back to Vienna. He took us on the outskirts of Mödling to the A-21 Motorway, the southern branch of the main east-west motor road across the Vienna Woods. Our guide, who now appeared to have little to say, suddenly ordered us to "look sharply!" to our right. "You are seeing the Liechtenstein Castle," he said. "Doesn't it look a bit like the castle in Vaduz?" Then he sank again into a reverie, maybe thinking of the pretty fellow guide on the bus we had left behind.

We all obediently gazed to our right, although the reference to Vaduz must have sounded baffling to most of the passengers on our bus. I reminded my friends that we had glimpsed the Liechtenstein Summer Palace in Vienna on our way to Heiligenstadt. As for Vaduz, I said, it is the town, or rather village, on the young Rhine that is the capital of the Principality of Liechtenstein; the reigning prince and his family reside in a seven-hundred-year-old gray castle on a wooded rock looking down on Vaduz. What we saw on the hill near Mödling was a tall fairy-tale structure, its prevailing color beige, rising from clumps of firs and other trees. Its main tower is more slender than the squat, square keep of Vaduz Castle.

The Liechtenstein Castle near Mödling is to a large extent

a fanciful reconstruction of the ancestral home of the family that today is ensconced in Vaduz, some 375 miles (600 kilometers) to the west. Dating back to the twelfth century, the original Liechtenstein abode in the Vienna Woods was damaged by various sieges and conquests through the centuries and after the Turkish wars was a gaping hulk. The immensely rich Prince Johann II of Liechtenstein (1840–1929), who lived most of the time in Vienna, had the historic family home rebuilt and filled it with copies of ancient furniture.

Like Prince Johann I of Liechtenstein (1760–1836), Johann II, the field marshal, spent huge sums to transform the land that the family owned between Heiligenkreuz and Mödling into a vastly artificial landscape. The false ruins about which I told my friends in the Hinterbrühl include a Temple of Diana and a spurious ancient amphitheater. There is also a Temple of the Hussars on a hill south of the Hinterbrühl, a memorial to the soldiers who Prince Johann I said had saved his life during a scrape in the Battle of Aspern (1809), in which the Austrian troops defeated Napoleon. Near the village of Sparbach, now off the Hinterbrühl exit of the A-21 Motorway, the Liechtensteins created their own game park. Many of the scenic roads and paths in the hillside west of Mödling were built with funds from the munificent princes as well.

The First Swastika Flag

We noticed development of another kind as our bus left the A-21 Motorway again and approached Vienna on other high-

ways: the city was unmistakably eating into the Vienna Woods with clusters of one-family houses, villas, and ranch-type residences. Rolling northward on the rim of the hillside we saw the familiar late-twentieth-century suburban sprawl to our right, down in the plains of the Vienna Basin.

During the last stage of Tour Number Four our guide was silent, and we didn't even get treated to the tape with the waltzes. I told my friends from Chicago about a Cistercian monk whom nobody had mentioned to us in Heiligenkreuz. He was a Viennese, Adolf Josef Lanz (1874–1954), who will be remembered as "the man who gave Hitler his ideas," in the words of his biographer Wilfried Daim. I myself heard about Lanz from August M. Knoll, a staunchly anti-Nazi scholar whom I had known when I was an editor at a Vienna magazine from 1936 to 1938, and whom I saw again long after the war. Professor Knoll had then just had a talk with the aged former monk.

Lanz, the son of a Vienna teacher, became Friar Georg when he entered the Cistercian Order at Heiligenkreuz as a novice in 1893 at the age of nineteen. Five years later he was ordained to the priesthood and said his first Mass. For two years afterward he served as a teacher at the abbey's boarding school. The Babenberg tombs below the Chapter Hall apparently fascinated Lanz; he became interested in medieval chivalry, the age of the crusades, and the Knights Templar. He also seems to have been strongly influenced by the anti-Semitism of a novicemaster at Heiligenkreuz. In 1899 Lanz left the order, "surrendering to the fallacies of the world and seized by carnal love," as a Latin entry into the abbey register noted.

Soon after shedding his white Cistercian hábit Lenz founded an "Order of the New Temple" and started publishing a magazine, *Ostara*, which he named after a Germanic goddess of the dawn and of spring. In *Ostara* and in many pamphlets that he also published he expounded a hodgepodge of mystical, esoteric, racist, anti-Semitic, and antifeminist theories—an ersatz religion with a basic dogma: the superiority of blond Nordic men over those he called "subhumans," such as Jews. The former Friar Georg called himself Jörg Lanz von Liebenfels (*Jörg* is a Teutonic-sounding variation of Georg); he invented a fake genealogy, claiming to be the son of a baron, and falsified his own birth date.

As a publisher and chief of a nutty organization, Lanz made enough money to buy a ruined castle, Werfenstein, in Upper Austria, proclaiming it the seat of his Order of the New Temple. At Christmas 1907 he hoisted there a flag with a symbol of Aryanism—the old Indian swastika, usually interpreted as a representation of the sun. Lanz's magazine *Ostara* had a widely disparate readership in Austria-Hungary and abroad. It included the prolific Swedish writer August Strindberg; Britain's Lord Kitchener, who had reconquered the Sudan and in South Africa had herded Boer women and children into concentration camps; and an untalented painter obscurely living in Vienna since 1907, Adolf Hitler.

Hitler kept a stack of *Ostara* magazines at the bleak men's hostel where he was a regular guest for some time. At one time he called on its publisher in person and asked for back copies. Lanz didn't charge anything for them, and even gave the shabby-looking young fellow a little money. Professor Knoll

told me that when he spoke to the former monk and grand master of the New Temple Order after World War II, Lanz vividly remembered Hitler's visit. He also confirmed that after Austria's annexation by Nazi Germany in 1938 the Gestapo had forbidden him to publish or to speak in public. The Führer clearly didn't want attention to be drawn to an important source of the Nazi doctrine.

Toward the end of his long life Lanz appears to have approached the Cistercians in Heiligenkreuz, seeking reconciliation, but it seems he was rebuffed. He died in 1954 and was not buried at the abbey, as he had wished, but in his family's tomb at the Penzing Cemetery near the Lainz Game Park. The headstone there gives his name as Georgius Lanz, not Jörg or Adolf Josef.

My brief outline of the curious career of Hitler's early guru was about over when our bus crossed the Ringstrasse, drove around the State Opera, and stopped at its left side. Our tour guide disappeared, and the driver made himself inconspicuous as if to signal that no tipping was expected. Charles and Betsie went off to their hotel to pack for their departure.

11.

VIENNA WOODS
DRAMA

❀

While on our sightseeing bus tour, my friends from Chicago
had asked a lot of questions concerning Crown Prince Rudolf
and the Mayerling events. Was the crown prince buried in
Mayerling? Where is the tomb of his girlfriend? What do you
think *really* happened here? "This is still a big historical mys-
tery," I had told them. It wasn't a romantic love tragedy as
the Mayerling films would have, and I knew of at least thirty
theories on the murky events before, during, and after January
29, 1889—some serious, others fantastic. Today we have a few
more clues than earlier generations had at their disposal, and
it isn't to be ruled out completely that some other document,
object, or testimony may still turn up, shedding new light on
the Mayerling enigma. There are many twists to the story.

Crown Prince Rudolf was not yet thirty years old when
he wrote a long essay on the Vienna Woods. It was a contri-
bution to a twenty-four-volume encyclopedia, *The Austrian-*

Hungarian Monarchy in Word and Picture, that had been in the process of being published since 1884 and would be completed by 1902. Rudolf was the initiator and one of the editors of the project, which was inspired by the supranational principle that all peoples and religions in the Habsburg Empire were entitled to enjoy equal rights and dignity.

Besides his other official positions, Rudolf also held a high, though nominal, command in the army and liked the military life, but he took his publishing job seriously. He presided at editorial conferences and thoroughly researched the subjects of encyclopedia contributions that were assigned to him. His prose, which was neither pretentious nor elegant, reads well enough. For years the crown prince had also been writing anonymously for *Neues Wiener Tagblatt*, the liberal newspaper of his friend Moriz Szeps, who was Jewish. In his unsigned articles, which most readers thought were authored by the daily's founder and editor-in-chief Szeps, Rudolf cautiously advocated a pro-French foreign policy, voiced distrust of Prussian-led Germany, and supported Hungarian aspirations (his mother, Elisabeth, loved the Hungarians).

In his signed essay on the Vienna Woods in the Lower Austria volume of the encyclopedia, Rudolf praised the forested hills as a major asset of the region and the monarchy. He noted the long mountain ridges, the great number of little streams, and the scarcity of significant rivers in the hill country with its magnificent woods and other abundant vegetation. "From the botanical-geographic viewpoint the Vienna Woods must be considered one of the most interesting landscapes in central

Europe," he wrote. He singled out the black fir as the most remarkable tree, to be found nowhere west of the Vienna Woods.

As for the fauna, the crown prince, an indifferent huntsman, observed that bears, lynxes, and wildcats had long vanished from the Vienna Woods but that in severe winters one or two wolves might break loose from some pack in the Hungarian lowlands and end up marauding in the hills near the Austrian capital.

In a stylistic flourish the crown prince paid tribute to the "loveliness of the green landscape" and extolled it as a veritable natural park for the Viennese, offering them admirable vistas and healthy pleasures: "One may boldly state that no other European city with millions of residents has in its vicinity such a beautiful environment and such a remarkable panoramic vantage point as the Kahlenberg." Rudolf continued furnishing detailed descriptions of outstanding hills, valleys, streams, towns, and villages of the Vienna Woods. In passing he also mentioned the "charmingly situated Mayerling." Just these three words.

When the crown prince's article appeared in print in the encyclopedia, he had long been a Mayerling habitué. In 1886 he had bought a property there, known as the "little castle," from Count Reinhard August ("Leini") Leiningen-Westerburg, a retired cavalry officer who as a descendant from an old aristocratic dynasty was entitled to be addressed as "Serene Highness." People in Mayerling, Baden, and Vienna told each other piquant stories about him and the crown prince. It seems

Rudolf had had an affair with a soubrette of the Civic Theater in Baden, Nina Pick, a beauty from Bohemia, before she became, in a twist that might have been taken from the operettas in which she sang, a Countess Leiningen-Westerburg and a Serene Highness. Count Leini married her in the Mayerling church in 1885.

In 1887 the crown prince enlarged his Mayerling property by purchasing a complex of buildings near the "little castle" from Heiligenkreuz Abbey. Extensive work transformed the structures into a comfortable, though far from opulent, mansion that was generally described as the crown prince's hunting lodge. Actually Rudolf didn't do much hunting around Mayerling, although he would invite friends, including Count Leini, to shoots there. The crown prince himself often repaired to his sylvan hideaway to spend time with some girlfriend and, occasionally, to read reports or get down to a little writing. To reach Mayerling from Vienna, Rudolf either took a train from the Southern Railway Terminal to Baden and from there continued by coach through the Helenental, or he traveled by coach all the way from Vienna in a little more than two hours.

Crown Prince and Cabman

At about the same time that the crown prince became a property owner at Mayerling he hired a personal coachman, Josef Bratfisch. (The name is German for "roast fish," and many people thought, wrongly, that it was a sobriquet.) Not an employee of the imperial court, the short, mustachioed

Bratfisch was what the Viennese call a *Fiaker* (from the French word *fiacre*, or hackney carriage)—a cabdriver. Rudolf became fond of the man, who was in his late thirties, spoke the genuine Viennese dialect while shunning vulgarisms, and was a wonderful singer and whistler; seated on the box of his cab he would whistle all the popular songs of Vienna for the heir apparent to the imperial throne. Above all, Bratfisch was discreet. Neither during his service with the crown prince nor after Rudolf's death did he ever talk about what he had seen and heard, except in succinct answers under questioning by the police.

The crown prince had official cabdrivers assigned to him by the court and the army, but most of the time he traveled in Bratfisch's cab. The folksy yet deeply respectful cabman with the pleasant singing voice and vast whistling repertoire was his confidant and knew a lot about Rudolf's liaisons. A couple of times the crown prince, accompanied by a steady girlfriend, Mitzi Caspar, visited Bratfisch and his wife in their ground-floor apartment in a tenement in a lower-middle-class section of Vienna.

Every now and then Bratfisch would drive the crown prince and the tall and dark Mitzi Caspar, his pretty girl of the people, to the Waldschnepfe (Woodcock), a wine tavern in Vienna's green Dornbach suburb. There, among simple people, the cabdriver, seated next to Mitzi, would sing to the accompaniment of the Schrammel quartet. Rudolf himself authored the lyrics of songs for Mitzi, some of which are conserved in the original handwriting. A sample verse in translation from the Viennese dialect:

To Black Mitzi a gentleman says so softly
Little treasure, my heart beats hotly for you.

In 1881 Rudolf, not yet twenty-three years old, had married the bride whom his father (against the will of Empress Elisabeth) had chosen for him, Princess Stephanie, then seventeen, a daughter of King Leopold II of the Belgians. (The Belgian king was at that time in the process of acquiring his own private African colony and amassing an immense fortune from this "heart of darkness" in the ruthlessly exploited Congo.) When Rudolf had traveled to Brussels for his engagement to a young woman he had never seen before, he had—not so secretly—taken one of his girlfriends with him, either Mitzi Caspar or Nina, the future Serene Highness, or maybe both.

To Rudolf and his young wife a child, Elisabeth Marie, was born in due course, but Stephanie produced no male heir. The Belgian was plain-looking, timid, and terrified by her frigid father-in-law; courtiers derided her behind her back as "that Flemish peasant." The crown prince had little time for her. In the beginning he had been affectionate toward his unsophisticated wife, but soon he began to ignore her.

Frustrations

A well-read intellectual and a freethinker, Rudolf had in his early twenties been dreaming of liberal reforms in the old

empire that he was to inherit. Progressives in Austria-Hungary placed their hopes in the dazzling crown prince. At the same time, curiously, he was also highly popular among the officers of the army, a conservative force, because Rudolf made them feel he was one of them. The emperor, however, allowed him no say in the affairs of state or in military matters. Not much, if anything, changed when Franz Joseph in 1888 appointed the crown prince as Inspector General of the Infantry, an important-sounding title that actually was just a ticket for trips to remote army garrisons.

Rudolf was widely believed to have written, or at least to have inspired, an *Open Letter to His Majesty, Emperor Franz Joseph I* by a pseudonymous "Julius Felix" that was published in Paris in 1888. The pamphlet was at once banned in Austria-Hungary, but quite a few copies of it were inevitably smuggled in. People in the know were aware that the document, which also bore the title *Austria-Hungary and Its Alliances*, reflected the views of the crown prince on foreign affairs, as he had expounded them in many conversations with intimates and hinted at them in the anonymous articles in *Neues Wiener Tagblatt*. The style too was Rudolf's. No manuscript of the pamphlet was ever found, and it isn't certain even that the police or the government told the emperor about it. If, as is most likely, the crown prince himself wrote the plea to his father, he did so probably in the heart of the Vienna Woods, at Mayerling.

The pamphletist respectfully addressed Franz Joseph throughout as "Your Majesty." The pseudonymous author wrote: "I am an Austrian like you, Your Majesty, and love my

country as you do . . ." The text bitingly criticized Bismarck and the manifest ambitions of the Prussian-German Empire, warned Franz Joseph against trusting the Germans, and advocated for Austria-Hungary an alliance with Paris instead of with Berlin and Rome. At one point the document emotionally reminded Franz Joseph that an earlier, great Habsburg ruler, Maria Theresa, "fought Prussia for seven years."

Diplomats in Paris and Vienna filed reports to their governments on the *Open Letter* affair, but official Austria-Hungary pursued its policy of close cooperation with Germany and Italy in their Triple Alliance. In October 1888 Emperor Wilhelm II of Germany made a pompous state visit to Vienna. Franz Joseph, who personally wasn't wild about his younger colleague, acted the perfect host, and the crown prince, despite his barely masked dislike for Wilhelm, had to attend all the official functions.

Rudolf's political and family frustrations may be blamed to a great extent for his profligacy. Genetic factors also burdened his personality. His mother, Elisabeth (the cousin of his father), was an eccentric, as were other members of her family, the Wittelsbachs. Her once-brilliant cousin, King Ludwig II of Bavaria, had descended into insanity and in 1886 drowned himself in Lake Starnberg, taking his doctor with him into death. Franz Joseph too had Wittelsbach blood from his mother, Sophie of Bavaria. In earlier generations the House of Habsburg-Lorraine had had its own mental cases, like the weak-minded Emperor Ferdinand, who nominally reigned from 1835 to 1848.

Before and after Rudolf's marriage he had one affair after another, and some simultaneously. His conduct was considered neither scandalous nor decadent. In the climate of hedonism in fin-de-siècle Vienna, contrasting with the ostensible moral codes of the Victorian era, young noblemen, army officers with some money, and scions of wealthy upper-middle-class families were expected to have their flings before settling down. They would briefly woo and rapidly conquer some seamstress or shop assistant from the suburbs, who would be happy to accept a pair of golden earrings or enjoy a champagne supper in exchange for her favors without expecting more than a little affection during a passing, pleasant relationship. Arthur Schnitzler was to portray that type of Viennese "sweet girl" in his plays and novels. The glamorous, charming crown prince, of course, had not only his "sweet girls," like Mitzi Caspar, but could also choose from among a bevy of aristocratic ladies.

Rudolf drank a lot, preferably French champagne and cognac, although he didn't disdain the Vienna Woods wines either. There is some evidence that he had begun using morphine as a sedative. But, at least by the standards of his time, he could not be described as either an alcoholic or a drug addict.

Ambitious Baroness

The young woman who was to die with the crown prince, Marie Alexandrine ("Mary") Baroness Vetsera, was by no

means the quintessential "sweet girl." She belonged to a wealthy family, had a highly ambitious mother and internationally known sportsmen uncles, and was herself a fashion plate and something of a snob. She lived with her mother, the widow of an undistinguished diplomat, and her sister Hanna in Vienna's elegant Salesianergasse near the Belvedere Palace. The three were regularly seen in their boxes at the Court Opera and the Court Theater, in the high-life enclosure of the Prater horse-racing course, and at smart receptions. The Vetseras also entertained in their own plush home. Still a teenager, Mary Vetsera had become a darling of the Vienna society reporters and often saw her name in the newspapers, along with descriptions of what she wore to various important parties.

Mary's mother, Baroness Helene Vetsera, was a born Baltazzi, belonging to a Levantine family that had made a lot of money through financial deals with the government and with railroad companies. Mary's uncles, the four Baltazzi brothers, owned racehorses in Vienna and London, hobnobbed with British peers, and were members of Vienna's exclusive Jockey Club. They and the Vetseras were part of what caste-conscious Viennese called the Second Society. If the First Society was the imperial house and the high nobility admitted at court, the Second comprised aristocrats of less exalted lineage, high officials, and wealthy bourgeois. Some parvenus who recently had made the Second Society were forever maneuvering and scheming for recognition and acceptance also by the First, most of the time without success. Mary's mother was one of these. When the emperor's son was barely twenty years old, Baroness

Helene Vetsera had propelled herself into his presence on various occasions, causing his entourage to mutter that the pushy Vetsera woman was making a play for Rudolf.

Mary herself had been idolizing the slim, handsome crown prince since her adolescence. Most Viennese girls of her age did, yet the Vetsera sisters had an advantage over almost all of them because they were able to glimpse Rudolf at some theater premiere or charity affair and were maybe even allowed to curtsy to him in a reception line.

The crown prince, on the other hand, read enough press reports and heard enough society chitchat to know who the Baltazzis and the Vetseras were. Rudolf and Mary were brought together in October 1888 by a woman who merrily shuttled between the First and Second societies, Countess Marie Larisch. She was a niece of Empress Elisabeth on her father's side and therefore had access to the imperial palace, if not to court. Her mother had been an actress, and she herself had married a count. Countess Larisch may also have acted as a go-between for the crown prince and prospective partners in earlier erotic adventures. High-class procurers were known to have furnished fresh talent to Rudolf all the time.

Cabman Bratfisch was in on the intrigue with the "little Vetsera" from the beginning. Everyone always referred to her as "little" Vetsera to distinguish her from her mother, the "big" Vetsera. At some secluded spot, such as in Vienna's vast Prater Park, two closed carriages would draw up, one next to the other, and Mary would slip out of hers and into Bratfisch's. The lovers met most of the time in the Prater, but on at least

a couple of occasions the girl was smuggled into the crown prince's quarters in the imperial palace with the complicity of Bratfisch and trusted footmen. Throughout the affair Rudolf kept visiting Mitzi Caspar too at her apartment near the teeming Naschmarkt outdoor market, and he was seeing other women, probably also at Mayerling. The police who shadowed the crown prince for his own protection and to keep the government and the emperor informed knew about his frenetic sex life.

Foreign diplomats in Vienna were also more or less accurately informed of the crown prince's escapades, and so was the apostolic nuncio, the Pope's representative in the Austrian capital. Rudolf, as a liberal, a notorious libertine, and a suspected freethinker, was anathema to the Roman Catholic hierarchy, and the apostolic nuncio was aware of this. It therefore must have come as a big surprise to Pope Leo XIII to receive a letter from the anticlerical crown prince of Austria-Hungary in which he asked for a church annulment of his marriage to Stephanie. Maybe Rudolf also complained in the message about being politically sidetracked. The exact text of the letter is still unknown, as is its date; it was almost certainly written before Rudolf had met Mary Vetsera.

Nor is there any evidence that the Pope ever replied directly to Rudolf, though Leo XIII did send the crown prince's secret message—or a copy of it—to Emperor Franz Joseph. The letter episode was later thought to have been the main reason why the emperor had brusquely and ostentatiously turned away from his son as the crown prince was about to

kiss his hand during an official function. Rudolf always used to kiss his parents' hands in public appearances. The startling show of the emperor's displeasure, noted by courtiers and diplomats, occurred on January 26, 1889. Two days later, after another night with Mitzi Caspar at her home, Rudolf left for Mayerling.

An Aborted Hunt

He had invited friends to a hunting party in the Vienna Woods on January 29. In the afternoon of Monday, January 28, he would find "a few hours' leisure" at Mayerling for working on an overdue essay regarding the royal residence of Gödöllö near Budapest for *The Austrian-Hungarian Monarchy in Word and Picture*, or so he had informed one of the other editors of the encyclopedia. Rudolf had also a secret agenda: a tryst with Mary Vetsera at his forest retreat.

On the morning of January 28 Countess Larisch called at the Vetsera home to take Mary out for what they told her mother would be some errands and shopping in the city center. By then Baroness Helene Vetsera must have had at least an inkling of her daughter's involvement with the crown prince, but she feigned ignorance. The previously rehearsed comedy of Mary's slipping from a hired cab into a side wing of the imperial palace near the Court Opera to be taken over there by Bratfisch was once more enacted. When Bratfisch and the little baroness reached the Vienna Woods at a place south of

the Lainz Game Park known as Roter Stadl (Red Barn), the crown prince, who had arrived in another carriage, joined Mary. Proceeding toward Mayerling, Bratfisch's horses got stuck in snowdrifts, and Rudolf jumped out of the carriage to help get it moving again. The crown prince and Mary spent the night in Mayerling.

The next morning, January 29, two guests in the proposed hunting party arrived in Mayerling from Vienna. They were Prince Philipp of Coburg, the crown prince's brother-in-law, and Count Josef ("Josl") Hoyos-Sprinzenstein, who for ten years had been Rudolf's hunting companion. While Mary was invisible, the two had a late breakfast with the crown prince, who told them to go ahead with the shoot—for which two dozen beaters had been hired—although he himself would not take part in it because of a head cold. There were probably also other participants in the hunting party, but if so, their identities remain unknown.

Early in the afternoon the Prince of Coburg returned to the crown prince's mansion from a not-too-successful shoot to get ready to leave for Vienna, because the emperor had asked him to a family dinner. The affair, at the Hofburg, was to celebrate the engagement of Franz Joseph's daughter Marie Valerie to a remote cousin, Archduke Franz Salvator of the Tuscany branch of the Habsburgs. Rudolf too was supposed to attend, but he told his brother-in-law to make his excuses because he didn't feel too well. The crown prince also sent a telegram to his wife, Stephanie, asking her to apologize on his behalf to the emperor for his absence from the dinner. Cable

traffic from and to Rudolf was relayed via the post office of the nearby village of Alland.

Count Hoyos, and maybe other visitors too, were to stay overnight at Mayerling. The crown prince's guests were usually put up in the former residence of Count Leini in the lower part of the estate. Hoyos, and possibly other persons, had an early dinner with the crown prince and retired soon afterward to their quarters to rest up for another shoot on the following morning. Mary had been kept in hiding in the crown prince's apartment, but Bratfisch, who slept in the servants' quarters, of course knew of her presence, as did at least one or another of the Mayerling staff.

Mary's disappearance in Vienna the day before had plunged the Vetsera-Baltazzi family into terror. Countess Larisch, the procuress, had told the girl's mother she had "lost" Mary in the bustling city center. The next morning, while the hunting party near Mayerling was in full swing, Baroness Helene Vetsera appeared at Vienna police headquarters, accompanied by one of her brothers, Alexander Baltazzi, and asked the police chief, Baron Franz von Krauss, to order a search for her vanished daughter. The crown prince and Mayerling were mentioned. The police chief, unsurprisingly, appeared reluctant to interfere in a matter that might involve the imperial family, who were considered above the law. He suggested Mr. Baltazzi personally might go to Mayerling to see "whether his suspicions are justified," according to a memorandum that Baron Krauss himself wrote, and which became public sixty-six years later. It is not known whether Baltazzi or one of his brothers followed

the advice, but there have always been rumors that at least one of the Baltazzis turned up in Mayerling on January 29.

Any serious reconstruction of what happened during the night of January 29 to 30 in Mayerling must take into account a long memorandum that Hoyos wrote immediately after the deaths of the crown prince and Mary. He later turned over the document to the official Archives of the Imperial House and the State (Haus-Hof und Staatsarchiv) in the historic building on Vienna's Ballhausplatz that is now the seat of the government of the Austrian Republic. Several reliable sources concur that Emperor Franz Joseph personally requested Hoyos to swear never to divulge anything of what he knew about the Mayerling tragedy. The count kept his pledge. The Hoyos memorandum was sealed, and it was published four decades later, long after the fall of the House of Habsburg.

According to his memorandum, Josl Hoyos was awakened the morning of January 30 with a message from the crown prince's valet, Johann Loschek, reporting he was having trouble waking Rudolf. The crown prince, the message said, had been up earlier in the morning and had ordered his valet to call him again at seven-thirty, after which time, softly whistling, he had gone back into his bedroom. Hoyos hurried from his quarters up to the crown prince's residence and knocked and eventually hammered with his fist at the door of the latter's bedroom. As this produced no effect, he asked Loschek to break down the door. Only then did the valet inform Hoyos that the crown prince wasn't alone, being with young Baroness Vetsera. "This communication understandably caused me the greatest consternation," Hoyos wrote.

It was then that the Prince of Coburg returned from Vienna, where he had attended the Habsburg family dinner the night before; he was supposed to take part in the scheduled shoot. Hoyos informed him of the delicate situation, and both men decided to assume the responsibility for having the bedroom door forced open.

Bedroom Mystery

The valet fetched a wood-chopping axe and in the presence of the two aristocrats smashed a door panel. Loschek looked into the bedroom and reported that the crown prince and Baroness Vetsera were "lying lifeless on the bed." Hoyos and the Prince of Coburg discussed whether to call for a physician, "but this, under the circumstances when all life had departed, was not advisable." The two guests told the valet to enter the room to make sure the couple inside were actually dead. Loschek, reaching through the hole, turned the key with which the door had been closed from inside, opened the door, and stepped in. After a few moments he emerged again, reporting that there was no trace of life in the two and that the crown prince's body was prone over the edge of the bed, a large pool of blood in front of it, and "that death apparently had been caused by cyanide, since it frequently causes such hemorrhages." Death through a firearm "was only later ascertained," the document adds. Had nobody heard any gunshots?

It is extraordinary that, if the Hoyos memorandum is to be believed, an old friend of the crown prince's and Rudolf's

brother-in-law should have relied on the observations, even a diagnosis, by a valet whose official position in Rudolf's apartment in the imperial palace in Vienna was that of a doorkeeper. Why didn't the two noblemen themselves enter the bedroom? Why didn't they summon a doctor at once?

As the Prince of Coburg felt it was beyond his strength to convey the terrible news to the emperor, Count Hoyos agreed to do this. He raced in Bratfisch's cab to Baden railroad station and prevailed upon the stationmaster to stop the Trieste-Vienna express for him, as it was due to pass Baden at 9:18 A.M. Hoyos arrived at the imperial palace in Vienna shortly after 10:00 A.M., entered the apartments of Empress Elisabeth, who for once happened to be present in Vienna, and broke to her the news of her son's death.

12.

JOB 14:2

❀

It was Elisabeth who informed Emperor Franz Joseph of the discovery at Mayerling and not, as many accounts of that convulsed morning in the imperial palace maintain, the sovereign's lady friend Katherine Schratt. All sources agree, however, that Mrs. Schratt, an actress of the Court Theater, was in the palace that morning, and that she tried to console the emperor and his wife. Mrs. Schratt, then thirty-three years old, had been close to the emperor since the early 1880s. Whether their relationship was or wasn't platonic has intrigued the Viennese ever since. The pretty, pert actress, a native of Baden, provided for Franz Joseph the only home life he knew since Empress Elisabeth had virtually deserted him and become transient.

The emperor had given Mrs. Schratt a villa across the street from the park of Schönbrunn Palace. The arrangement enabled him to slip out of the imperial summer residence to

have a cozy breakfast with his friend and listen to her gossip about theatrical matters and personages, which he enjoyed. The comedienne of the august Burgtheater, however, was discreet, never disclosing anything the emperor had said to her, and rarely throwing her weight around as his confidante, though all Vienna knew of her offstage role. Elisabeth favored her husband's liaison because it let her off the hook. To facilitate meetings between Franz Joseph and Mrs. Schratt in winter when the emperor resided in the Hofburg Palace at the city center, the empress had officially appointed the actress as her reader. It was in this capacity that Mrs. Schratt called at the palace on January 30, 1889—ostensibly to recite poetry or read selected prose to the empress, actually to breakfast with Franz Joseph and amuse him with her anecdotes of Court Theater intrigues and the peccadilloes of society figures.

Count Hoyos's report of the crown prince's death by poison was the first version the empress and Franz Joseph heard. The emperor sent his personal physician, Dr. Hermann Widerhofer, to Mayerling together with various officials to ascertain what had actually happened and to have his son's body transferred to Vienna. A special railroad train with Rudolf's remains arrived in Vienna from Baden late on January 30. Only then did the emperor learn that his son had died of a gunshot wound.

The newspapers in Vienna and throughout the Austrian-Hungarian monarchy from the Swiss to the Romanian frontiers, from the Adriatic Sea to Cracow, appeared on Thursday, January 31, with black-bordered front pages, announcing that the

crown prince had died suddenly at Mayerling. Most of the dailies attributed his demise to a heart attack; only a few spoke of a hunting accident. Two days later the official *Wiener Zeitung* printed an authorized statement on a postmortem that three clinical experts—Dr. Widerhofer and two professors of Vienna University's medical school—had carried out in the imperial palace on January 31.

The three experts declared that the crown prince had "above all" died from a fracture of his skull and from lesions of the anterior part of his brain, caused by a gunshot fired against his right temple from a minimal distance. The statement noted that the projectile had exited from the skull and could not be found and observed that "there is no doubt that His Imperial and Royal Highness shot Himself, and that death occurred at once." The last paragraph of the statement cited pathological findings from the examination of Rudolf's cranium "that in accordance with experience are linked with abnormal psychic conditions, and therefore justify the assumption that the [suicidal] action took place in a state of mental confusion."

The postmortem report left many circumstances unclear. The word *zunächst* ("above all") at its beginning appeared enigmatic to experts and nonexperts alike, and the document's concluding part alleging a psychic disorder was generally understood as an attempt at placating public opinion and above all the Roman Catholic Church, which would not have countenanced a religious funeral for a sane and lucid suicide.

Neither the postmortem report nor any other official communication contained a word to the effect that the crown

prince had not died alone, that he might have killed another person before shooting himself and therefore was a murderer. It was as if Baroness Mary Vetsera had never lived. Until the collapse of Austria-Hungary in 1918 her name could not legally be printed in the empire.

But all Vienna knew. Insistent rumors in the capital had immediately linked the "little Vetsera" to the crown prince's death. The Vienna correspondents of foreign newspapers pieced together information from diplomats and society figures as well as other local gossip, enabling them to come up soon with detailed accounts of the events in Mayerling and with infinite speculation. The police banned those foreign publications with the more gruesome stories, and censorship clamped down heavily on the domestic press, but many facts of the affair became known within weeks. For the world at large, Mayerling provided a top-notch thrill, and to Victorians it was a deliciously shocking proof of Viennese decadence.

Macabre Comedy

Very few people, however, knew precisely what had happened to Mary's body. There was no regular postmortem for her. Mary's uncles Alexander Baltazzi and Count Georg Stockau were summoned to Mayerling on January 31 to identify the corpse in the presence of one of the imperial physicians, Dr. Franz Auchenthaler, and an official of the imperial court. A statement signed by them, and for many years afterward kept secret, declared that on January 30, 1889, "a female corpse was

found in the municipal area of Mayerling," that Dr. Auchen-thaler had "without any doubt" established suicide by a firearm as the cause of death, and that in conformity with a request by the representative of the family, Count Stockau, "the corpse is to be removed."

The removal of the cadaver of a young woman who by then had presumably been dead for thirty-six or more hours and, according to Dr. Auchenthaler's findings, showed "many livid spots," was a macabre comedy. Mary's body was dressed, complete with hat, veil, and fur, after which the two uncles took it between them and hauled it to a carriage. The weather had changed, and rains had followed the earlier snowfall, mak-ing the roads slippery. Late at night the carriage with Mary's body, propped up and held by her uncles on either side, reached the cemetery of Heiligenkreuz. At dawn on February 1, 1889, the little baroness was buried close to the cemetery wall in a grave that was long to remain unmarked.

Eventually the casket was transferred to a tomb in the Heiligenkreuz cemetery. The headstone was a chunk of Vienna Woods rock surmounted by a stone cross. A plaque read: "Mary Baroness von Vetsera, born March 19, 1871, died Janu-ary 30, 1889. Man cometh forth like a flower and is cut down. Job 14:2." (The German translation of the biblical passage uses the noun *Mensch*, meaning "human being," regardless of whether male or female.) The existence and location of Mary's tomb soon became widely known through word of mouth, and visitors, even some from foreign countries, arrived at Heiligenkreuz asking for directions to the cemetery.

At the end of World War II a group of Soviet soldiers

who had their army headquarters in nearby Baden used the cemetery chapel as a field kitchen. They dug up Mary Vetsera's wooden coffin and with a garden hoe pried it open, apparently looking for jewelry and other loot. In 1959 the remains of the little baroness were placed in a new metal casket and reburied. According to eyewitnesses, the dress in which she was buried was still recognizable and her skull was intact except for a lesion presumably caused by the hoe in 1945. A pathology professor of Vienna University suggested in 1988 that Mary's remains should again be disinterred for a thorough postmortem, but Fernande Vetsera, a grandniece of the dead baroness, successfully blocked such action.

Such an examination was nevertheless carried out 103 years after Mary Vetsera's death because of another bizarre twist in her story. In December 1992 the mass-circulation Vienna tabloid *Kronen-Zeitung* reported that the coffin with the remains of the little baroness had been stolen from her Heiligenkreuz tomb. The police had the tomb opened in the presence of the Abbot of Heiligenkreuz, the Right Reverend Gerhard Hradil, and it was indeed found empty. An investigation quickly established that a furniture dealer from Upper Austria with the unlikely name Helmut Flatzelsteiner (which in German sounds comical if not slightly indecent) and two accomplices had opened the tomb one night in July 1991 and carried away the metal casket with Mary Vetsera's remains in a truck. The casket with its contents was found in the storeroom of a forwarding firm on Vienna's southern outskirts. The grave robber had apparently hoped to make money by selling the coffin and

skeleton to a collector or an eccentric, but all he was able to sell was the story of the empty Heiligenkreuz tomb; he obtained a formal contract with the *Kronen-Zeitung*. The coffin and its contents were transferred to Vienna's Institute of Forensic Medicine, which ascertained that the skeleton was in fact Mary Vetsera's and analyzed her remains prior to reburial.

Immediately after the deaths of the crown prince and Mary Vetsera became known in Vienna, Mary's mother, Baroness Helene Vetsera, was ordered by the government to stay away from the capital for some time. Months later she wrote a long *Memorial* about the drama of Mayerling, which was circulated privately and was at once seized by the police. It was published in Berlin in 1900 but remained banned in Austria-Hungary until 1918. The statement by Mary's mother clearly aimed at proving that all the Vetseras and Baltazzis were respectable and had acted honorably. After Helene Vetsera's death in 1925 her relatives, allegedly in accordance with her last wishes, burned all papers regarding Mary and Mayerling. Among the documents thus destroyed were presumably farewell letters by Mary that Helene Vetsera had quoted in her *Memorial*.

According to various trustworthy sources the Baltazzi brothers were requested to pledge to Emperor Franz Joseph by word of honor that they would never reveal what they knew about the events at Mayerling. The social position of the rich Baltazzis at any rate did not suffer following the Mayerling affair, and their prestige in horse-racing circles and in the Jockey Club remained high.

Four days after Mary's furtive burial at Heiligenkreuz cem-

etery, Crown Prince Rudolf was laid to rest next to the sar-
cophagi of many other Habsburgs in the imperial vaults below
the Capuchin Church in Vienna's center. Tens of thousands of
Viennese had filed past the dead crown prince in the court
chapel of the imperial palace where he had been lying in state,
and they saw that the upper part of his head was bandaged.
Rudolf's funeral took place with all the pageantry that the
Austrian-Hungarian Monarchy and its army could muster. The
German Emperor and other foreign royalty and dignitaries,
however, were asked not to attend because of the Habsburg
family's deep sorrow. The Roman Catholic Church concurred
in the somber obsequies; it consented to religious rites because
the ecclesiastical authorities, under strong pressure from the
emperor, had accepted the official version that the crown
prince had been psychically disturbed when he died by his
own hand.

Vanished Documents

One of the many legends surrounding the Mayerling tragedy
is that Franz Joseph, in a top-secret two-thousand-word tele-
gram, gave Pope Leo XIII a personal account of what had
happened. The only telegram from Austria-Hungary's ruler
that the Vatican's Secret Archives have so far produced consists
of fifty-seven words. In it Franz Joseph informed the pontiff
in Italian of the "sudden death" of his son, declared to accept
God's will "without a murmur," and requested the papal

blessing for himself and the imperial family. Leo XIII replied with a formal telegram of condolences and his apostolic benediction.

It is possible that Franz Joseph furnished the official version of his son's death and some explanations to the pope in a personal letter, delivered by special courier. A "secret telegram" at that time would have been a contradiction in terms because Austrian and Italian postal employees would have had to transmit and receive it, and even if it had been in cipher it would have been decoded eventually. The Vatican at any rate did not object to a religious funeral for the presumed suicide, but some prelates and priests in various parts of the Austrian-Hungarian Empire registered their protests by refusing to have church bells tolled in sign of mourning. Rudolf, after all, hadn't been a friend of the Roman Catholic hierarchy.

Some time after the authorities had concluded their confidential inquiry into the two deaths, Emperor Franz Joseph handed a file containing secret documents related to the Mayerling case to his prime minister, Count Eduard Taaffe, commanding that the papers never become public. Ordinarily such a dossier should have been deposited with the Ministry of the Imperial House, but Franz Joseph trusted his old friend Taaffe more than he did his own bureaucrats. Taaffe, who in addition to his Austrian titles was also a member of the Irish peerage as a Baron of Ballymote, died in Bohemia in 1895. His heirs reportedly destroyed his papers, but it is not totally impossible that the Mayerling file, once safeguarded by the former prime minister, may still surface some day.

The disappearance of the Taaffe dossier and of other important documents has always been a cause of frustration to historians. So were the reticent postmortem reports and the many inconsistencies and contradictions in the official version of what had happened at Mayerling in those ominous days and nights of January 1889. Speculation and purported revelations about the "Mayerling mystery" became something of a cottage industry after the fall of the Habsburgs in 1918, and Hollywood got interested.

More than a hundred years after the Mayerling drama the predominant theory is still that the crown prince and Baroness Vetsera died in a suicide pact, and that Rudolf first shot Mary and then himself. The statement signed by a court doctor and two of the young baroness's uncles to the effect that she had committed suicide is generally discounted as an attempt at clearing the crown prince from the crime of murder (if only on demand by the victim).

The suicide-pact hypothesis is supported above all by the farewell letters Rudolf and Mary were said to have left. Most of the presumed suicide notes, unfortunately, are no longer available in their originals, and it is not clear where all of them were found—at Mayerling, in the crown prince's quarters in the imperial palace in Vienna, or elsewhere.

Rudolf's handwritten suicide note to his wife, Stephanie, now kept in the Austrian National Library in Vienna, is doubtless authentic. "Dear Stephanie! You are liberated of my presence and vexation," it begins. The letter writer asked Stephanie to be kind to their little daughter, "the only thing that remains

of me," and to convey Rudolf's last greetings to relatives and friends. The conclusion: "I am calmly seeking death, which alone can save my good name. Most fondly embracing you, lovingly, Rudolf."

The letter is undated, which has induced some researchers to theorize it may have been written in advance by the crown prince, who had long been toying with the idea of suicide, and kept in his desk for possible use at some future time. During his last months Rudolf had had a human skull on his writing desk in the imperial palace.

Also undated is a note in Hungarian in which the crown prince gave instructions to the executor of his will, László de Szögyény, of which photographs are available. Among other things, Rudolf asked Szögyény, a high official, to open his desk in the imperial palace without anybody else present. It seems that Rudolf's Hungarian aide was unable to comply because the emperor ordered other bureaucrats to witness or carry out the search of his son's desk.

Rudolf is said to have left a farewell note to his old girlfriend Mitzi Caspar as well, but no original of this and of other supposed letters could be traced. The same is true of the notes that Mary Vetsera was reported to have left. Critics of the suicide-pact theory have dismissed most of the presumed posthumous letters as fabrications.

Scholars who believe that the crown prince killed Baroness Vetsera at her request and then himself point to the morbid tastes of the times and the proclivities of the couple. Intellectual Vienna in the fin-de-siècle years was fascinated by erotic pas-

sion and death, and the theme of the romantic doom of two lovers had been highly fashionable ever since Wagner's *Tristan und Isolde* had reached, somewhat belatedly, the Vienna Court Opera. Rudolf surely suffered from depression, and he was deeply unhappy over his difficult relations with his father and his wife. The excesses in his personal life must have impaired his physical and mental health. There is evidence that he had mentioned suicide more than once as a solution to his problems and that he had asked various persons, including Mitzi Caspar, either in jest or in seriousness whether they would be willing to die with him. Mitzi, for one, would not.

Mary Vetsera, on the other hand, was ambitious and high-strung, maybe romantically overexcited by the prospect of seeking death together with the emperor's only son and heir, thereby becoming the protagonist of a world sensation. After weeks of aesthetic flirtation with the thought of a double suicide in a passionate embrace, the "little Vetsera," strong-willed as she was, may eventually have pressed her neurotic lover into ending it all. Serious historians over the last few decades have suggested that the possibility of Mary Vetsera's having been pregnant—or of her having pretended to be pregnant—should have been more thoroughly explored.

Sinister Theories

Critics of the suicide-pact version cite the many commitments assumed by the crown prince during the last few days of his

life as evidence that he didn't plan to kill himself just then. Among other arrangements for scheduled meetings, on January 29, 1889, Rudolf invited the Hungarian Count Pista Károlyi to visit him in Vienna on January 31, to discuss with him the status of a national defense bill then pending in the Budapest Parliament. Count Károlyi confirmed the appointment by telegram and left at once for Vienna, only to learn en route of the crown prince's death.

As the diplomatic archives of the major powers were opened over the years it appeared that foreign ambassadors accredited at the imperial court in Vienna had from the beginning rejected the official version of the Mayerling events in their secret reports to their home governments. Although the Vatican has not released the dispatches that the apostolic nuncio, Msgr. Luigi Galimberti, sent to the pope, he too is thought to have believed that Rudolf was slain. The papal envoy had excellent sources in the Austrian-Hungarian aristocracy and, of course, among the church hierarchy and clergy.

Who might have assassinated the crown prince? Conspiracy theorists have been reveling for a century in scenarios of some plot to eliminate the liberal, anti-German, pro-French heir apparent to the thrones of Austria-Hungary. A commando of Austrian policemen—no, of Hungarian army officers—no, of uniformed killers hired by a foreign power (Germany?) had raided the Mayerling estate and killed Rudolf and maybe also Baroness Vetsera, so the stories went.

The conspiracy theories received startling support in 1983 when the last empress of Austria-Hungary, Zita, declared in a

newspaper interview that Rudolf and Mary had been murdered. The former empress, who was born a princess of the Bourbon-Parma family, was then eighty-eight years old and living in a convent in Switzerland. She never denied the statements attributed to her; in the interview she was quoted as asserting she had heard of the double murder in Mayerling from various close relatives since her childhood. Zita died in 1989.

In 1992 her son, Archduke Otto, declared instead that he was convinced Crown Prince Rudolf had committed suicide. Otto was chief of the House of Habsburg then and, theoretically, a potential pretender to the vanished thrones of Vienna and Budapest since the death of his father, Karl, the last emperor of Austria-Hungary, in exile on the Portuguese island of Madeira in 1922. Discussing the Mayerling case on Austrian television after the discovery of the Heiligenkreuz grave robbery, Archduke Otto, eighty years old at the time, said he didn't think the mysteries of the deaths of Rudolf and Mary Vetsera would ever be cleared up.

According to reports that at the time were unverifiable, Archduke Otto had in his safekeeping a box containing Crown Prince Rudolf's army revolver, suicide notes by him and maybe also by Mary Vetsera, and locks of the hair of both lovers. Otto was supposed to have received the box from a family of Habsburg loyalists around the middle of the 1980s. The whereabouts of the weapon or weapons that killed Rudolf and Mary was never disclosed.

A hypothesis that will not be put to rest assumed that Rudolf died in a fight, or maybe a drunken brawl, involving Mary, and that she too was killed either accidentally or to get

rid of a witness. One version: One of the four Baltazzi brothers, alone or with another person, may have followed the police chief's advice, gone to Mayerling the day after Mary disappeared in Vienna, and penetrated the crown prince's quarters. In a heated confrontation Rudolf may have been slain with a champagne bottle or shot to death. Then there is the even more unlikely forester story, which circulated widely in Vienna and the Vienna Woods towns after the Mayerling drama: a jealous gamekeeper whose girlfriend or wife had been seduced by the crown prince burst into the latter's bedroom and killed his rival either with a shotgun or a champagne bottle.

Even today a postmortem on Rudolf's skeleton, especially the condition of his skull, might furnish clues as to how he died. No Austrian authority, however, has so far considered touching the metal sarcophagus in the imperial vaults where Rudolf was laid to rest; the sarcophagus of his father, Franz Joseph, who died in 1916, is nearby.

Unless new, revealing documents—maybe the vanished Taaffe file—come to light somewhere, Mayerling will remain one of history's enigmas. The tragedy in the heart of the Vienna Woods was an ominous prelude to the decline and fall of the Habsburg dynasty. Nine years later Rudolf's mother, Empress Elisabeth, was stabbed to death in an irrational attack by an Italian anarchist in Geneva. Rudolf's successor as heir apparent to the Habsburg thrones, Archduke Franz Ferdinand, was assassinated together with his wife by Serbian nationalists in Sarajevo in 1914, the event that marked the end of what Austrian writer Stefan Zweig would nostalgically call the World of Yesterday.

13.

ON THE
WINE ROAD

❧

For a trip to the towns, villages, hills, vineyards, and forests along the Wine Road on the eastern edge of the Vienna Woods I rented a car and asked an old friend to accompany me. Robert was in fact my oldest friend. We went to high school in Vienna's Albertgasse together (though we were in different sections), attended Vienna University at the same period, and stayed in touch ever since. My friend specialized in languages and Austrian literature, and at a time of record unemployment was fortunate to land an administrative airline job. After Austria's annexation by the Nazis he left for Amsterdam, where he had been a foster child during the famine in Vienna after World War I. Unable to find employment in the Netherlands, he returned to Vienna and the airline job. During World War II he was drafted into the Nazi Luftwaffe, was captured with his entire ground outfit when the Allied troops advanced in Germany, and ended up in a prisoner-of-war camp in Pennsyl-

vania. Because of his proven anti-Nazi background he received favored treatment and was soon repatriated. In Vienna he was appointed to a medium-level position in a public agency, with which he stayed until retirement.

When I saw Robert again after an interval of several years of correspondence, I found he had become something of a Vienna character. He despised television and had no set at home, although his wife would have liked one. For three hours every weekday morning he went to the National Library with the regularity of an imperial-and-royal civil servant and immersed himself in books. He had a long list of volumes he intended to read or to consult. After lunch and a siesta at home he would stroll around the neighborhood with his wife and afterward spend a couple of hours at a corner coffeehouse to read all the newspapers and magazines that the management kept at the disposal of patrons.

Dinner at home was followed by classical music from the radio or the record player and more reading, although Robert's wife said it wasn't good for his weak eyes. My friend had taken up ancient Greek again, and he told me with pride of his progress in enjoying Plato and Aristophanes in the original. Between them, he and his wife spoke or read seven languages.

Biedermeier Graffiti

During weekends the couple walked a lot in the parts of the Vienna Woods closest to the capital. Robert looked everywhere

for faded graffiti reading "J. Kyselak." It was one of his hobbies, preparatory to a possible book project. My friend was captivated by the Biedermeier eccentric Joseph Kyselak, who sought, and to some extent won, fame and possibly immortality of sorts by putting his name in conspicuous places.

Joseph Kyselak (1799–1831) was a file clerk at the court registry office in Vienna. After failing as a poet and actor he began attracting public attention by painting his name (with the aid of a template) on buildings, bridges, rocks, and other surfaces or scratching it into columns and the walls of ruins. He sought out hard-to-reach places and must have devoted most of his free time to disseminating his name, especially on the outskirts and in the environs of Vienna. In 1825 he undertook a walking tour of the Alpine regions of Austria and daubed "J. Kyselak" on Tyrolean precipices. He wrote *Sketches from a Journey on Foot* about his enterprise. The phrase "Kyselak was here" became proverbial, and long after his death it was still used in Vienna to deflate claims that something had been achieved for the first time.

Curiously, during World War II Allied soldiers left inscriptions, "Kilroy was here," on house walls and in other places. Few, if any, of the graffiti scrawlers were aware that they were following a Viennese Biedermeier precedent. The ubiquity of the mythical Kilroy, who shared three letters of his name with Kyselak, achieved inclusion in Bartlett's *Familiar Quotations* as "Army saying, World War II" under "Anonymous."

Kyselak, who described himself as an "autographist," was no innovator either. Otherwise obscure individuals have left

their signatures on monuments since remote antiquity, and sightseers, lovers, and children have cut their names into trees or scratched them into stone throughout time. The Biedermeier crackpot nevertheless astonished his contemporaries by the volume and daring of his graffiti production, which was also noted by the newspapers of his time.

My friend told me one of the many anecdotes that Kyselak's tireless off-duty activities generated. "It may be apocryphal," Robert said, "but it proves his reputation." When Emperor Franz was to inaugurate a new bridge across the Danube Canal in 1829, the police warned Kyselak not to try one of his stunts. On the day of the ceremony the emperor wanted to see the new structure from below, and he was rowed under the bridge in a boat. "J. Kyselak" in big letters greeted him from a girder. Next day the lowly file clerk was summoned to the emperor, and Franz in person administered a dressing-down. The autographist seemed contrite, but after he had left the emperor found "J. Kyselak" scribbled on one of the police reports on his desk.

Almost all of the hundreds of graffiti that Kyselak left during his short life had by now vanished, Robert said, but he had spotted some scratchings of the name in a few places on the approaches to the Vienna Woods. "Maybe we will find some other ones today," he suggested hopefully.

Our first stop was in the village of Rodaun, southeast of the Lainz Game Park, now a part of the Vienna municipal territory. We drove along the tracks of the No. 60 streetcar line across the suburb of Mauer with its parks and gussied-up

old village streets, past many pretentious new villas and fake ranch houses. It has become a very fashionable residential section with luxury cars in the driveways, meticulously tended flower gardens, and old trees. The slopes of the Vienna Woods on the west are close by.

We passed the Schwarzwald-Gasse, which caused me to reminisce at some length about Flora, who attended the Schwarzwald high school for girls and was my friend when I was a university student. Robert knew Flora well and joined us from time to time on our rambles in the Vienna Woods. Flora's school at Vienna's center and the suburban street we had just crossed were both named after Dr. Eugenie ("Genia") Schwarzwald, the institution's founder and virtual chief (although there was a different principal then). Flora was an Armenian from Teheran, Iran, and she had been sent by her parents to Vienna to get a central European education. She always spoke with enthusiasm about the "Frau Doktor."

Everybody called Genia Schwarzwald (1872–1940) "Frau Doktor." She was a philanthropist and a pioneer of women's education in Vienna. Born in Galicia in the far northeast of the Austrian-Hungarian Empire, Eugenie Nussbaum went to elementary school in Vienna, was trained at a teacher's college in what was then Czernowitz (later Cernauti in Romania and Chernovtsy in the Ukraine), and became one of the first women to win a degree at Zurich University. Back in Vienna, she married Hermann Schwarzwald, a high Austrian civil servant and sometime government member. She organized schools and adult-education classes and wrote for newspapers, and opened

her institutions and her home to artists and writers. The painter Oskar Kokoschka taught in her schools, Arnold Schönberg and other avant-garde musicians performed their compositions, and Elias Canetti, the future Nobel laureate, gave one of his first readings there. During the hungry years after World War I, Genia Schwarzwald fed the novelist Robert Musil and other notable Viennese in a kind of Vienna Woods soup kitchen for intellectuals at a property she and her husband had in the Hinterbrühl, the narrow valley near Mödling. "Frau Doktor" died in Zurich, where she had found refuge from the Nazis.

Celebrities at the Little Castle

The center of Rodaun, which we reached a few minutes after passing the Schwarzwald-Gasse, is a mixture of low, old village houses and modern residential buildings. We turned right and drove up the Ketzergasse to have a look at a "Little Castle" at No. 471. The poet and writer Hugo von Hofmannsthal, best known abroad as librettist of Richard Strauss, lived in the graceful Habsburg yellow two-story mansion for nearly three decades, until his death in 1929. Now privately owned, it isn't open to visitors; through the porte cochere in the high wall between the main residence and a lower service building, passersby glimpse the rising garden with the fruit trees of which Hofmannsthal was so proud. The Vienna Woods start with a forested slope right behind the garden.

A plaque says that the Schlössl (Little Castle) was erected

in the eighteenth century and was the home of Countess Fuchs. Actually, the building was commissioned by a Prince Trautsohn for his mistress; Countess Fuchs-Mollardt lived there later. The good countess was the governess and later the confidante of Empress Maria Theresa, and in her old age she was called out of retirement to help educate the empress's older daughters. When Countess Fuchs died in 1754, Maria Theresa's fourth daughter, Marie Antoinette—who would become queen of France and die on the guillotine—was not yet born. The empress was so fond of "die Fuchsin" (the Fuchs woman) that she had her buried in the imperial vaults: "Since in her lifetime she was always with us, why shouldn't she be with us also in death?" Thus Countess Fuchs rests together with 12 emperors, 16 empresses (including the most recent one, Zita), and 135 other members of the Houses of Habsburg and Habsburg-Lorraine; "die Fuchsin" is the only person buried below the Capuchin Church who didn't belong to the imperial family.

Hofmannsthal couldn't have afforded the Little Castle at the time when he moved in had he not married rich: his wife Gertrude ("Gerty"), née Schlesinger, was the daughter of a well-to-do Vienna banking executive. The poet himself came from a once-wealthy family, but there wasn't much money left. His great-grandfather, Isaak Löw Hofmann, had come to Vienna from Bohemia in the late eighteenth century, had promoted silkworm cultures in the eastern part of the empire, had adroitly engaged in the silk trade, and had been elevated to hereditary nobility by Emperor Ferdinand I in 1835. Grandfather von Hofmannsthal had married into the northern Italian

silk industry and converted to Roman Catholicism; the writer's highly cultured parents were a bank official and the daughter of a judge.

As a teenager Hugo von Hofmannsthal was a literary sensation. He crafted preciously worded, formally perfect poems that newspapers and magazines were glad to print, if only under the pseudonym Loris, because high school students were not permitted to be published at the time. When the chameleonic author Hermann Bahr, then a celebrity, wanted to meet the critic who had written a particularly perceptive review of one of his many works, he expected to see a man of the world, maybe a Parisian, in his fifties, and was stunned to find that Loris was a schoolboy who pleaded he couldn't stay long at the literary Café Griensteidl where they were having their encounter because he still had to do his homework.

At my high school we once produced the little verse play *Der Tor und der Tod* (The Fool and Death), which Hofmannsthal had written a year after his own high school graduation. I am not sure we grasped much of its rich imagery and lyricism. I remember, however, that I was pleased when the morality playlet's "fool," the aristocratic aesthete Claudio, impersonated by a fellow student I couldn't stand, was reproached by "death" for past wrongs: he had made his mother unhappy, abandoned his girlfriend, and failed to come to the support of a friend in trouble. I should have liked to do the part of "death," but since Hofmannsthal represented him as a musician, a boy who played the violin much better than I did was cast for the role; he had plenty of difficult verses to learn by heart.

Hofmannsthal was living in the Little Castle at Rodaun when Richard Strauss asked him for permission to use his dramatic poem *Elektra* (1903) for an opera. The author consented, and a long period of fruitful collaboration ensued. Hofmannsthal wrote much of his libretti for Richard Strauss's operas *Der Rosenkavalier, Ariadne auf Naxos,* and *Die Frau ohne Schatten* while in Rodaun. The composer was often a visitor at the Little Castle, as were Rainer Maria Rilke, Thomas Mann, Stefan Zweig, Franz Werfel, Arthur Schnitzler, and other writers and artists. For the benefit of first-time guests, Hofmannsthal would do his lord-of-the-manor number, showing off his terraced garden, the frescoed halls, the period furniture, and an eighteenth-century ceramic stove. Felix Salten, the novelist who wrote the Bambi stories and also went out to Rodaun occasionally, found a certain aristocratic aloofness in Hofmannsthal: "Only in letters did he become cordial."

The Rodaun mansion bordering on the Vienna Woods became the scene of tragedy in July 1929, a few months after our school performance of *The Fool and Death.* The author's only son, Franz, just back from a trip to Paris, shot himself in his room at the Little Castle, and Hofmannsthal suffered a fatal stroke the morning of the funeral. In accordance with his long-standing instructions he was buried at the Rodaun cemetery, clad in the coarse habit of the Third Order of Saint Francis.

I was fortunate to meet Hofmannsthal's daughter, Christiane, in New York in the early 1980s, I told my friend Robert. She was then eighty years old, alert, outgoing, and full of literary anecdotes. Writers and intellectuals from central Eu-

rope who were visiting the United States invariably called on her at her Greenwich Village home. Christiane von Hofmannsthal had married a German expert on Indian civilization, Heinrich Zimmer, had earned a master's degree in social work from Columbia University, and had served as a consultant to private welfare organizations. "I just had to tell her of our school production of *The Fool and Death*, although she must have heard a lot of similar and much better stories about her father's impact on Vienna and the Viennese," I said. "But she was kind enough to show real or feigned interest."

My friend and I reminisced about our school performance of the Hofmannsthal playlet, and we discussed how the one-time aesthete had in later life become something of a mystic, as we were strolling about the neighborhood that he had loved. We passed a modern residential building next to the Little Castle with a tablet stating that once the bathhouse of a sulfur spring and a chapel dedicated to Saint Anne had stood there. The village of Rodaun in fact lies on what geologists call the thermal line of the eastern Vienna Woods, a succession of hot springs stretching from the outskirts of the capital for nearly 15 miles (24 kilometers) southward. The old bathhouse became a spa hotel and restaurant in the nineteenth century, and the place won fame for its cuisine. The sulfur spring eventually dried out, but habitués kept flocking to Rodaun for the food and wines at what was then the Stelzer Restaurant. It was heavily damaged during World War II and was eventually razed to make room for the present residential complex, known as Stelzer Hof.

We walked up to the Rodaun parish church, sturdy as a

fortress on a hill above the village. A boarding school for girls with a large garden is nearby, and a chestnut forest covers a slope behind Church Square. Several hiking paths start from Rodaun. One leads in ninety minutes to Roter Stadl, the place where Crown Prince Rudolf and Mary Vetsera had their last rendezvous. Another popular hiking trail is the Liechtenstein Hochstrasse (High Road), laid out by the princes of Liechtenstein in the nineteenth century. The road, up and down the hills southwest of Rodaun, is closed to motor traffic; some inn, refuge, or restaurant is always just a short stroll distant. The Liechtenstein Road traverses the Fir Mountains, a national park nearly three times the size of the Lainz Game Park. The vast forests of umbrellalike black firs and the limestone cliffs and ravines give the hilly area a highly romantic and faintly Mediterranean character.

There are Teufelstein (Devil's Stone) hill, 1,755 feet (547 meters) high, and Höllenstein (Hell's Stone) ridge, 2,069 feet (645 meters), both with observation towers and mountain refuges. Hikers reach the Höllenstein in the heart of the Fir Mountains from Rodaun in about three hours. The descent by way of the Kreuzsattel (Cross Saddle) to the village of Sittendorf at the entrance to the Hinterbrühl gorge takes another hour. From Sittendorf there are bus connections to Mödling and Heiligenkreuz.

Turning instead from the Kreuzsattel northward, one arrives at the long, stretched-out village of Kaltenleutgeben. Many Viennese make trips to the place in winter for its ski runs and in the other seasons for its alpinism schools—mountain-climbing training sites on the steep northern slopes of the

Höllenstein ridge overlooking the village. During his visit to Austria, 1897–99, Mark Twain lived for a few months in a villa at Kaltenleutgeben and made fun of the Liesing-Kaltenleutgeben railroad branch line because of the record slowness of its trains. The route was discontinued in 1951 because there wasn't enough coal for the locomotives, and it was never reactivated. Today buses run to Kaltenleutgeben from the center of Vienna, from Rodaun, and from Liesing.

Mark Twain traveled to Vienna from Kaltenleutgeben by way of Liesing in September 1898 to witness the funeral of Empress Elisabeth of Austria-Hungary after her assassination in Geneva.

During his stay with his family at the Villa Paulhof in Kaltenleutgeben Mark Twain wrote much of an essay that was later published, under a pseudonym, as "What Is Man." Only after his death was his authorship revealed. The philosophical essay, a fictional dialogue between "Young Man" and "Old Man," contends that human beings are mechanisms whose behavior is determined by heredity, character, environment, and education. The American writer, who had been lionized during his sojourn in Vienna, bared a pessimistic vein in the Vienna Woods essay.

Massacres and Songs

Both my friend and I, together and separately, had often gone on hikes in the Fir Mountains. I still remember how it hurt

when I was skiing down the Gaisberg (Goat Mountain) south
of Kaltenleutgeben as a boy one Sunday afternoon and sprained
my ankle in a spill. This time we did no hiking but proceeded
in our car from Rodaun right across the administrative border
between the regions of Vienna and Lower Austria to the
picturesque town of Perchtoldsdorf. We didn't say *Perchtolds-
dorf*—the official name—but *Petersdorf*, the name the Viennese
have since time immemorial called the place, although you
won't find Petersdorf on any map or in any gazetteer. To
natives of Vienna Petersdorf / Perchtoldsdorf means above all
Heuriger—evenings spent in a cozy garden or tavern with
young wine and in merry or romantic company. I found the
town architecturally unchanged from how I had recalled it,
only spruced up and visibly prosperous. The *Heuriger* trade still
appears to bring in a lot of money.

Every picture postcard of Perchtoldsdorf shows its massive,
freestanding watchtower, the town's landmark. Built between
the end of the fifteenth century and the beginning of the
sixteenth, the square structure in late Gothic style carries a
bell loft above an open gallery, surmounted by a steep roof
and four corner turrets with small onion domes. The tower
faces the choir of the town's imposing Gothic parish church,
Saint Augustine's, which goes back to the thirteenth century.
Behind the church are the restored remains of a medieval
castle, now housing the Perchtoldsdorf Culture Center. Castle,
church, and watchtower, once linked by walls and surrounded
by a moat, formed a fortified complex into which the towns-
people withdrew in times of danger.

When the Turks besieged Vienna for the first time in 1529 and harassed the Vienna Woods towns, the people of Perchtoldsdorf were able to weather the storm in their stronghold. Not so during the second major invasion in 1683. Turkish soldiery burned down many houses in Perchtoldsdorf but promised to spare the lives of the townspeople, who had once again repaired to the church district, if its defenders surrendered and the town came up with a huge ransom. The conditions were met, but the Turks slaughtered nearly 500 men and dragged hundreds of women and children off into captivity. The parish church and the watchtower burned out.

A gruesome painting of the massacre on Friday, July 16, 1683, commissioned by the town fifteen years later, can be seen in the bay-windowed town hall. This attractive fifteenth-century building with twin gables is today the seat of an Osmanli Museum, with memorabilia of the Turkish calamities. Austria now prefers to call past wars with the Turks Ottoman or Osmanli episodes, to spare the feelings of the many thousands of Turks who live in the country today as "guest workers" and their Austrian-born offspring, and to curb animosity toward them.

Robert and I looked at the old burghers' houses around the elongated market square with its Plague Column and angels' statues (1713) and strolled toward the northwest of the old town. There, in a sixteenth-century house at 28 Brunnergasse, Hugo Wolf lived from 1888 to 1896. He often took walks on the Hochberg (High Mountain), a nearby hill looking down on Perchtoldsdorf.

Wolf, the greatest composer of lieder (art songs) since Schubert, was born in what was then a far corner of Styria, Windischgraz (now Slovenj Gradec in Slovenia), but from his fifteenth year he lived in Vienna or the Vienna Woods. His father, a tanner, had sent the gifted boy to the empire's capital to live with an aunt and study music at the Vienna Conservatory. At that institution young Wolf made friends with a fellow student, Gustav Mahler, a native of Moravia. Both were Wagner enthusiasts—Wolf to a frenzied degree—and both liked rambling in the Vienna Woods. Mahler would later write in a letter that during his student days he "assiduously visited the Vienna Woods." He also stayed close to Wolf when the latter was expelled from the conservatory after two years because of a prank he had played on a teacher. The two friends changed Vienna addresses more often than Beethoven had and roomed together at times. Wolf apparently contracted syphilis from a prostitute when he was eighteen, and the disease is believed to have triggered his mental derangement later.

In 1880 Wolf, at twenty, spent the spring and summer in a country house, the Marienhof, in the hamlet of Mayerling, as guest of the family of Vienna architect Viktor Preyss. The countryside appealed strongly to Wolf; it soothed his agitated temper and spurred his creativity. For a few days a lover, Valentine ("Vally") Franck, the twenty-four-year-old daughter of a French-Austrian scholar, came to the town of Alland, and the two had romantic meetings in the forests. Wolf also returned to Mayerling in 1882 after a stint as an opera conductor at the Salzburg Civic Theater, and again in later years.

He had meanwhile been befriended in Vienna by the family of Heinrich Köchert, the court jeweler whose wife, Melanie, became his secret mistress. The influential and wealthy jeweler got the young composer a job as music critic of the *Salonblatt*, a prestigious Vienna weekly, apparently paying for Wolf's salary out of his own pocket in a confidential arrangement. Melanie Köchert is credited with inspiring Wolf's most mature compositions. They had trysts in the Vienna Woods and in other provincial places; she would remain at his side, more and more openly, during the years of his mental illness until his death.

In Mayerling, Wolf got to know the Werner family of Vienna, who frequently visited his hosts. The Werners owned a summer house in Perchtoldsdorf and offered its use to the composer. Wolf, despite his unstable character, must have had plenty of charm and a knack for finding free lodging and generous patronage. He became fond of the old building in Perchtoldsdorf's Brunnergasse and spent long periods in it. My friend and I walked up a winding stair to what is now a Hugo Wolf Memorial Room; it is simply furnished as it was at the composer's time, complete with his old-fashioned coffee maker. Wolf wrote musical settings here for poems by Goethe and Eduard Mörike as well as much of his only opera, *Der Corregidor*.

Robert proved to have become an expert not only on Kyselak but also on Hugo Wolf, whose music he loved. He told me about the composer's last years: Between sojourns in Perchtoldsdorf Wolf lived in the home of his mistress and her jeweler husband in the posh Döbling section on Vienna's

northwestern outskirts, becoming increasingly restless. After he suffered a frightening seizure in the town of Mödling in 1897 he was taken to a private clinic in the capital. Released after a few months, Wolf, with his sister, Käthe, and Melanie Köchert, journeyed to Trieste and nearby Adriatic towns on what was then Austria-Hungary's seacoast in the spring of 1898. Later that year, after a suicide attempt, the composer was committed to the Lower Austrian Provincial Asylum. The emperor and a Hugo Wolf Association that had meanwhile been founded paid for his private room in that institution. Melanie visited him three times every week until his death in 1903. Three years later she jumped to her death from a window of her home, leaving three daughters.

"Melanie Köchert added to our appalling statistics," Robert commented. "Propensity for suicide has been a Viennese trait before and after Crown Prince Rudolf and Hugo Wolf, especially among intellectuals. It's the same today even despite our relative well-being. I read the other day that Austria has the highest incidence of suicide next to Sri Lanka among all nations that publish data on the phenomenon. With suicide figures narrowed down to just Vienna and the Vienna Woods, we probably would come out on top of the list."

Schubert in Borrowed Clothes

Despite our dismal considerations about the suicidal Viennese, we were hungry. We drove from Perchtoldsdorf to the ancient

town of Mödling in less than ten minutes and were pleased
to find the long-dependable Babenberger Hof Restaurant still
in business. It's a place, I recalled, best shunned on weekends,
but on a working day we hadn't any trouble getting a good
table. We ordered vegetable soup followed by roast veal. I
asked for the house's Weissburgunder, a white wine made
from the pinot grapes grown in the vineyards on the nearby
slopes. It was agreeably pungent, and I was sorry I was driving
and had to sip sparingly. "That's why I never learned to drive,"
Robert said.

He wasn't too eager to walk around Mödling after what
he had drunk, but I dragged him to the remarkable parish
church in the upper part of town. Like Saint Augustine's in
Perchtoldsdorf, Saint Othmar's of Mödling was originally built
as a fortress-church with thick walls and battlements. Hungar-
ian raiders burned it down in 1252, and according to the
chronicles most of the fifteen hundred persons who had taken
refuge in it died on that occasion. Each Vienna Woods town
has its own massacre to commemorate. Saint Othmar's was
rebuilt and again destroyed, this time by the Turks. The present
church retains the fifteenth-century Gothic external walls, and
inside, if you look up, you can see Baroque vaults.

A freestanding burial chapel south of the church dates
from the twelfth century, its Romanesque foundations sur-
mounted by a seventeenth-century Baroque bell tower, and
the Romanesque portal is remarkable. Nearby, the high arches
of the Vienna Aqueduct span the entrance to the Klause, a
deep ravine through which the Mödling Brook flows out after

passing the Hinterbrühl and Vorderbrühl valleys. Tall limestone rocks with forests of black umbrella firs flank the ravine, and from a hill to its south a ruined castle glowers into the valley. The Kalenderberg (Calendar Mountain) north of the Klause belonged to the domains of the Liechtenstein princes, who built some of their make-believe ruins there.

From the parish church and the entrance to the ravine my drowsy friend, who missed his customary siesta, and I walked into the town center again, looking at attractive Gothic, Renaissance, and neoclassical houses. Mödling's town hall is a charming sixteenth-century building with an Italianate loggia. In front of it is a monument to Josef Schöffel, the "Savior of the Vienna Woods," who was mayor of Mödling from 1873 to 1882.

I couldn't persuade Robert to wait for the Civic Museum to reopen at 3:00 P.M. From an earlier visit I recalled that the institution, housed in a former Capuchin monastery at 2 Museumsplatz, contains prehistoric finds dug up on the Kalenderberg and in other sites near Mödling, as well as Beethoven and Schöffel collections.

The composer spent the summers of 1818 and 1820 in Mödling, and we sought out the town's Beethoven houses. He lived during his first sojourn in the so-called Hafner House, 79 Hauptstrasse, a three-story building dating from the late sixteenth century. In the summer months of 1820 he wrote his *Missa Solemnis* and other music in a fifteenth-century house at 2–6 Achsenaugasse. Almost every day during his stays, Beethoven took long, solitary walks in the Klause and up the hills on either side of it.

Schubert too was often in Mödling; he loved the romantic scenery of the ravine and, as mentioned earlier, was attracted by the Hinterbrühl gorge. Unlike his idol, Beethoven, Schubert was usually in merry company during his frequent outings into the Vienna Woods. From the time Schubert left the boarding school of the Piarist Fathers in the center of Vienna at the age of sixteen he was always surrounded by friends—former classmates, poets, writers, painters, and dilettanti who admired and supported him. They took turns housing and feeding the composer, and he would often borrow clothes from them.

The few times Schubert lived by himself his quarters were a mess. One morning the painter Moritz von Schwind called on his untidy friend to fetch him for one of their excursions into the Vienna Woods. Schubert started dressing, ransacking cupboards and drawers for a matching pair of socks, but all of them had holes. "I don't think they knit whole socks anymore," he remarked, shaking his unkempt head in mock seriousness.

Schubert's creativity during his short, disheveled life was prodigious. According to Otto Erich Deutsch, who compiled the fundamental catalog of the composer's works, Schubert wrote 1,515 pieces of music, including 634 songs, in addition to his symphonies, operas, masses, overtures, sonatas, string quartets and trios, and other items. Schubert himself lost track of many of his works. He gave away original scores to friends and allowed them to rifle through his papers, which were lying around, and take with them anything they liked.

I asked Robert whether he had any opinion regarding the theory, which has lately surfaced again, that Schubert was gay

or at least had strong homosexual leanings. Robert had read a lot about Schubert and the Biedermeier era (Kyselak and the composer were contemporaries); he said there was no clear evidence to prove or reject such an assumption: "Schubert certainly had a great need for male friendships. But when he referred to his 'beloved' friend Schwind it doesn't necessarily mean they had an erotic relationship or Schubert had a sexual crush on the painter. One must be very wary interpreting the past, applying modern standards."

The romanticism of Schubert's time, Robert explained, caused young people, especially intellectuals, to express themselves in a sentimental, high-flown manner. Schubert certainly cared for women. When he was eighteen, he fell in love with a girl of his native Lichtental parish, Therese Grob, who was not a great beauty but who sang the soprano part of one of his masses with feeling. They had hoped to get married, but when Schubert was still penniless after a three-year quasi-engagement, Therese's father, a soap manufacturer, sensibly prevailed on her to become the wife of a solid baker.

My friend added that wenching was a widespread pastime and business in Biedermeier Vienna, and that there is every reason to assume that Schubert too was a frequent customer of prostitutes. It is one explanation of his syphilis; another is that he caught the disease at the Esterhazy castle at Zselesz (now in Slovakia), where he spent two summers and, as he wrote to his friend Schober, "saw quite a lot" of a pretty housemaid. During this time Schubert was also hopelessly in love with one of his patron's two daughters to whom he gave

music lessons, the seventeen-year-old Countess Karoline. The composer also saw young women in Vienna at the "Schubertiads," gatherings in private homes during which his latest works were performed, and during his Vienna Woods jaunts. Most of Schubert's bohemian male friends became eminently respectable family men in later life.

Before leaving Mödling we had a look at a house at 6 Bernhardgasse, where the composer Arnold Schönberg lived from 1918 to 1925, founded his avant-garde Association for Private Musical Performances, and married for a second time. A small Schönberg Memorial Site in the building marks the spot where the champion of twelve-tone music and his disciples and followers, including Alban Berg and Anton von Webern, held rehearsals for their Vienna concerts.

Schönberg had often visited Mödling in earlier years when, after a short stint as a frustrated bank employee, he took a job as director of workers' choirs. One of these groups was based in the town where the composer would later make his home. To save money, he used to walk 5 miles (8 kilometers) from the last streetcar stop in Vienna to Mödling for rehearsals and concerts, then back again. The Socialist workers in the choir and in the audience addressed Schönberg as "comrade."

To the Pillory

Looking for the way to the Wine Road, I noticed scores of signs with directions to many Vienna Woods roads and paths.

Mödling is the starting point and finish of the annual International Vienna Woods Hike, conducted during three days toward the end of August. Entrants at the event, held since 1970, arrive from all over Austria and from other countries. According to their age group, they have to walk on designated paths and trails a total of 75 miles (120 kilometers), 62.5 miles (100 kilometers), or 54.3 miles (87 kilometers) to qualify for gold, silver, or bronze badges. Mödling is also the start and end of the Vienna Woods Connection Trail Number 444. This system of paths and roads, 33 miles (53 kilometers) long, leads from the town over the Anninger Mountain and other hills to Purkersdorf and Vienna's Grinzing suburb. Vienna Woods Trail Number 404 is 137.5 miles (220 kilometers) long, alternately linking Mödling with Grinzing, but in a wider loop, taking in Klosterneuburg. A performance badge is awarded to all who can prove they have walked the entire route in the prescribed number of days (or in a shorter time) by producing a "hiking booklet" with control stamps from the mountain refuges they passed.

The highest Vienna Woods hill near Mödling is Mount Anninger, with an elevation of 2,165 feet (675 meters), southwest of the town. The ascent of the limestone massif over picturesque paths is a classic excursion that many Viennese will undertake at least once in their lives, some much more often. I did it once as a boy and again in the late 1980s, when it took me two and a half hours to get to the summit from Mödling, with coffee stops at two spots—one at the foot of the hill, the other halfway up. The panorama from the observa-

tion tower on top of the Anninger is superb: green hills all around, to the east the plains of the Vienna Basin with Hungary on the horizon, and to the south the Limestone Alps of Styria.

A popular route up the Anninger starts at the Goldene Stiege (Golden Steps), once a vintners' path, a little south of the entrance to Mödling's Klause. One passes the Breite Föhre (Broad Fir), a mighty tree believed to be more than four centuries old. From there the route goes up and down subsidiary hills and eventually leads to the Anninger Refuge and the highest peak. Instead of returning to Mödling, a hiker may descend on various paths to the towns of Gumpoldskirchen in one and a half hours or Baden in two hours.

This time, however, my friend and I looked at the Anninger from below, on the Wine Road. This is a highway that runs from Mödling for 3 miles (nearly 5 kilometers) across vineyards to Gumpoldskirchen. The ancient Romans grew vines on the sunny slopes that gently rise from the plains to the black pine forests and the limestone cliffs of the Anninger massif. Today Gumpoldskirchen vintages are highly regarded in Austria; they are whites, mostly from pinot grapes, which are straw or amber colored and rather heady, and a few reds.

I parked near the parish church of Gumpoldskirchen, an often-repaired Gothic building with a solid square tower surmounted by a high, tapering roof of the kind to be seen on church steeples in the Alps. West of the church is a massive three-story castle with round corner towers that in the Middle Ages belonged to the Teutonic Order of Knights. Church and castle were once surrounded by a moat, a stretch of which is still visible in the northeast corner of the complex.

We sauntered to the sixteenth-century town hall, a Renaissance structure with arcades, a loggia, and a four-story corner tower with a sundial. A circular stone column at least 15 feet (4.8 meters) in height, with a conical top, rises in front of the town hall and near old linden trees. Local people may tell you it's a Roman milestone, but it isn't. It is a sixteenth-century pillory to which evildoers were chained.

"A nice challenge for Kyselak," my friend observed, pointing to the upper part of the pillory stalk. He walked around it and was disappointed not to find any sign that the Biedermeier autographist had been here. "I could get somebody to climb up during the night and paint 'J. Kyselak' on the top of the column," I offered, "so next time you come to Gumpoldskirchen you'll spot the name of your bizarre hero." Robert didn't think this would be a good joke.

I had read up on Gumpoldskirchen before our trip, learning that the old pillory had been removed in the Age of Enlightenment and stored in the town hall. Kyselak couldn't have seen it if he ever visited the town. The column was reerected as a historical landmark only a hundred years ago. "That explains it," my friend said. "If Kyselak had come to Gumpoldskirchen he wouldn't have left his signature on just any house wall. He had to display courage and virtuosity." He needed Mount Rushmore, I suggested.

Passing wine taverns and old vintners' houses with merrily painted facades and broad doorways through which we glimpsed smug courtyards, we went up and down the sloping main street, along a little brook, and back to the parish church of Saint Michael. Here the "Wine Education Path" starts. It is

lined with signposts and original implements—like a large wooden grape press—illustrating viticulture. An enormously oversize metal model of a grape phylloxera recalls the dire period in the second half of the nineteenth century when the pests had infested vast wine-growing areas in Europe and reached Lower Austria. The tiny insect threatened to ruin Gumpoldskirchen along with many other vintners' communities. The introduction of American phylloxera-resistant grapes and stocks eventually conquered the scourge.

Pests have nevertheless remained a threat to wine growers in Lower Austria. As a boy I often went with my grandfather or Uncle Julius up and down their vineyard as they were spraying the vines with green liquid they pumped out of containers strapped to their backs. They returned home from the Bisamberg slope with green-stained faces and hands, and I too managed to get green spots on my body and clothing.

The Vienna Woods Wine Road continues for another 2 miles (3.2 kilometers) from Gumpoldskirchen to the town of Baden, but my friend wanted to be at home for an early dinner, and I turned the car around, heading back for Vienna. I would revisit the old spa another time.

14.

TAKING
THE WATERS

❀

When I first saw the largest Vienna Woods town, Baden, I wasn't yet nine years old, and I don't remember much about that sojourn except that I had a miserable time. My grandmother on my dead mother's side, who was a widow, had wanted me for company during her annual two weeks in the spa whose hot, sulfurous water soothed her rheumatic pains, she said. My father and my new stepmother had told me that living it up in the elegant resort of Baden would be a treat for me, especially since the sanatoriums and spa pensions were supposed to be receiving extra food allocations for their patients and guests. Milk, eggs, sugar, meat, and other foodstuffs were still rationed elsewhere or hard to get.

The boardinghouse where my grandmother and I were staying was all right with me, although it turned out I was the only child there. What I came to dislike intensely was the daily bathing routine. I had grown up on the Danube, where I learned to swim early and enjoyed life on and in the water.

But Baden was something else. The first day, Grandmother dropped me off in the morning at the men's section of the bathing establishment—I don't remember which one of the many baths in Baden—and went over to the right side, reserved for women. The warm, soft, and milky water in the pool was nice, and one quickly got used to the sulfurous smell, but I was extremely uncomfortable with the many other people in the pool.

I was the only small boy there, and there weren't any bigger boys either. Some of the adult bathers seemed to me very old men (they must have been in their fifties and sixties). Most of the younger men were amputees—the war had ended, disastrously, only a few years earlier. The worst thing to me was that many of the old men were bathing without trunks. I was then quite shy; I went into the pool in my black gymnastics shorts from school and didn't know where to look.

After two or three days I told my grandmother I didn't want to go to the pool any longer. She quickly found out why and calmly said she would get me into the women's section.

She did, too. For many years Grandmother had owned and run a stall in the outdoor food market at the Karmeliterplatz, then the heart of middle-class Jewish neighborhoods in Vienna between the Danube River and the Danube Canal, to which she commuted from our village by railroad. She was very popular with her customers because even when Vienna had been close to starvation during the first years after World War I, she had come up with produce from her own vast vegetable garden. Her garden was rented from Klosterneuburg Abbey, as was my grandfather's business, which was close by. At the time

I didn't realize how hard Grandmother was working: she tended her garden every afternoon after returning from the market in Vienna; in the evening at home she bundled vegetables and herbs to take to the market on the first train the next morning; and on Sundays she spent most of her time with garden chores as well. Small wonder rheumatism was plaguing her. With all that she was ever cheerful and had a way with people.

The matron of the right-hand section of the Baden bathing establishment made an exception and allowed me to use the women's pool, and nobody seemed to have objected. I don't know how Grandmother did it. While she was getting her hot-water applications and massages in special rooms, I was in the milky pool with a bunch of women (*old* women, I said to myself). They weren't exactly nude the way some men on the other side were, but I didn't care for what I did see, either. On the Danube in our village of Langenzersdorf boys and girls used to swim, bathe, and row together, and I always had a small boy's crush on some girl or other. In Baden the grown women intimidated me, and I was always glad when my grandmother emerged from therapy, all dressed, and waved at me to get out of the pool and join her for our pre-lunch stroll. I am convinced my lifelong aversion to nudism stems from those summer weeks at Baden.

Nude Bathing

Many years later I was astonished to read in a book on the Biedermeier era that in those times of official prudery, Baden,

unlike other spas, permitted women and men to bathe together. True, they all had to wear bulky bathing skirts closed at the neck and to retreat afterward into separate rooms. The relative promiscuity in the pools and the merry social life in town and its environs in the eighteenth and early nineteenth centuries prompted priests to thunder from the pulpit against moral degeneracy in Baden, "that new Sodom."

Earlier centuries were much less puritanical. Baden's coat of arms, granted by Emperor Frederic III in 1480, shows a bearded man and a buxom young woman, both naked, sitting opposite each other in a wooden tub into which healing water is pouring from three spouts.

The most important resort on the thermal line of the eastern Vienna Woods, Baden receives plenty of sulfurous water at around 97 degrees Fahrenheit (36 degrees centigrade) from fourteen different springs. Austrians, like people all over Europe, swear by spa treatments, and Baden doctors assert that the hot springs cure a vast range of rheumatic, arthritic, and spinal conditions as well as gout, and are beneficial after surgery and injuries.

Bricks with the seals of legions Ten and Fifteen and much other archaeological evidence prove that the ancient Roman army had a bathhouse at what is today Baden. The so-called Antonine Itinerary, a road map of the Roman Empire from the beginning of the third century A.D., designates the site that would become a spa simply as *Aquae*—the waters. It wasn't the only hot-springs town of that name in the empire: there were Aquae Albulae (Whitish Waters) near Rome; Aquae Sulis,

today Bath, in England; Aquae Helvetiae, today Baden near Zurich; and several other medicinal springs. The ancient Romans loved baths as social centers and believed in the therapeutic properties of hot springs.

The rich content of sulfate of lime in Baden's waters comes from the nearby limestone hills. The radioactivity of the Baden hot springs used to be a big selling point in the past but is now being played down or glossed over in the spa's promotional material. I asked the genial lady in the Baden tourist information office on Hauptplatz (Main Square) about this during my last visit. "There are medical fashions," she said with a grin. "Once people thought radioactive waters were good for you. Now they think radioactivity is bad. Actually, radiation from our waters is minimal, and we stress their sulfur content."

At present Baden, with close to thirty thousand residents, offers six thousand beds in its hotels, boardinghouses, and rest homes all year round, and Austria's welfare-state national health system helps to fill them. One of its clients struck up a conversation with me as I was sitting on a bench in the main square, taking notes. He told me he was a retiree from a distant town in Lower Austria and was a guest in a rest house courtesy of his health insurance company. "My doctor prescribes a three-week cure here for my ailing back every year," he explained. "The insurance company, which acts for the national health service, always says okay. I think the water cure helps too—in any event it doesn't do any harm. This is my sixth year here. Most afternoons I sneak into the casino and risk a few schillings on the slot machines. So far I've come out all

right. The important thing is to know when to stop." Baden has had a gambling casino since 1934.

The retiree also advised me to try Baden's wine, which he said had more body than what he was ordinarily drinking at home north of the Danube. I don't know if Austria's national health service also pays for wine with the meals in the rest homes.

The spry pensioner and I were sitting in front of the Trinity Column, a monument of Baroque apotheosis erected in 1713 in sign of gratitude to the Deity for the end of a plague epidemic. In the triangular square facing the neoclassical town hall (1814–15) only pedestrians were to be seen; even cyclists had dismounted and were pushing their bikes. Baden's snug town center is closed to motor traffic, as the guide of Tour Number Four had told the sightseers on our bus a couple of weeks earlier.

This time I had come on my own, taking one of the many trains departing for Baden and stops beyond it from the Vienna Southern Railroad Terminal (Südbahnhof). The trip lasted twenty-five minutes. From Baden station I had walked for ten minutes through quiet streets to the town's core with its Biedermeier-style houses.

Great Music at the Spa

After my chat with the retiree in Main Square I strolled two blocks eastward to the parish church of Saint Stephen, a late

Gothic edifice with a mighty tower capped by a green onion dome and flanked by two short steeples with corner turrets. After several devastations by the Turks, the interior of the church was redecorated in the Baroque fashion in the eighteenth century. At the right side of the main entrance a winding stairway leads up to the choir loft. A plaque at the foot of the stairs reads: "W. A. Mozart in the year 1791 wrote the *Ave Verum* for his friend Anton Stoll, choirmaster here."

The short, moving classic of sacred music catalogued as K. 618 was to be one of Mozart's last compositions. He was spending a few days with his wife, Constanze, who was once again taking the Baden cure for her real or imaginary ailments, accompanied by their two sons. When *regens chori* (choirmaster) Stoll asked the composer, his friend, to contribute something for his singers as he had done on previous occasions, Mozart went to the little garden pavilion of the house at 4 Renngasse, where he had taken rooms for his family, and on the first scrap of paper that came to hand wrote the *Ave Verum Corpus* (Hail, True Body).

A few months later Constanze, still in Baden, received the news that her husband was very ill. She rushed to Vienna in a carriage and found Mozart dying. The garden pavilion in which the composer worked was dismantled more than a hundred years ago. The building at 4 Renngasse, close to Saint Stephen's, was completely renovated between 1978 and 1982, but the eighteenth-century facade has remained intact.

Walking from the parish church to the Renngasse I passed the Civic Theater, an elegant cream-colored structure in eclec-

tic-classical style with some Art Nouveau ornamentation. Since the house was inaugurated in the year when Austria-Hungary celebrated the sixtieth anniversary of Emperor Franz Joseph's accession to the throne, it was officially called the Civic Jubilee Theater, a name still on its architrave. Baden has had theaters since 1718, and in the second half of the nineteenth century it was a place where each successful operetta was performed soon after its Vienna premiere. At present the Civic Theater produces operas, musicals, and legitimate drama during its winter season, from the end of October to March. In summer (July to mid-September), the theater stages popular operettas by masters of the genre, from Johann Strauss the Younger to Lehár and Kálmán, in its arena in the nearby Kurpark (Spa Gardens), an Art Nouveau building erected in 1906 with a retractable glass roof that is opened when weather permits.

I went back to the Main Square and walked a few steps beyond it to a simple yellow two-story corner building with a shingled roof at 10 Rathausgasse, called the House of the Ninth Symphony. Beethoven lived in it during three summers, and here in 1823 he wrote large portions of his crowning composition. His former quarters upstairs are now Beethoven Memorial Rooms, containing an early nineteenth-century clavier of the kind he used and period furniture, with old Baden views on the walls.

Beethoven spent fifteen summers in Baden; that he stayed in the house on Rathausgasse during three seasons was exceptional. As in Vienna, he frequently changed addresses in Baden. Other known Beethoven houses in town are at 4 Antongasse,

once the Inn at the Sign of the Golden Swan, near the parish church; at 26 Braitner Strasse, near the railroad station; and at 10 Frauengasse, a building called Magdalen Court, off Main Square.

Cozy Summer Capital

Beethoven was only one among a multitude of famous guests during the period when Baden was the cozy summer capital of the Austrian Empire. The old spa assumed this function because Emperor Franz II (as Austrian emperor he called himself Franz I) passed every summer from 1803 to 1834 in Baden. Franz had been raised in Florence, where his father was the Grand Duke of Tuscany, and Italian had been his first language. He married four times, having been bereft of his empresses one after the other. With his consecutive wives the popular emperor lived simply in Baden. Instead of building himself a palace, he preferred a vacation home like that of any well-to-do subject. The neoclassical building at 17 Hauptplatz opposite the town hall was his summer residence after 1813; it is to this day known as the Emperor's House. (The last ruler of Austria-Hungary, Emperor Karl, would spend long periods in the building when, as nominal commander-in-chief of the empire's military forces during World War I, he wanted to stay near the army high command, which had its seat in Baden.)

The Emperor's House was one of the first buildings to go up after a catastrophic fire in 1812, which destroyed two-thirds

of Baden. Beethoven happened to be at Carlsbad in Bohemia, another famous spa, when he heard of the Baden conflagration in the spring of 1812; he took part there in a charity concert for the victims of the disaster.

The emperor called a leading Vienna architect of the time, Josef Kornhäusel (1782–1860), to Baden to rebuild the town. At the age of thirty Kornhäusel already had an impressive number of constructions to his credit—residential buildings, hotels, theaters, and palaces. He had developed a dignified personal style, derived from the classicism that had dominated the architecture of the French Revolution and Napoleonic eras. He designed Baden's new town hall, with its impressive portico, and many other buildings around town. The neoclassical core of present-day Baden is essentially Kornhäusel's creation.

It is worth mentioning that Kornhäusel, as architectural director for Prinz Liechtenstein, also designed the Temple of the Hussars south of the Hinterbrühl and other constructions on the wealthy aristocrat's land. Furthermore, the Vienna architect built a large castle, the Weilburg, for Archduke Carl, a brother of Emperor Franz, beneath the Rauheneck ruin at the southern hill of the Helena Valley's mouth. "A precious site," wrote the archduke in a letter. Carl had just retired from a more than honorable military career; he had inflicted a painful defeat on Napoleon at Aspern, beyond the Danube near Vienna, in May 1809 (the French emperor recouped with a victory at nearby Wagram six weeks later). The Weilburg inspired many painters and designers. It burned in 1945, and the ruins were razed.

In his mature years Kornhäusel refined his neoclassicism into a sober style that made him the foremost representative of Viennese Biedermeier architecture. Vienna's Jewish community commissioned him in 1822 to build a synagogue in what had been the ghetto in the city's center. The noble, domed edifice on Seitenstettengasse that he designed is still Vienna's main synagogue. It is hidden behind a residential building—today housing Jewish community offices—because at the time it was built, structures serving non–Roman Catholic religious groups were not permitted to have street frontage.

Near the synagogue Kornhäusel built Vienna's first high-rise residential structure, with a study for himself on top. The lofty workroom of the immensely industrious architect could, and still can, be reached only by means of a ladder, which Kornhäusel used to draw up with a rope to remain undisturbed. Such yearning for privacy earned him a reputation as an eccentric, but the Viennese had an explanation too: Kornhäusel's wife was a redoubtable nag, and the retractable ladder was his way of shutting her up and out. The Kornhäusel Tower is still a landmark in the heart of Vienna.

Kornhäusel and his assistants, as well as other architects, had already raised many new buildings in Baden when the Congress of Vienna, 1814–15, brought throngs of visitors and first-time guests to the town. In addition to Emperor Franz and his court, many top aides and high officials, aristocrats, foreign diplomats, ambitious or wealthy commoners, beautiful women, high-stakes gamblers, and spies also made the two-hour carriage trip from Vienna to the spa. It was a giddy time

in the fashionable watering place. Every day there were social affairs in some count's villa or garden, merry rides into the Helena Valley or up the hills, musical soirees, and glittering dinner parties.

In June 1815 a new iron bridge spanning the Schwechat River, which flows across Baden, was inaugurated. The archbishop of Vienna blessed the construction, and one of the emperor's younger brothers, Archduke Anton, cut the ribbon. After the official ceremony a huge crowd surged forward, and the bridge collapsed. Hundreds of people fell into the water; two drowned and many were injured. A son and a daughter of Prince Metternich were among those who ended up in the river, but neither suffered any harm. Three days later Napoleon was decisively and ultimately defeated at Waterloo.

Metternich Is Busy

Those were hectic days for Metternich. He and his family had lived in Baden off and on during several summers and would be remembered by local people above all for a talking parrot that an Austrian seaman had given the prince; the voluble bird was a Baden sensation. As chancellor of the Austrian Empire and stage manager of the Vienna Congress, Metternich didn't always have time to drive out to Baden to report to his sovereign on the latest political maneuvers and to stay with his family for a few hours. Besides being a main player in the

international power drama that was being enacted in Vienna, Metternich also had to give and attend innumerable dances and other parties for Congress participants and Vienna society figures and to take care of his mistresses.

An English observer and adviser at the Congress of Vienna, Sir Edward Cooke, was scandalized by Metternich's nonchalance and reported that the Austrian chancellor was "most intolerably loose and giddy with women." Metternich's principal liaison then was with Duchess Wilhelmine de Sagan, née Princess of Kurland. The attractive, witty duchess was one of the two foremost society hostesses in the Vienna of those years. She was the rival of a Russian princess, Katherina Pavlovna Bagration, who ran another celebrated Vienna salon (which secret police reports to Metternich described as a high-class bordello). The Duchess of Sagan often visited Baden too, watched there, as in Vienna, by undercover police agents.

One of the main chores of the secret police in Baden was to keep close surveillance over Marie Louise, Napoleon's empress and Emperor Franz's daughter, and especially over the couple's son, the small "King of Rome." It had been Metternich who had promoted the marriage in 1810 of the pretty eighteen-year-old archduchess to the French emperor after Napoleon had repudiated his first wife, Joséphine Beauharnais. The Prince de Ligne may have had his hand in the wedding arrangements; at least he claimed so. When Napoleon's military fortunes turned and he abdicated for the first time, Marie Louise managed to travel with their son to her father in Austria, escorted by her equerry, the one-eyed Count Adam Adalbert Neipperg.

First her lover, Neipperg would eventually become her second husband. Marie Louise refused to rejoin Napoleon on the Island of Elba, and she remained in Austria during the Hundred Days when he attempted to restore his empire.

After Waterloo, Metternich, who was in Paris, informed Marie Louise, then in Baden, that Napoleon was in satisfactory health, was being treated well, and would be taken to northern Scotland. Later however she received word that her husband would not reside in Scotland after all but was being shipped out to Saint Helena. Neither she nor their son would ever see the ex-emperor again. The Congress of Vienna assigned to the former empress the Italian dukedom of Parma, Piacenza, and Guastalla and accorded Napoleon's son the title of Duke of Reichstadt.

As Duchess Maria Luigia, the former empress became popular in Parma, ruling with good sense and, at least in the beginning, with a measure of liberalism. Her son, the Duke of Reichstadt, remained in Austria as a virtual prisoner of Emperor Franz, who was said to be very fond of his grandson. Marie Louise spent summer vacations in Baden, where she was reunited with her son. She and the Duke of Reichstadt lived there in a building in the Empire style, erected in 1817 from designs by Kornhäusel. The graceful mansion at 5 Frauengasse is known as the Florastöckl (a dialect name meaning Flora Residence), after a statue of the goddess of flowers adorning it; it is today a girls' high school. The slightly winding Frauengasse from Main Square to Josefsplatz has been called Baden's loveliest street.

The Duke of Reichstadt, whom Bonapartists kept calling Napoleon II, succumbed to what was diagnosed as consumption in Vienna in 1832, aged twenty-one. Marie Louise died in 1847. Metternich's family, who had been vacationing in Baden for years, talked the chancellor into buying a small house there in 1819. They liked that summer home, until Metternich began hating it after his beloved oldest daughter, Marie, the wife of a noble Esterhazy, died there in the summer of 1920. Two months earlier Metternich had lost another daughter, the beautiful Clementine, but Marie's death caused him particular grief because, as he said, she had been his "best friend." Eventually he sold the Baden house. Between 1830 and 1840 the chancellor owned a bigger place in Baden, at 10 Theresiengasse, near Main Square. It was the first building to be erected in Baden by the young Kornhäusel (1807, five years before the great fire), and is today known as the Metternich Hof (Metternich Court).

During the 1820s many more new structures went up in the resort, including a columned bathing establishment, the Frauenbad, on Josefsplatz near the Schwechat River; it looks like a Greek temple and is now an exhibition hall. The death of Emperor Franz in 1835 spelled the end of the town's brilliant aristocratic period. Franz's oldest son, Ferdinand, was recognized as his successor, but the new emperor was feeble-minded, and actual power was wielded by Metternich with the support of a regency council including two archdukes and high officials. Emperor Ferdinand didn't like Baden because a futile attempt on his life had been made there.

Baden achieved a comeback and new prosperity after the

opening of the Southern Railway in 1841. Many families of Vienna's new middle class, quite a few of them Jewish, started regularly taking the water cure in the spa, which was now easy to reach from the capital, and spending summers there in houses and villas they rented, bought, or built.

15.

TALES FROM THE
VIENNA WOODS

❀

Nineteenth-century bourgeois tastes are reflected in the Kurpark (public gardens) in Baden's north. Beeches, birches, horse chestnuts, oaks, and other trees form dense clumps with lovingly tended flower beds and lawns between them. In the warm months palms and other exotic plants are brought out of a hothouse, providing touches of lushness. Sightseers and vacationers, most of them elderly, sit on the park benches and feed the birds, which seem to consider the park their property and privileged nesting ground.

The Kurpark starts on level ground with a gazebo and an outdoor café, a five-minute walk from Main Square. The stroller soon reaches a slope that is gentle initially but later becomes steeper. Outcrops and eventually jagged limestone formations are covered with firs and pines. A rock path and other promenades lead directly into the Vienna Woods by way of the Rudolfshof (Rudolf's Court) Inn and a hollow known

as Einöde (Wilderness). From there, hikers comfortably climb the south flank of the Anninger massif on paths commanding extensive views of the vineyards, the Wine Road, and the plains of the Vienna Basin.

Coming from the town center on Theresiengasse and walking up the incline of the public gardens, I passed a monument to Josef Lanner and Johann Strauss the Elder, Vienna's first princes of the waltz, who gave concerts in Baden during the summer seasons. The sculptured group by Hans Mauer, put up in 1911, represents Lanner standing, fondly looking at the seated Strauss, both men in Biedermeier frock coats holding violins. Their friendship didn't last long.

The two musicians contributed mightily during the Metternich years to the transformation of the Ländler, the country dance of Upper and Lower Austria and the district around Vienna, into the waltz that would conquer the imperial city's society and soon be played around the globe. Until then aristocrats had danced primarily quadrilles, the stately polonaise, and the elaborate minuet. It is true that Haydn, Mozart, and Beethoven wrote many "German dances," usually on commission, ennobling the peasant tunes of the Ländler and paving the way toward the waltz. "German" in that context meant folksy and unsophisticated, as opposed to French or Italian dance music. Schubert and Weber also wrote early waltzes. It was through Lanner and Strauss, however, that the rustic dance with its whirling and hopping was perfected into the dreamlike three-quarter-time gliding and giddy spinning of the Viennese ballroom waltz, possibly with a frenzied, duple-time round dance, the galop, as a coda.

Johann Strauss the Elder heard the Lanner trio for the first time at the age of fifteen, and he soon joined it as a viola player, making it a quartet. By 1824 the Lanner-Strauss group had become a band, playing in coffeehouses and giving open-air concerts in Vienna and Baden. After a few years the two musicians had a falling-out, and a composition that Lanner wrote about that time was later, probably improperly, called the *Separation Waltz*. Strauss set up his own orchestra and became a rival of Lanner's in popular favor. When Lanner died in 1843, only forty-two years old, all Vienna mourned. Strauss attended the funeral; in the years to come he would go from triumph to triumph.

The Viennese have always known that the famous Strauss dynasty was of Jewish descent. His grandfather, Wolf Strauss, a Jewish immigrant to Vienna from Hungary, had either converted to Roman Catholicism himself or had his offspring baptized. The Strauss family could be traced over three generations in the Vienna parish registers, and there was always evidence of that Jewish grandfather. Under Nazi racial laws, musical programs in greater Germany would have had to be purged of Strauss waltzes, but in 1941 Goebbels ordered the Vienna parish rolls to be doctored. The Jewish grandfather, Wolf Strauss, disappeared from the records. The falsification, however, was so clumsy that researchers after World War II were easily able to reestablish the true genealogy of the Strausses.

In 1830 Johann Strauss the Elder had already split from Lanner when he evoked in music the romantic scenery of Baden's Helena Valley in his *Souvenir de Baden: Helena Walzer*

(Opus 38). Lanner too wrote a Baden waltz. Lanner's and Strauss's orchestras were often heard in the spa between tours of foreign countries. The older Strauss and his musicians gave concerts in the German states, the Netherlands, France, and England; they played at Buckingham Palace in London. The amiable, though mentally impaired, Emperor Ferdinand was an admirer of Strauss and in 1835 named him Director of Music for Court Balls. Strauss furnished the waltzes expected from him, but it was in a military mode that he did more for his country than a conquering general could have done: he composed the *Radetzky March* (Opus 228), dedicated to Field Marshal Josef Count Radetzky, the Austrian Empire's most famous military leader of the nineteenth century. A hundred years or so later, whenever my father heard the stirring martial tune he would perk up as if to spring to attention and say, "That's what the band played when our battalion had to parade in front of some general or archduke." Including his three years of compulsory military service and his participation in World War II, Father had spent seven years in uniform.

King of the Waltz

The younger Johann Strauss, born in 1825, wrote a composition at the age of six when he was living in a house on the edge of the Vienna Woods at 13 Dreimarkstein Gasse, in Vienna's Salmannsdorf suburb. His mother called the thirty-six-bar piece in three-quarter time "First Idea." The little house, which

belonged to her parents, still exists, bearing a plaque with an inscription in naïve rhymes that declare a "great musician" composed his first waltz here. Despite the mother's pride, Johann Strauss the Elder was dead set against the boy's going into the music business. The younger Johann Strauss nevertheless had his own orchestra by the time he was twenty. Initially bitter rivals, father and son eventually made up. (Johann Strauss the Elder died of scarlet fever in 1849, aged forty-five.)

Only a few years later Johann Strauss the Younger was already heading several bands in Vienna, employing hundreds of musicians. During the city's feverish *Fasching* (carnival) he would rush from restaurant to café to ballroom to conduct at least one of his waltzes in each of the half-dozen places where Strauss orchestras were performing that night. He also appeared in Baden and other cities and towns throughout the empire and aroused enthusiasm everywhere during his tours of foreign countries. He was a world celebrity, and such musical giants as Richard Wagner and Johannes Brahms praised his talent.

With all the adulation he encountered and the money he earned, Johann Strauss the Younger didn't appear to be a happy man. His intimates knew that he was given to brooding. Whenever he felt low he withdrew to his villa in a lush garden at Schönau on the southeastern approaches to the Vienna Woods, 5 miles (8 kilometers) distant from Baden. The death in 1878 of his beloved first wife, Henriette ("Jetty"), who was seven years older than he and had been a renowned singer, struck him deeply. To overcome his depression Strauss married

a woman thirty-five years his junior, who eventually abandoned him. His third wife, Adele, who was Jewish, succeeded in giving him domestic tranquillity, especially at what he called their "knights' mansion" at Schönau.

Jetty was still at Strauss's side when he wrote the waltz *Geschichten aus dem Wiener Wald* (Tales from the Vienna Woods, Opus 325) in 1868. The composition was not exactly descriptive music; Strauss often chose names for his pieces at random. For instance, his most famous waltz, the *Blue Danube*, was originally written for lyrics that had little to do with the big river but urged the Viennese to be merry despite the financial woes following the lost war of 1866. Other waltzes were called *Wine, Women, and Song* and *Artists' Life*—interchangeable titles.

Yet *Tales from the Vienna Woods* struck a newly sensitive chord in the Viennese: they read into the waltz nostalgia for the forests and hills at a time when their expanding city's suburbs were clawing into the Vienna Woods and when it was fashionable to profess regret for vanishing sylvan bliss. *Tales* was also a hit abroad. One fan was the Prussian king who would soon be the emperor of unified Germany, Wilhelm I. In 1866 Bismarck had hardly been able to keep him from marching to Vienna in triumph and thereby humiliating Emperor Franz Joseph; a few years later Wilhelm would sentimentally observe that of all the marvelous compositions by the King of the Waltz he liked *Tales from the Vienna Woods* best. Strauss performed both *Tales* and the *Blue Danube* during his tour of the United States in 1876, the centennial of the Declaration of Independence. (He was paid $100,000 plus travel expenses.)

I kept ruminating about the ambivalence toward the Viennese waltz that I had been feeling most of my life as I was strolling past other monuments in Baden's public gardens—a bust of Emperor Joseph II among palms; a neoclassical Mozart Temple; and a circular, domed Beethoven Temple, erected in 1927.

A waltz, maybe even *Tales from the Vienna Woods*, was probably the first music I ever heard. One of my very few recollections of my mother is of her sitting at a table and playing the zither and me standing opposite her, my eyes hardly reaching the tabletop and her instrument, watching her fingers and marveling at the metal pick she had put on one of them for plucking the strings. In my memory I see more clearly that finger with the pick than the dark eyes and hair of the young woman whose little boy I was. (She resembled the faded brown photographs of her Italian grandmother, Anna Mazzolini.) She wouldn't live long after that scene imprinted in my brain. She had taken a job at the railroad office to support us while my father was a soldier on the Russian front, inadvertently pricked a finger with a pen she had dipped into red ink, and died in the hospital of blood poisoning at the age of twenty-five; antibiotics, which might have saved her, had not yet been developed. Later I was told she had liked to play waltzes.

My father, who had been given a brief furlough from the front because of his wife's death, arrived too late for the funeral. He treasured the zither for years, but it was lost later in one of our many moves. As a young man he had been a great waltzer, appreciated by my mother and other village girls for his leftward spin at the dance. As for myself, I have never

danced the waltz and feel ill at ease whenever I hear the *Blue Danube*, which is supposed to be something like the national anthem of Vienna, or other popular tunes in three-quarter time from which you can't escape in my native city. I always found Beethoven's "Pastoral" Symphony and the songs by Schubert and Hugo Wolf much more evocative of the greenbelt around Vienna than the *Tales*.

In the "German dances" of the late eighteenth and early nineteenth centuries and in the waltzes by Josef Lanner and Johann Strauss the Elder I am still able to hear echoes of the rustic life and of merrymaking in village inns. Most of the later waltz music is, to my ears, a slick, professional city product from an era of smug hedonism, come what may, that didn't want to see the approaching doom. Hermann Broch, the Viennese writer who in a famous essay described the late nineteenth-century mood in our city as the "joyful apocalypse," castigated its waltzes and operettas for their "outright cynicism" at a time when Vienna was "the center of the European vacuum of values."

Broch, incidentally, was frequently seen in Baden. For years he headed his wealthy family's textile plant in the company village of Teesdorf, 3 miles (about 5 kilometers) southeast of the spa, before choosing to become a full-time intellectual and novelist. He knew and visited most of Vienna's literary and artistic figures between the two world wars, and he was able to leave Austria after the Nazis had invaded it because James Joyce, Irish though he was, had obtained a British visa for him. Broch moved to the United States and taught at Yale University; he died in New Haven, Connecticut, in 1951.

Like Broch, the playwright Ödön von Horváth distrusted the joyous smoothness of the waltz. In his comedy, *Tales from the Vienna Woods*, Horváth exploded the sham of Gemütlichkeit (friendly coziness) that is widely associated with waltz music, the Vienna Woods, and wine taverns on the green. Strauss's *Tales from the Vienna Woods*, played on a "tired piano" (as the stage directions read) in an apartment above a butcher's shop in a lower-middle-class section of Vienna, is heard as a theme song in the first scene; a portable gramophone grinds out the *Blue Danube* waltz during a Vienna Woods picnic in a clearing on the big river later in the Horváth play. Its characters flirt, smooch, trade banalities and, above all, lie to each other during their Vienna Woods excursions and conversations over the local wine at the *Heuriger*.

Horváth—who was born in Fiume (now Rijeka in Croatia), was brought up speaking four different languages and had a Hungarian passport—dazzles in his comedy with an uncanny mastery of the Viennese dialect and idiom. *Tales from the Vienna Woods* had its premiere in Berlin in 1931, where it incensed Nazi and other right-wing critics but won the prestigious Kleist Prize. Vienna got around to producing Horváth's satire on the presumed jolliness of the waltz, the Vienna Woods, and the wine taverns only in 1948—to mixed reviews. The author would have been amused by charges he had "insulted" Vienna. Horváth had died in a bizarre incident soon after his arrival in Paris in 1938 as an anti-Nazi refugee from Austria: a branch crashing from a tree on the Champs Elysées killed him.

Today, Horváth is generally recognized as a legitimate continuator of the Viennese popular theater of the eighteenth

and nineteenth centuries and is often performed. Baden's Civic Theater near the Kurpark just had a new production of his *Tales from the Vienna Woods* on its schedule when I last visited the town.

That Old Blue Tram

My walk around the Baden public gardens ended at the Römer-quelle (Roman Fount), a pump room with fragments of ancient Roman walls and other archaeological finds. Adjacent are the arcaded gambling casino and a convention center. In front of them is a flower clock of the kind seen also in Geneva near the lakefront and in many other resorts. At present the roulette wheels spin and slot machines click at the Baden Casino from 4:00 P.M. until early morning every day. I didn't enter, although the pensioner on the bench in Main Square had suggested that I too try my luck. When I was a teenager I once traveled by train from Paris to Le Havre and an elegant, mellow Frenchman in the compartment who had struck up a conversation with me told me he was a croupier and gave me what he said was the best advice he could impart: "Never set foot in a gambling casino! Never, *jamais!*" I never had, and I recalled the French croupier's "*jamais!*" also in Baden.

Instead I decided, for old time's sake, to return to Vienna on the Baden tram rather than by commuter train. The blue cars of that tram, which in part roll on the tracks of the Vienna streetcar network, have leisurely linked the center of the Aus-

trian capital and the center of the resort town since 1908. As a youngster I rode the tram often; innumerable Viennese have. The tram still runs at intervals of twenty or thirty minutes. I boarded a train waiting at the terminal in Josefsplatz and found myself in an almost elegant new coach with little wooden tables between seats facing each other.

The Baden tram route follows the old Trieste Road (B-17), which used to carry all motor traffic between Vienna, Baden, and the south before the Southern Motorway (A-2) was built. Today the flatland just east of the Vienna Woods is filled with manufacturing plants, furniture marts, cash-and-carry emporiums, shopping centers, and housing developments. Our tram stopped every few minutes to let students with their backpacks and other short-trip passengers get on and off. Most of the people in our car traveled on commuter tickets and seemed to know one another.

An elderly woman who got on in Baden and sat opposite me had a voluminous handbag with her. She showed the conductor a one-way ticket like mine and soon told me she was visiting her daughter and grandchildren in Vienna for a few days. It developed that she was a native of Baden, had never traveled much anywhere, and was looking forward to returning home, as much as she wanted to see her daughter's kids. "I don't care for the big city," she said. "Baden has everything—theater, concerts, coffeehouses, stores, good restaurants, excellent medical services, and the Vienna Woods a few minutes from our doorstep. Why should I go elsewhere? Everybody sooner or later comes to Baden anyway."

"Yeah," I ventured, "like the Russians." I was alluding to the period from 1945 to 1955 when Baden was the seat of the Red Army high command in occupied Austria.

"We had Soviet soldiers billeted in our house for ten years," the woman informed me. "We lived in our basement all the time. The Russian officers also took the hotel rooms and sanatoriums. A large part of the town center was reserved for the occupation troops, the streets leading to it boarded up. We weren't permitted to move freely in our own town. We couldn't believe it when the Russians went home at last. Toward the end we were quite friendly with them, and they were sorry to leave. They sure liked Baden, our wine, and the Vienna Woods."

I was reminded of what my father had told me about the Soviet occupation when I saw him soon after it had ended. Just before World War II he had been able to build himself a little house in our village with his savings and a big mortgage, and in 1945 it was taken over by the Soviet forces like many other buildings nearby. My father, then nearly sixty, had been in uniform again for a few days because the Nazis, in a desperate last-ditch defense effort, had rounded up oldsters and teenagers, pressing them into a Volkssturm (People's Assault) militia. When the Red Army advanced on Vienna from Hungary, the pathetic "assault" militia units melted away, got out of their uniforms, and threw away their rifles. Father was lucky. He still had a service apartment in a building at Vienna's center that had miraculously remained undamaged during the air raids and the Battle of Vienna, and he got a decent Soviet lieutenant as occupant of his house in our village.

The lieutenant was a musician from Kiev. My father remembered a few Russian, Ukrainian, and Ruthenian words and phrases from his years on the eastern front in World War I and, like every Viennese, had a repertoire of at least two dozen Yiddish expressions, all of which enabled him to communicate with the guest who had been forced on him. After a couple of weeks the lieutenant called my father "Poppa" and wanted to be addressed as Grisha. They got on famously. Grisha, who was drunk on Bisamberg wine, wept and kissed "Poppa" when he had to return home. He wrote my father for years. "The Soviets raped and looted and robbed, especially the line troops during the first few weeks," my father recalled. "But, for one thing, they were good to children. And Grisha was special. He had a girlfriend, a Russian woman in uniform, and I taught them our dialect and took them up the Bisamberg. I was kind of sorry when Grisha had to leave but of course also glad to have the use of the house again."

An Ex-King's Phone Bill

While the lady from Baden and I were still talking about the Soviet occupation our tram had climbed a low ridge and was rolling down again into Vienna proper. An hour and five minutes after we had departed from Baden's Josefsplatz we were at the tram's last stop near the State Opera. I walked toward the Imperial Hotel where I knew my friend Robert and his wife were having coffee. On their table in the Café Imperial was the day's issue of the *International Herald Tribune*

with a front-page story on the family affairs of the British royal house; the abdication of King Edward VIII was recalled in it. "Do you remember, we saw the ex-king a few weeks later at almost exactly this spot?" my friend asked. I didn't remember, but with his prodding the episode came back to me.

After stepping down from the throne in December 1936, the ex-king, who had become Duke of Windsor, traveled to Austria to start his exile in the Vienna Woods near Baden, of all places. From time to time he slipped into Vienna to shop and to drink his favorite Hungarian apricot brandy at the bar of the Bristol Hotel, diagonally opposite the Imperial. The offices of the magazine where I was then working were on the Ringstrasse nearby, and one evening my friend had come to meet me there to accompany me to some affair at the city center. As we were walking near the Bristol Hotel we saw people staring at a slim man who walked into the hotel as policemen at its entrance were saluting. *"Der König"* (the king), a bystander importantly informed us.

For Austria, the former king of England in the Vienna Woods and Vienna was a most welcome sensation. The red color indicating the dominions, colonies, and dependencies of what our textbooks called the "British World Empire" was still all over the maps; British prestige was yet undiminished. To play host to such an exalted visitor from a superpower was felt to strengthen the position of small Austria at a time when its independence was already gravely threatened by the many Nazis at home and by Hitler in his "Eagle's Nest" above Berchtesgaden, just beyond our border near Salzburg.

Edward VIII had arrived from England on the Orient Express and was the guest of his friend Baron Eugene von Rothschild in the latter's country estate at Enzesfeld, in the hillside 5 miles (8 kilometers) southwest of Baden. The property comprised vast, secluded grounds and a golf course (now the Golf Club Enzesfeld).

The privacy of the ex-king was relative. There was soon plenty of gossip in Vienna about what he was doing. Journalist friends told me he had endless telephone conversations every night with Wallis Warfield Simpson, who was in Cannes, France, waiting for her divorce to become final. It seems that Mrs. Simpson, whom Edward in his farewell broadcast to his subjects had called "the woman I love," was jealous of Kitty von Rothschild, the wife of his Austrian host, and on the telephone went on interminably about their suspected liaison.

The Viennese told each other with delight later that the new Duke of Windsor (whose stinginess was to become legendary) had left staggering unpaid telephone bills at Enzesfeld, but Kitty von Rothschild bravely denied the rumor. Eugene and Kitty von Rothschild eventually moved to Paris—just in time—while Eugene's brother, Baron Louis Nathaniel, the chief of the Vienna branch of the House of Rothschild and the wealthiest Austrian at the time, stayed on and was arrested by the Gestapo after the Nazi invasion. He was held for more than a year in the infamous Hotel Metropole, the Gestapo headquarters in Vienna, until relatives abroad ransomed him and the Nazi government took over all Rothschild assets in Austria and Czechoslovakia.

The Duke of Windsor was bored at Enzesfeld. Vienna socialites had it that he would get up late; breakfast on tea and marmalade shipped to him by Fortnum & Mason in London; play a round of golf if the weather wasn't too bad or go skiing in the nearby hills; have the resident chef prepare a gourmet dinner; and stay up until the small hours, playing poker with visiting British friends and drinking apricot brandy when he wasn't on the phone with Wally Simpson. After three months he had had enough of the wintry Vienna Woods and moved to a villa in the Alps near Salzburg.

Unfinished Symphony

Enzesfeld, where a former king first tasted what would be a thirty-five-year exile, lies on the Triesting River, which marks the southern boundary of the Vienna Woods. The mountains beyond the Triesting Valley rise to altitudes of 3,000 feet (935 meters) and higher, the loftiest nearby peaks, Schneeberg and Rax, both being in the 6,500-foot range (2,000 meters).

The Semmering Pass, at 3,160 feet (985 meters) in altitude, between fir-clad heights about 50 miles (80 kilometers) south of Vienna, is traversed by the oldest of the great trans-Alpine railroads, constructed with many bends, tunnels, and viaducts between 1839 and 1842. The resort hotels above the Semmering Pass were particularly fashionable between the two world wars.

The soaring mountains, snowy peaks, and precipitous cliffs south of the Triesting River belong to the Limestone Alps and

are quite different from the Vienna Woods, which W. H. Auden praised in Kirchstetten as "Modest in scale / And mild in contour / Conscious of greater neighbors." A humane landscape.

To me the Vienna Woods always evoke the "Unfinished" Symphony by Franz Schubert, the most Viennese of all composers; conversely I have a vision of the greenbelt around my native city whenever I hear that wistful music, although it is far from descriptive. I first heard Schubert's posthumous work, absurdly, when I had to play it. Our fifth-grade teacher, Mr. Krenn, had been asked by a colleague to "lend" the school orchestra a few boys from his class who could fiddle at a performance for visiting Board of Education officials. For some time I had reluctantly taken violin lessons because my father insisted on it, and I was picked to help beef up the orchestra for the occasion.

I couldn't play well and was dismayed to find myself sitting next to another boy whom I didn't know before the second-violin score of Symphony No. 8. The music was far above my beginner's level, and most of my fellow players weren't much better. The rehearsals were ragged, and so was our concert for the Board of Education inspectors.

Since then I have heard the "Unfinished" Symphony I don't know how often. I am convinced Schubert thought of the Vienna Woods—maybe its more dramatic ravines at the onset of a thunderstorm—when he wrote it. (The work was found in the drawer of a friend thirty-seven years after the composer's death.)

For a long time the nostalgic melodies would sadden me because they brought back that evening of March 12, 1938, when Vienna Radio played a recording of the "Unfinished" Symphony after the announcement that Hitler's troops had begun the invasion of Austria and that it was useless to resist. Soon afterward we would hear the triumphant shouts of the Nazi mobs in the streets. The world at large heard and read about the jubilation in our city but didn't know that other Viennese were sobbing in their homes following the Schubert music. Hundreds of Hitler's airplanes were flying over the Vienna Woods and thousands of tanks and troop carriers were rumbling across the green valleys to reach the Austrian capital. But history too marched on. Nazi rule was to end in infamy and ashes within a few years; Schubert's music is immortal; and the Vienna Woods have survived.

INDEX